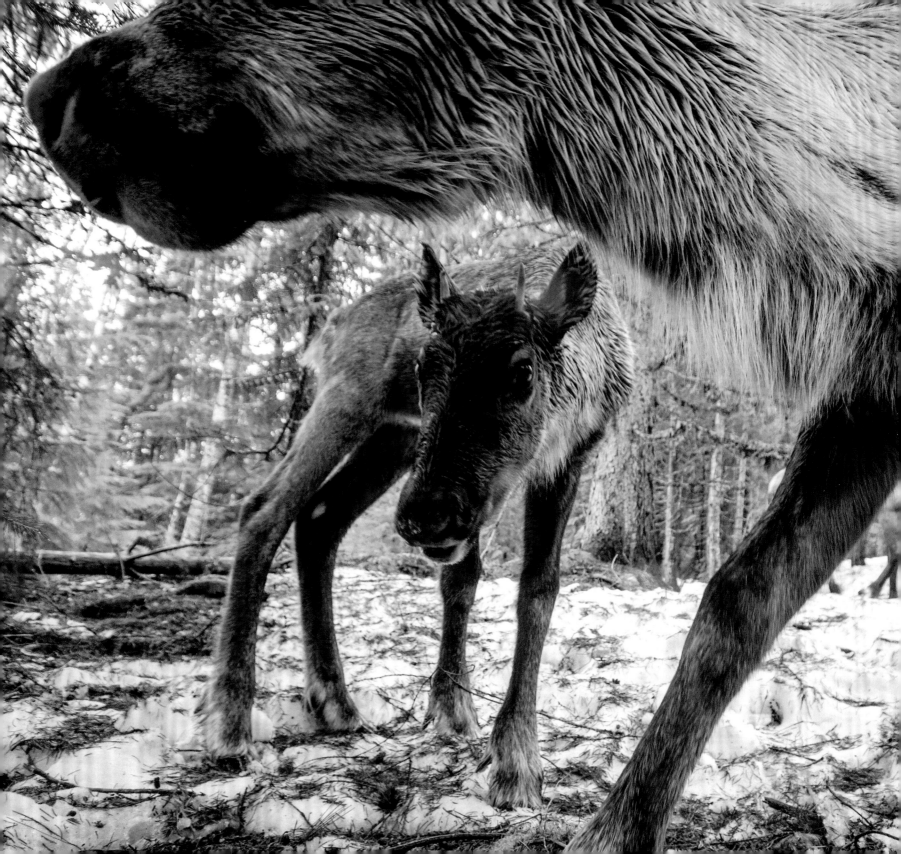

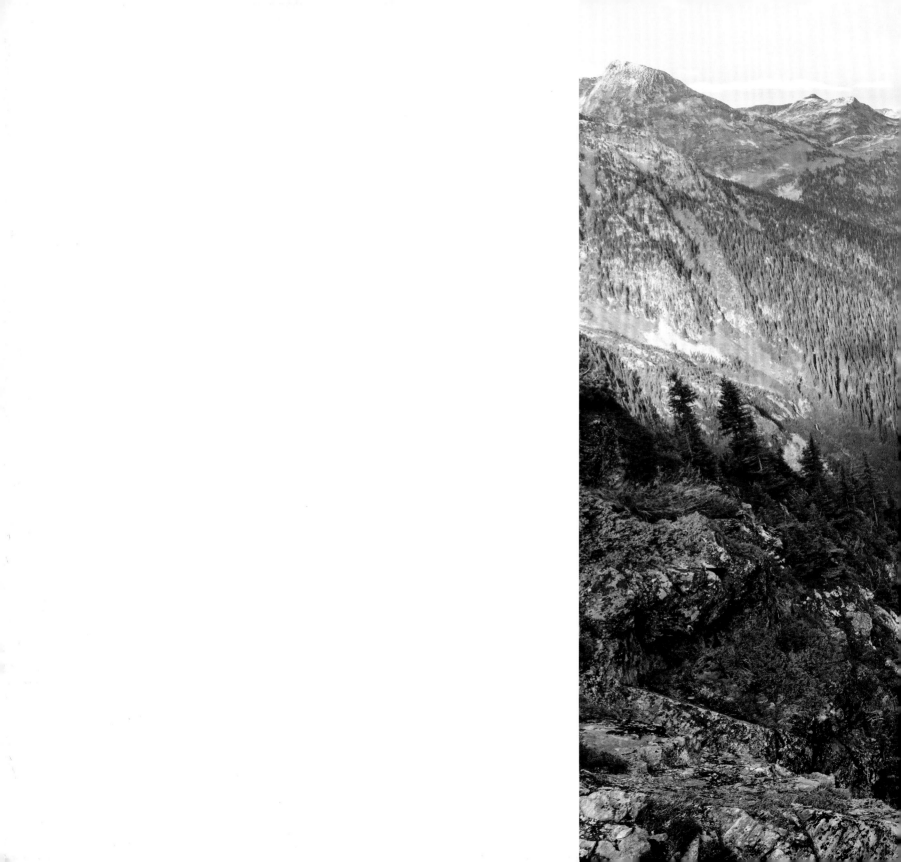

DAVID MOSKOWITZ

CARIBOU RAINFOREST

from HEARTBREAK *to* HOPE

BRAIDED RIVER

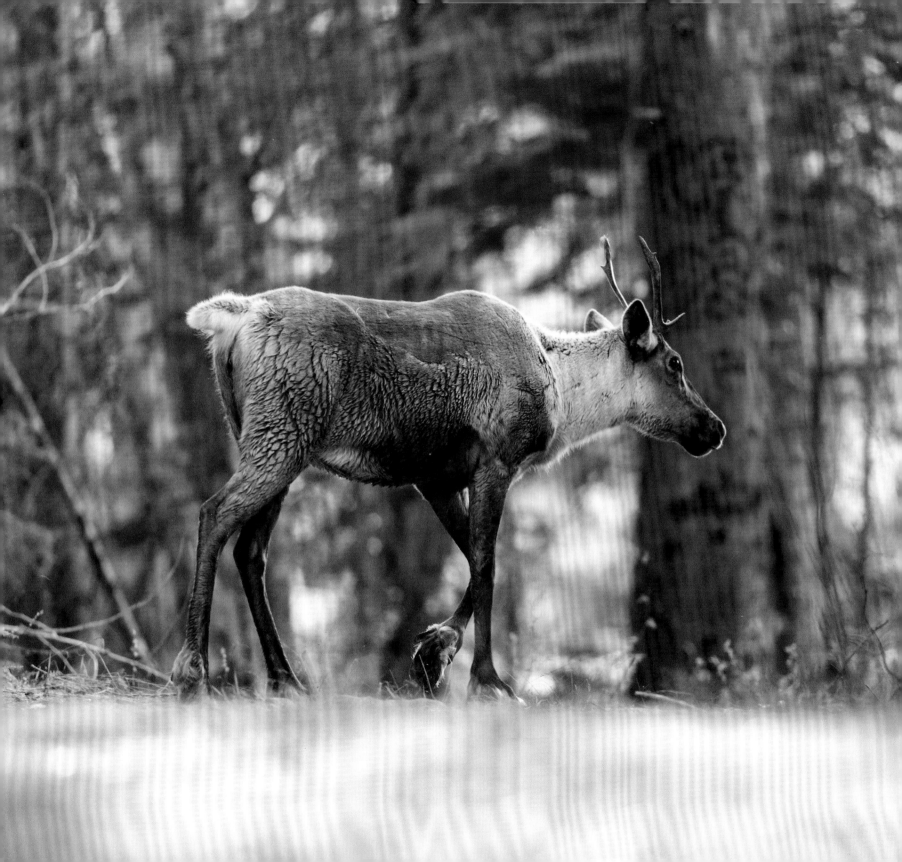

For Darcy Ottey,
for so many reasons
large and small

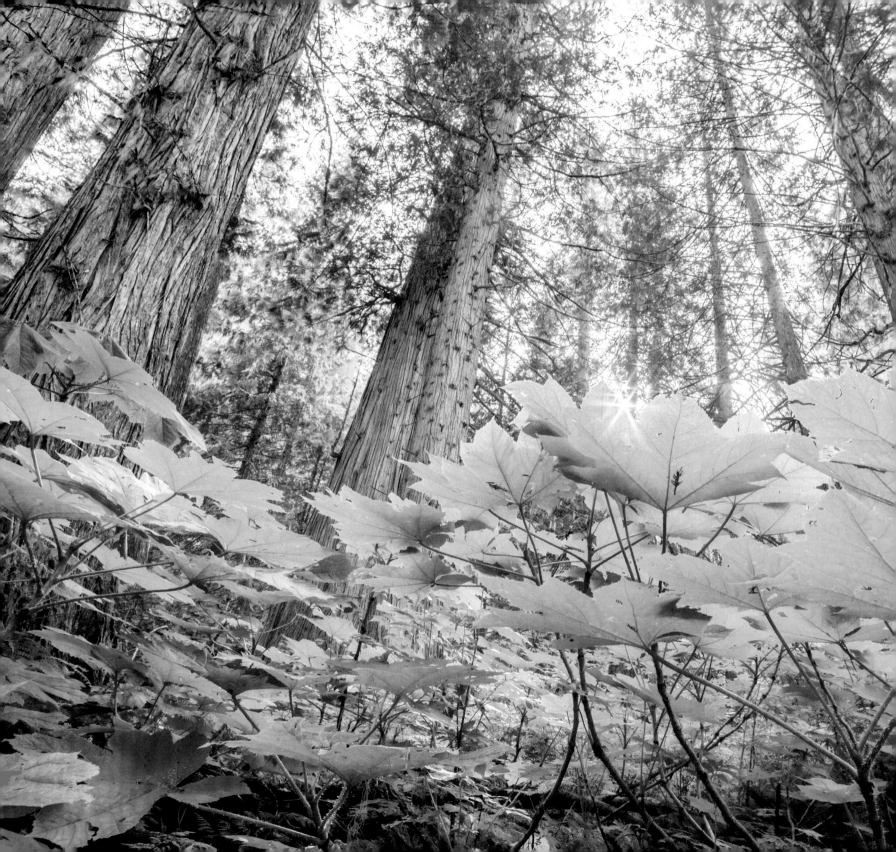

CONTENTS

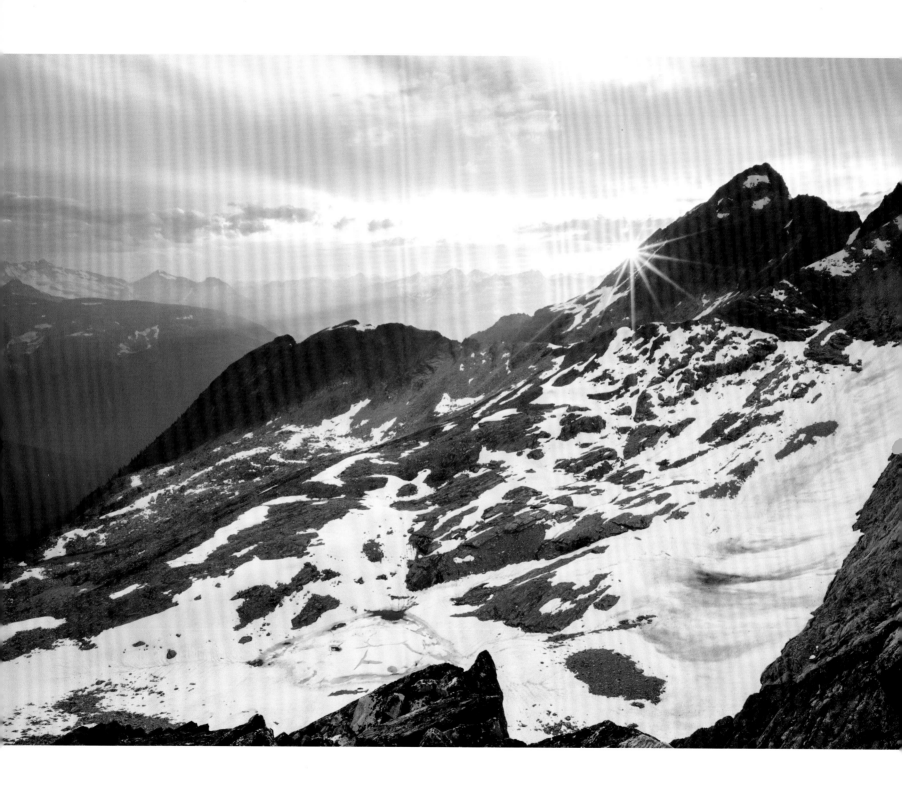

NORTH AMERICA'S HIDDEN RAINFOREST

Color is just coming back into the world with the morning twilight. Quietly, I set out from my camp in the Monashee Mountains of southeastern British Columbia. Crossing a small stream, I find tracks of an animal that had come down to the water. Perhaps having caught wind of my camp, the animal abruptly turned and went the other way. The trail is fresh and the huge, round tracks identify its maker: after years of searching, my first encounter with a mountain caribou is at hand.

For years I had read about these almost mythical creatures of the interior mountains of northwestern North America. Once abundant, they are now on the verge of disappearing. I follow the trail along a forested mountain ridge. To the north and south, the landscape rises to craggy, snow-clad peaks. To either side, the land falls away into the characteristic steep-sided canyon walls, polished cliffs, and milky emerald-colored streams of a glacier-carved landscape.

This mountain fortress I trod across, following the traces of a caribou, is in the heart of a little known rainforest hundreds of miles from the Pacific Ocean. The rainforest stretches discontinuously for more than 500 miles north to south across a series of rugged mountain ranges in northern Washington, Idaho, and Montana in the United States and southeastern British Columbia in Canada. The territory of the mountain caribou and the expanse of this interior temperate rainforest eerily coincide, hinting at their deep relationship and the possibility that this is truly a "Caribou Rainforest." As with so many parts of this story, traditional ecological relationships have been turned on their head. While mountain caribou evolved to depend on these remote forests to protect and feed them, these

OPPOSITE *Sunset over Eagle Peak in the northern Selkirk Mountains*

creatures now stand as one of the last major barriers to the annihilation of one of the most unusual forest ecosystems found anywhere on the planet. The legal protection of these endangered caribou is one of the only safeguards these vast tracts of rainforest have—a tenuous situation that demonstrates the need for further conservation efforts in the region.

For many people, it comes as a complete surprise that the interior mountains of the Pacific Northwest are home to the greatest interior temperate rainforest on Earth as well as one of the most unusual populations of caribou. Situated between the world-renowned coastal rainforests of the Pacific Coast and the soaring peaks of the Rocky Mountains, much of these rugged, lightly populated mountains were largely unacknowledged by outdoor enthusiasts and conservationists until recently. A closer look reveals a landscape of extraordinary beauty and global conservation significance.

Nowhere else in the world have geography and latitude come together to create an interior rainforest of this scale and isolation that, until recently, has preserved the forests and creatures so well. Here large swaths of primeval forest, undisturbed by humans since they emerged after the end of the last ice age, blanket remote mountains and harbor every native species of plant and animal traditionally found here. But human incursions of every sort are making this refuge ever more tenuous. Decades of logging, mining, road construction, hydropower infrastructure, and development now threaten to undermine the integrity of this ecosystem.

OPPOSITE An old-growth western redcedar and western hemlock forest in the northern Selkirk Mountains shortly after the snow has melted in spring

I follow the trail slowly, carefully scanning the openings in the spruce and fir forest as I go. The air is still. Cresting a small rise I spot a bull caribou, antlers in velvet, grazing in a clearing. Only my wide eyes betray my excitement as I stop and carefully lift my camera to snap a few shots, the *click* of the shutter drawing the attention of the caribou. He looks at me for a moment, then moves slowly but deliberately into the forest. I do not follow. After first reading about these legendary animals years before and then having gone on numerous outings to search for them, I felt like I had seen a ghost.

While the experience of seeing a mountain caribou is one of the joys of encountering that which is rare in the world, it was not always this way. As elusive now as they once were abundant, these animals played a vital role historically for the indigenous peoples of this place. Members of several indigenous groups from the region describe mountain caribou as a kind of food insurance. As Chief Roland Willson of the West Moberly First Nations shared with me, "Caribou were considered to be a convenient food. There were so many caribou here the elders said they were like bugs on the landscape." Harry Turney-High, an early ethnographer of the Kootenai tribe along the Idaho–British Columbia border, recorded his impression: "The caribou was considered something of a safety valve in the economy. They felt that they could always find caribou when other meat was scarce."

In another twist of fate, several of the region's indigenous groups who depended on caribou for sustenance now find themselves serving as the protectors

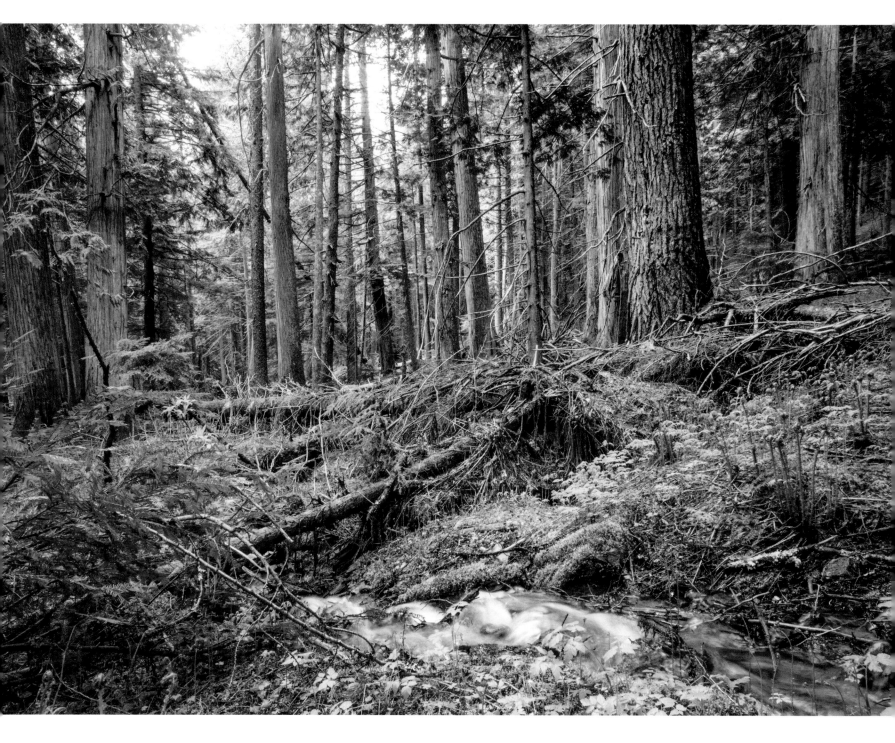

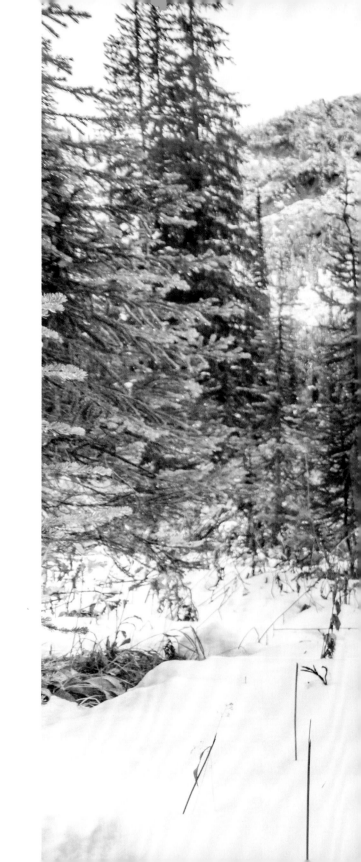

of the caribou against the same colonial forces that decimated the numbers of their own peoples: "We need them as much as they need us for protection," said Harley Davis, former chief of the Saulteau First Nations. "Without the animals and without the trees and the forest, our culture could not survive."

Here, the stories and fates of caribou, rainforest, and humans are irrevocably intertwined. What is unfolding in this mountain- and rainforest-clad region is of global significance, coming at a moment of great consequence for life on this planet. With the impacts of human-caused climate change at hand, a growing number of species on the planet are heading toward extinction as cultural rifts within human populations loom ever larger. National boundaries and twentieth-century legislation are failing to cope with the issues. Here we find a microcosm of what is playing out in ecosystems around the planet—indeed, the region is a crucible for developing effective approaches to tackling the socioenvironmental challenges we will face in the decades to come. This story is one of a landscape in flux, of shifting boundaries, physical and metaphorical, and a creature that wanders across it all.

WHEN MOST PEOPLE think of caribou, they probably imagine enormous herds of barren-ground caribou (*Rangifer tarandus groenlandicus*) streaming across the open tundra. Mountain caribou are a distinct ecotype of the forest-dwelling woodland caribou (*R. t. caribou*). Mountain caribou travel in smaller groups and frequent forests and

One of the last mountain caribou, whose home range straddles the international border between the United States and Canada in the southern Selkirk Mountains

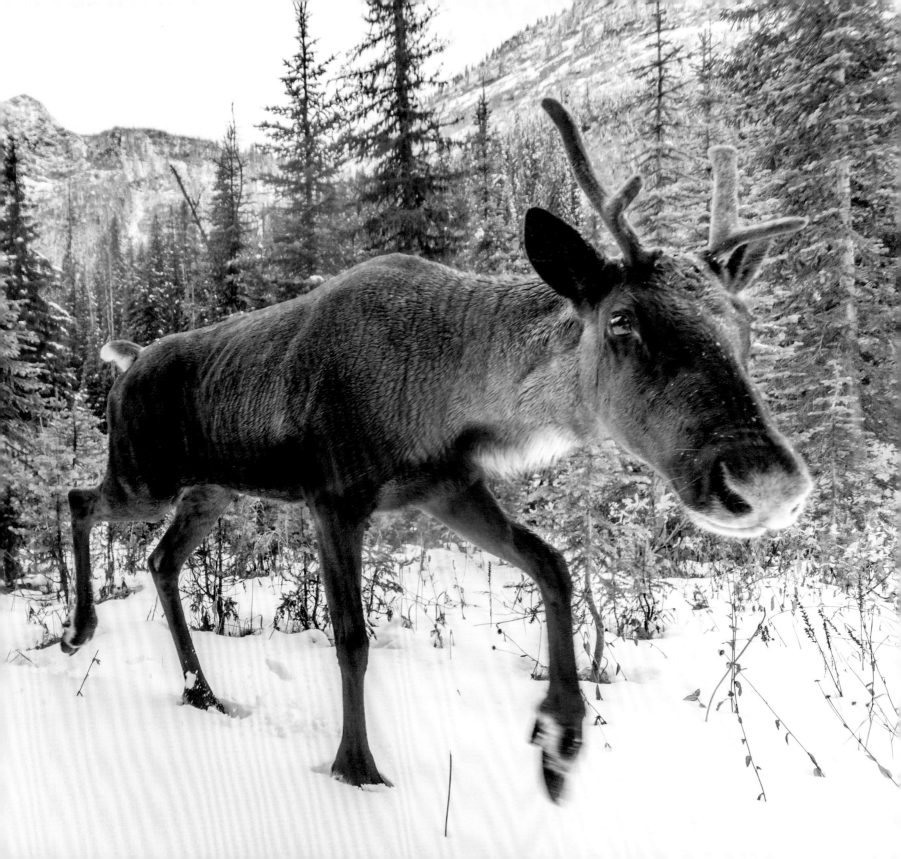

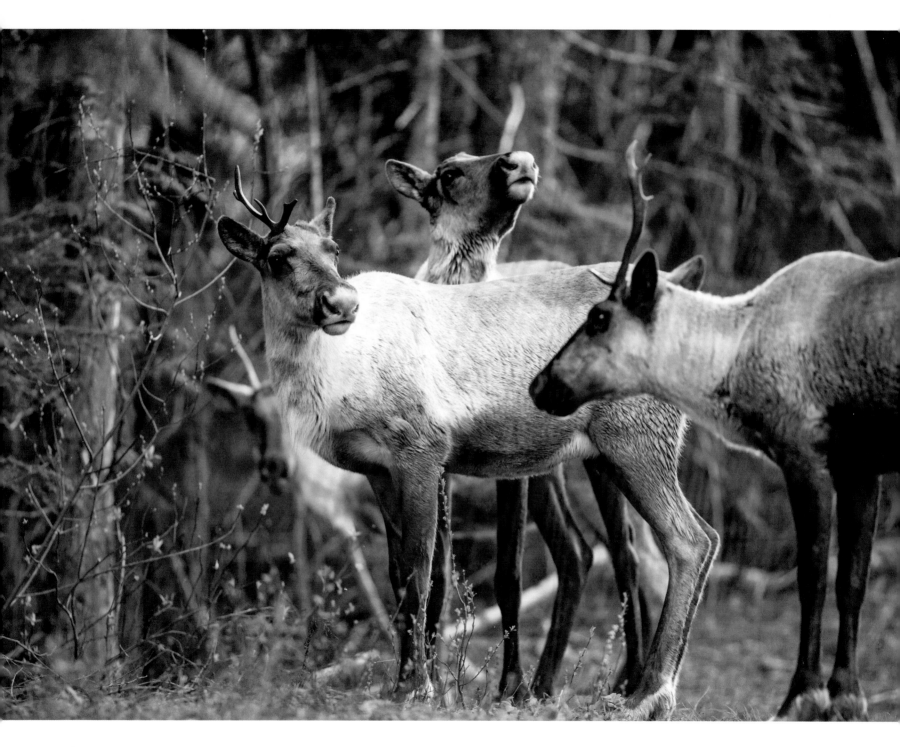

steep mountainous terrain south of the boreal life zone. Behaviorally, mountain caribou are one of the most unusual ecotypes of caribou found in the world because of the unusual environmental conditions they have adapted to, which includes a winter snowpack in excess of fifty feet (fifteen meters) some winters.

Caribou can be found all around the northern latitudes of the northern hemisphere. In Europe, where they are typically referred to as reindeer, indigenous peoples of Scandinavia have semidomesticated the species and their traditional lifeway revolves around reindeer herding. Here in North America, our native caribou are completely wild, having never been domesticated.

A creation of the ice age, caribou are well adapted for the cold and snow. They average slightly smaller in size and weight than elk. Males weigh an average of 240 pounds (110 kilograms). Females are smaller, averaging 175 pounds (80 kilograms). Like the Canada lynx, snowshoe hare, and wolverine, three other winter-adapted species that share their range, mountain caribou have large feet for their body size, giving them greater flotation when traveling over the snow. Their round feet are cupped in the middle, and in winter they can use them like shovels for pawing through snow to access plants and lichens buried beneath.

Caribou are members of the order Artiodactyla, hoofed mammals with an even number of toes on each foot, and the family Cervidae, which includes deer, moose, and elk. Cervids are unique among hoofed mammals in that they are the only animals that have antlers, deciduous bony structures that grow each summer and are shed every winter. Further, caribou are unique in this family because not only males (bulls) but also females (cows) grow antlers. Cervids primarily use their antlers in courtship and breeding behaviors.

MOUNTAIN CARIBOU ROAM up and down the mountains from valley bottom to mountaintop, back and forth across an international border, in and out of political discourse, and through the history and dreams of people in this region. The forests of these mountains, epic in scale, are home to an assemblage of species found in northern boreal landscapes, coastal rainforests, and the temperate intermontane forests that stretch along mountain ranges across the western United States and Canada. Weather in the region blankets the mountains with coastal moisture and continental chill.

To fully appreciate this story, we must understand the history of how this ecosystem has evolved since the end of the last ice age as well as explore predictions for how it will continue to evolve as the climate changes. We must travel through the traditional territories of numerous indigenous communities and across international boundaries with conservation laws that govern each side. We need to understand the variety of cultural values and experiences of the first peoples of the land and examine the colonial culture of people of European descent, now divided across economic and geographic lines.

Sorting out how to protect this region and heal the wounds inflicted on it since European colonization

OPPOSITE *Mountain caribou cows that have descended to where the snow has melted in low-elevation rainforest and spring green-up has begun*

involves yet another exploration of a shifting landscape of conservation theory from traditional single-species approaches (as laid out in the Endangered Species Act in the United States and in the Species at Risk Act in Canada) to unfolding concepts around ecosystem management. This process involves questioning classic habitat protection models, where the standard has typically been setting aside land as wilderness of one sort or another. Instead we might explore new ideas about nurturing resilience in natural systems for which further human intervention might be useful in the face of the coming impacts of climate change. Like the web of relationships that helped create the mountain caribou's fragile ecological niche, some of the options for protecting this landscape are complicated and counterintuitive, even seemingly contradictory at times.

THE CURRENT SOUTHERN EDGE of mountain caribou populations can be found along the United States–Canada border in the Selkirk Mountains. Mountain caribou once roamed the peaks and forests of what is now Glacier National Park in northwestern Montana and the mountain ranges to its south and west. Early colonial records of the region document caribou in the mountains of central Idaho, but they have not been recorded there in the past sixty years. For well over a century their numbers have been dwindling, as they have retreated north from their historical range in the western United States. Precise historical population levels are impossible to pin down, but for the past fifty years the trend has been a

A bull mountain caribou on an alpine ridge in winter in the Hart Ranges

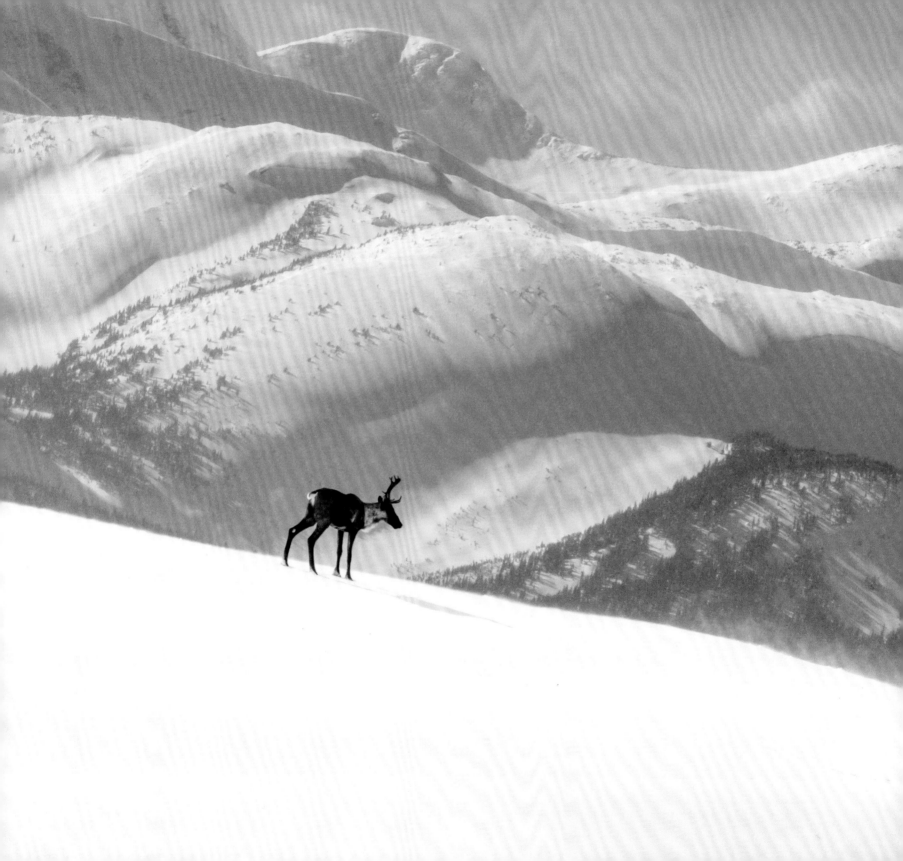

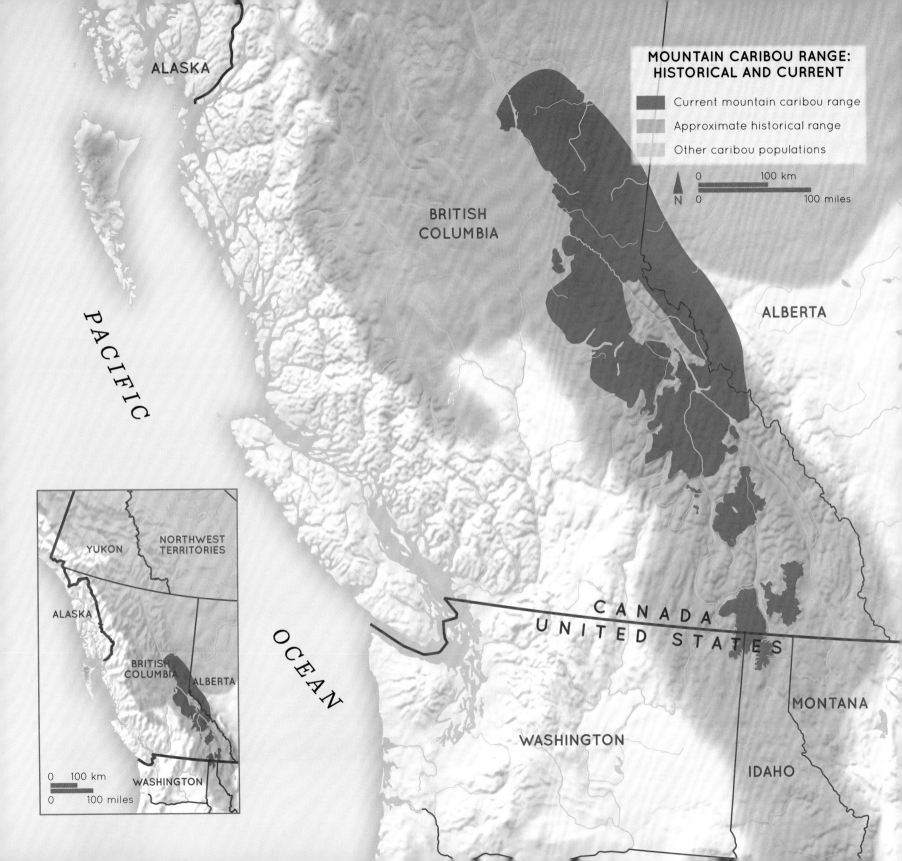

MOUNTAIN CARIBOU RANGE: HISTORICAL AND CURRENT

- Current mountain caribou range
- Approximate historical range
- Other caribou populations

0 100 km

N 0 100 miles

ALASKA

BRITISH COLUMBIA

ALBERTA

PACIFIC

OCEAN

CANADA

UNITED STATES

WASHINGTON

MONTANA

IDAHO

YUKON

NORTHWEST TERRITORIES

ALASKA

BRITISH COLUMBIA

ALBERTA

WASHINGTON

0 100 km

0 100 miles

marked decline. Now fewer than 1,300 mountain caribou remain across their current range, according to the BC Ministry of Forests, Lands, Natural Resource Operations, and Rural Development. Separated by rugged geography and habitat fragmentation, the population is further divided into subpopulations that have no contact with one another, making them even more vulnerable to disappearing.

The rainforest itself has also dwindled in the past century. The western slope of the Rocky Mountains in Glacier National Park, Montana, still contains beautiful old stands of cedar and hemlock trees protected within the park boundaries. Heading west from there in the United States, old-growth rainforest persists in patches, now fragmented by development, industrial logging operations, and sprawling open-pit mines.

To the north, where mountain caribou and the interior temperate rainforest reach the zenith of their existence, a similar story unfolds. In the Selkirk Mountains, ongoing logging creeps up to the edges of Glacier National Park, British Columbia, leaving a shrinking island of uncut rainforest too small to protect mountain caribou and the particular ecosystem they depend on.

At an ever-increasing rate, contemporary Canadian and American society's quixotic quest for capitalistic profit has unraveled this ecosystem's intricate web of relationships, a story played out many times over across the world. Beyond the possible demise of these mountain caribou and this magnificent rainforest-clad mountain region, there are far-reaching lessons for conservation on a global scale. The failing attempts to turn the tide for this ecosystem, and the wildlife and humans that depend on it, is a modern conservation parable. It sheds light on the increasingly complex human impacts on landscapes, even in our most cherished parks and most distant corners of the planet.

Thousands of miles from the continent's decision-making capitals, hundreds of miles from any major cities, North America's inland rainforest beckons us to revel in its untamed beauty. Whether the story of mountain caribou will be recorded as yet another environmental tragedy of our time or instead become a case study for rebuilding resilient ecosystems will depend on our generation's will to act decisively.

MY OWN EXPERIENCES in the Caribou Rainforest Ecosystem have spanned most of my adult life. My earliest encounters with the region, twenty years ago, were driven by a personal love of adventure and a fervent desire to immerse myself in wild places. Later I returned as a student of the region's natural history, and finally now as an advocate for its conservation.

For me, the journey to track mountain caribou became a quest to understand something much larger about humankind's relationship with the world around us, and a personal reckoning with a society seemingly headed down a dark path toward ecological catastrophe. Some experts believe that much of the current population of mountain caribou is doomed. Indeed, conservation ecologist Greg Utzig

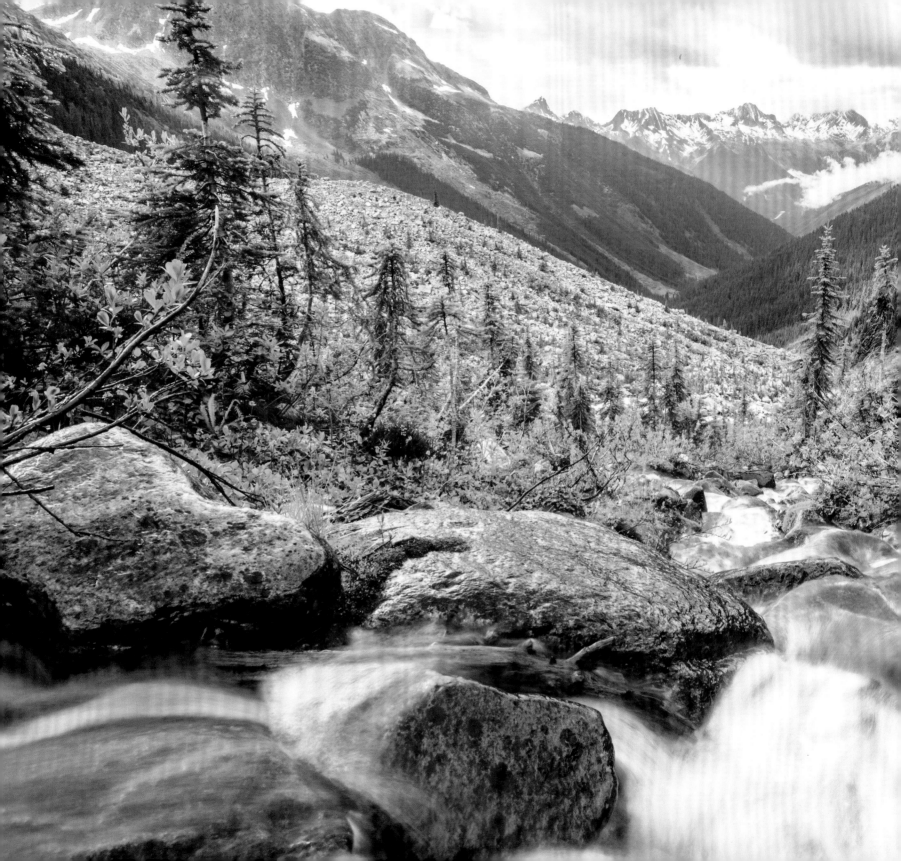

explained to me how the entire inland rainforest eco-system is in the process of disintegrating in the face of continued resource extraction and the specter of climate change. Similar assessments are coming in from every corner of the planet from the people who spend their lives looking deeply into the prospects of the world's natural systems. On a practical level, how do we reconcile the needs of an ever-increasing human population with the finite resources of the planet? On a personal level, in the face of seemingly insurmountable global forces, how does an individual spend each day trying to turn the tide of these forces?

In that first dawn encounter, the magnificent mountain caribou locked eyes with me briefly. I thought of the role he unknowingly now plays in the world. I wondered, what messages from the forest and mountains does this caribou have for us humans? Thousands of square miles of protected forests hang in the balance, dependent on his life or death. In an interview, Chris Ritchie, the head of caribou conservation for the province of British Columbia, made it clear that if these caribou disappear, the forests set aside for them will go back on the chopping block, barring some new justification for their protection. In the United States, should caribou go extinct, critical habitat protections for them will no doubt be lifted. I considered the mounting threats the caribou and his offspring will face as the ecosystem shifts under their feet.

Looking at this caribou, the biologist in me sees an animal assessing an unfamiliar part of the landscape and a potential hazard. The photographer and visual storyteller in me see a powerful creature set in

A mountain stream tumbles across glacial moraine debris and past stunted subalpine firs close to treeline in the Selkirk Mountains.

the context of the high-elevation forest it calls home. The part of me experiencing the primal thrill of contact with a large and elusive mammal sees a piece of my own species' evolution. As a conservationist, I see how this grand evolutionary experiment could end, and how fragile the future of this rare animal and rainforest is.

As I have sought to unravel this story, to bring the mysteries of these rugged and remote mountains down from the heights and out of the dark forest, I have looked into the eyes of many wild creatures, sat on mountaintops taking in the world, and felt the rain and snow sift through the high branches of ancient rainforest trees. I have also looked into the eyes of many people and listened to their stories and experiences of this land, heard their grief, concerns, aspirations, and hopes for what lies ahead for us.

Like the complex tangle of ecological relationships that defines the ecosystem itself, the human experience is similarly complex and beautiful. We must grapple with how to meet our needs while ensuring a reasonable existence for all future generations. The human communities of this place, like the caribou and the grizzly bear, the ancient cedars and glacier-carved peaks, are manifestations of this place. As such, this is their story as well.

OPPOSITE *A cow (foreground) and bull (background) from the Southern Selkirks caribou herd close to the international border*

WHAT IF A MOUNTAIN CARIBOU wasn't an object, a type of animal classified discretely, that you could pick up and move from one place to another and have it still be what it was originally? That's not how we typically think about animals. If you take your family dog on a road trip from Florida to the Yukon, it is still fundamentally the same creature you started the journey with. Your dog is your dog, whether on the beach in Florida or in the forests of the Yukon. In this book, we need to step out of this mode of understanding our reality and into a very different way of perceiving the world.

In complicated ecosystems, characteristics arise from the relationships among the constituent parts. Nothing about a body of water causes it to ebb and flow, yet out of the relationship between the oceans, the moon, and our moving planet arise the tides. If you disrupt the relationships, these characteristics will change, perhaps even disappear. The large temperature difference at the equator and at the poles causes the massive currents in our oceans, which set the stage for our planet's rich marine ecosystems. But at other times in the globe's history, these currents did not exist and the oceans were far less biologically rich. As systems evolve, new elements are introduced, others fade away, the interactions among the parts evolve, and these emergent characteristics change. Let's consider the forests, wildlife, and even human cultures of the Caribou Rainforest within the ecological context that gave rise to them.

THE INLAND TEMPERATE RAINFOREST is much more than a collection of trees. It is the product of an unfathomable number and variety of interactions among the geography, climate, and constituent species found there. As this rainforest grew, in places its own mass influenced the conditions within it, and it

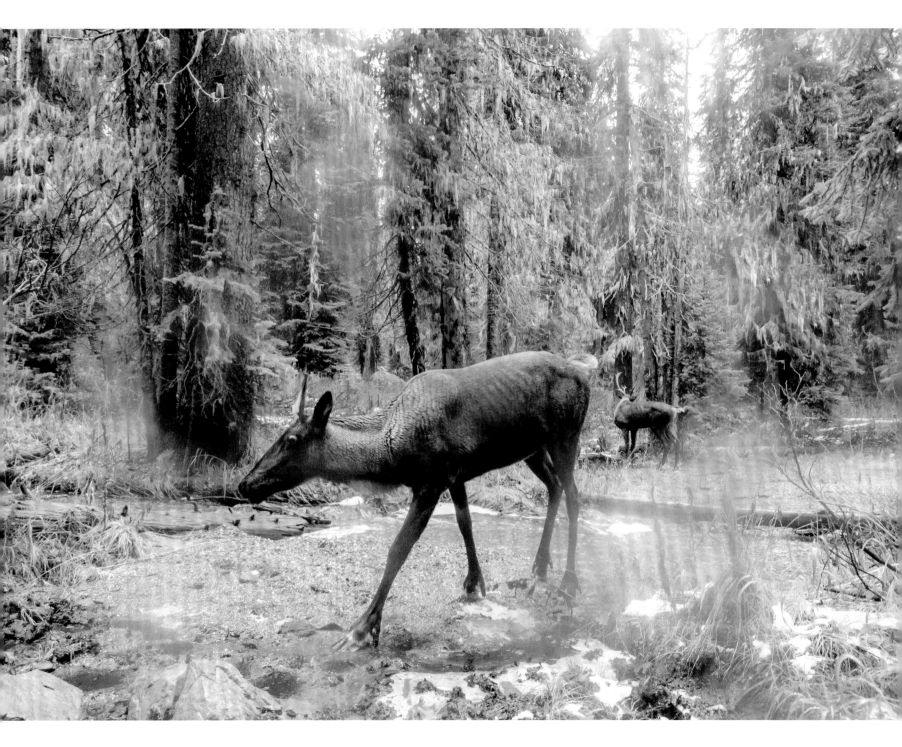

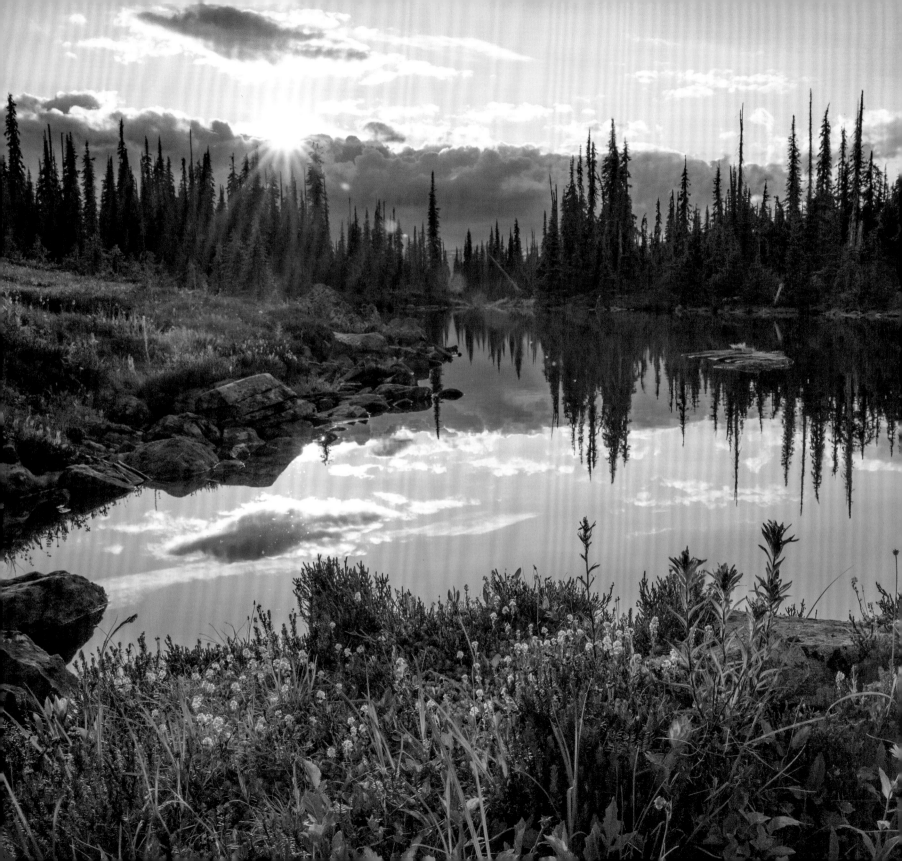

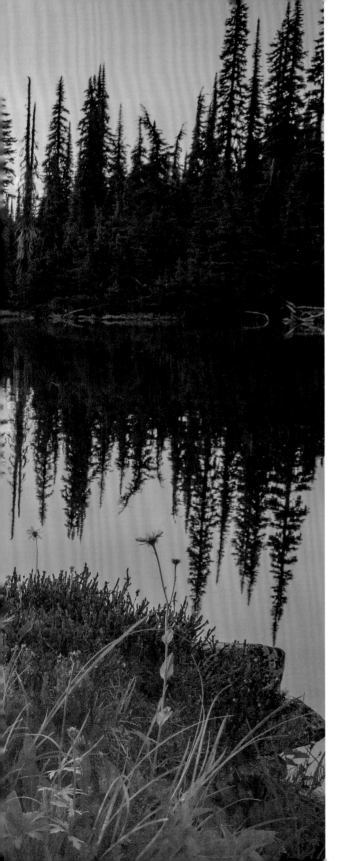

created microclimates conducive to life for its inhabitants. In turn, the amazing life history of animals like the mountain caribou arose out of this complex network of relationships. If you take a mountain caribou out of these mountains and put it in a zoo, you will not have captured a *mountain* caribou. What makes this animal special is the context in which it carries out its life and the web of interactions that make that life possible—and so, too, for the countless other plants and animals that call this region home.

The same can be said about the humans of this landscape. Western civilization has worked hard to perpetuate a myth that our species is somehow separate or different from every other species on the planet. But when we entertain the thought that perhaps our lives, our cultures, even the choices we make are driven by the environment we find ourselves in and our relationships, we realize that, like the mountain caribou and the rainforest, we are elements of a system far larger and more complex than we can grasp.

The challenges we face in the modern world do not end with the protection of distant places and iconic species. My intention is for this book to be one of self-discovery for my kin, humans. The journey begins by understanding the largest of contexts for this ecosystem—the geology, geography, and climatic influences upon which all else has been built. From this foundation the forest evolved. And beyond this came the wild creatures that inhabit this tapestry of mountains and forests. With that as the preamble, we can once again turn back to our own kind and perhaps

A subalpine forest and wetland in the Monashee Mountains, typical summer habitat for mountain caribou

understand ourselves and our place in the world from a fresh perspective.

I believe our love of exploration and experimentation are two of our species' most powerful characteristics. In the pages that follow, I have tried to illuminate this magical rainforest landscape and give voice and view to the diversity of life struggling to survive there. A brief encounter with a mother caribou and her calf, or a mother wolf and her pup, and it becomes clear that one characteristic we share with all living creatures is an innate passion and concern for future generations. Let this book be an exploration of a fascinating, complex, and beautiful world, a review of our experiments as a species within it, and a starting point for conversations about how to care for future generations of all the living creatures of the Caribou Rainforest and the world beyond. We can learn valuable lessons from these mountains, forests, creatures, and people.

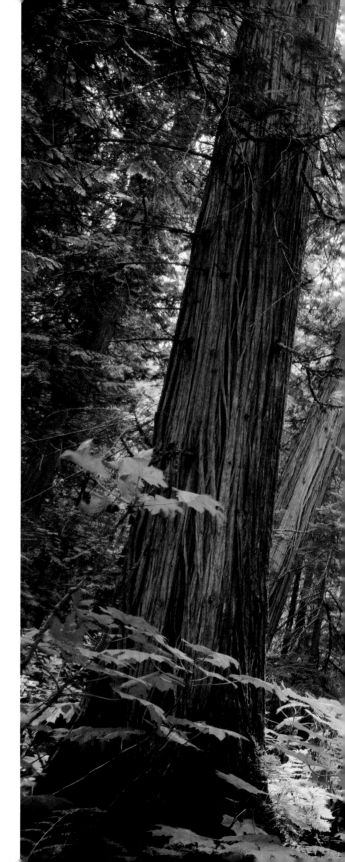

When the valley between the Selkirks and Purcells around Trout Lake (British Columbia) was logged, these ancient cedars were spared. This monument to a lost forest reminds us of what remains in other parts of the Caribou Rainforest.

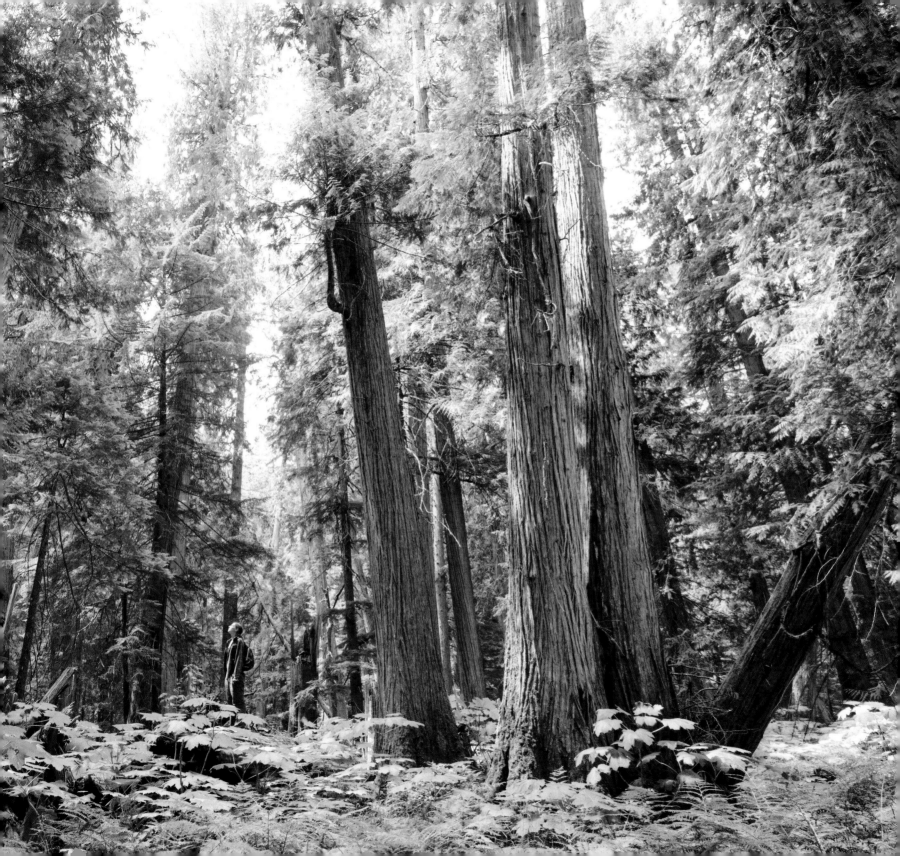

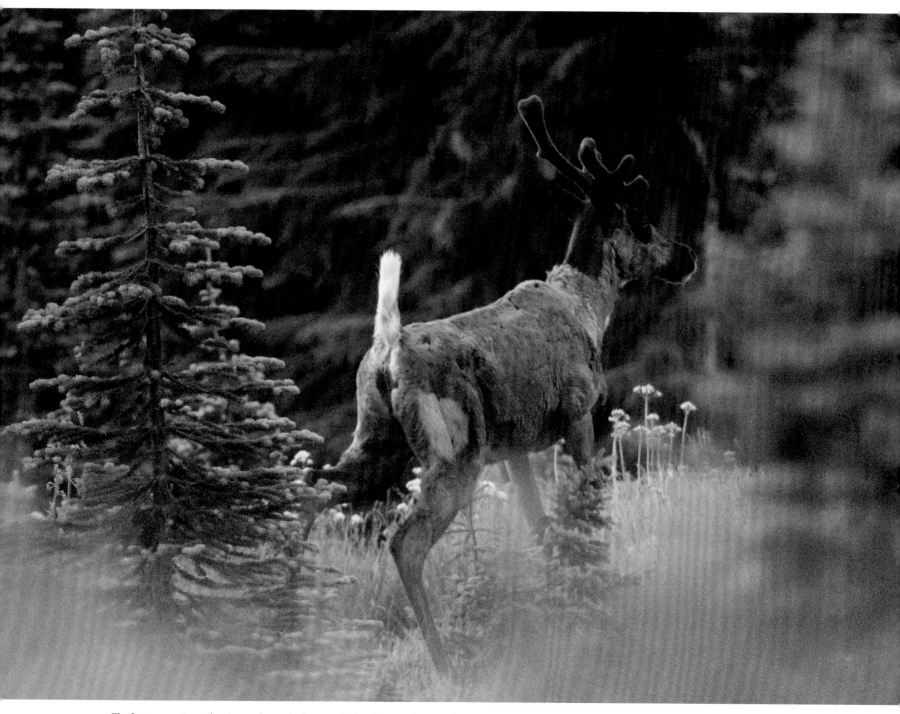

The first mountain caribou I ever observed, photographed at dawn in the Monashee Mountains

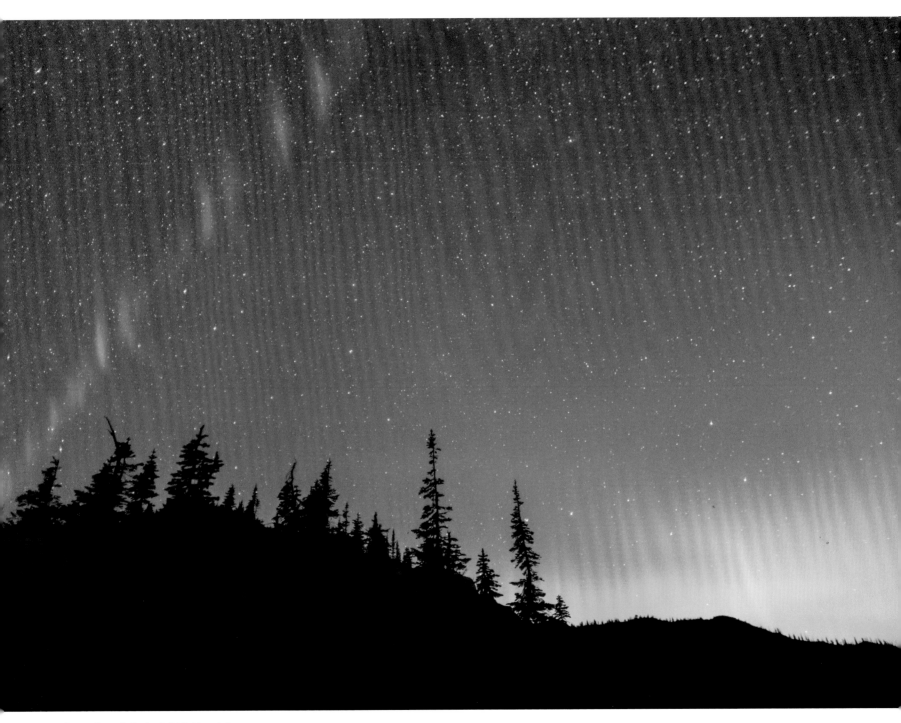

Aurora borealis in the Selkirk Mountains

Summer thunderstorm and rainbow over Caribou Meadows in the northern Cariboo Mountains

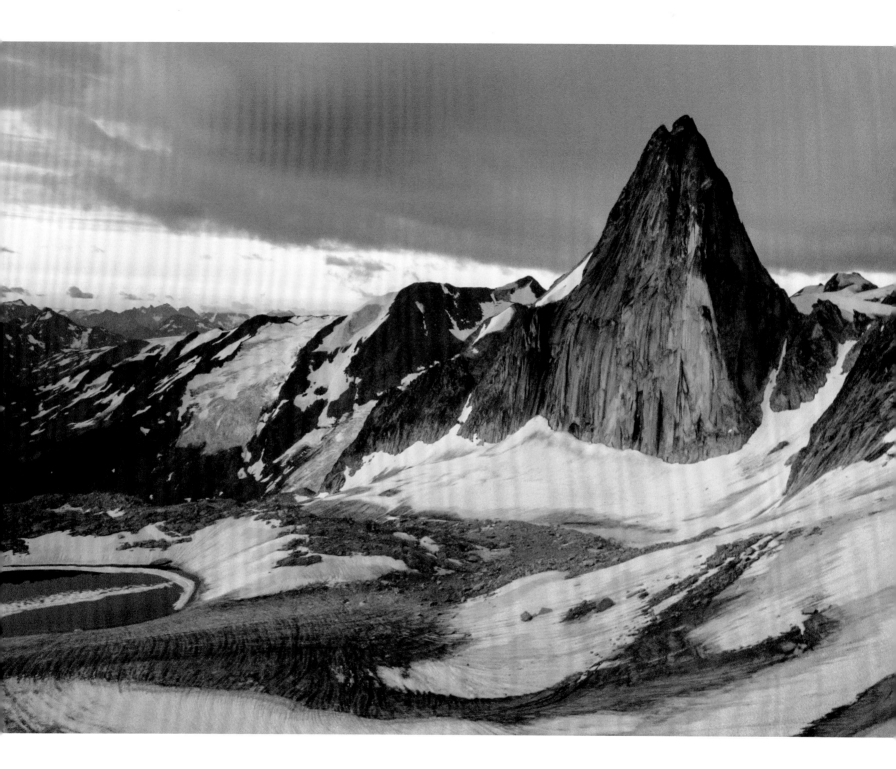

THE MOUNTAINS: OUR PLAYGROUND, THEIR LAST REFUGE

My first trip to the Caribou Rainforest had nothing to do with caribou or rainforests. I did not even know mountain caribou existed. I was looking for adventure. At the age of twenty-one, I planned a two-week off-trail high-elevation summer traverse in the Purcell Mountains of British Columbia with a climbing partner. There are many world-class alpine destinations in the region with established high routes. Wanting to see some terrain that felt unexplored, we didn't choose any of those. Ultimately, we got more than we bargained for.

Our fantasy of a grand ramble across a stunning alpine landscape turned into grueling bushwhacking through miles of mosquito-infested slide-alder jungle. On our second day the futility of our endeavor seeped in. After a hair-raising crossing of a glacier-fed torrent, we found that slide alders blanketed the basin and mountainside between us and the alpine pass that was our destination. We never made it. After two hours of thrashing through thick brush, having progressed less than half a mile, we sat wearily under the leafy alder canopy and admitted defeat. At our current pace, it would take us two days to reach the pass, and we had no idea what lay beyond that. Not wanting to fully retreat, we decided to drop down into the valley below and see where it led us. Our maps ended just a

OPPOSITE *Snowpatch Spire in the Bugaboo subrange of the Purcell Mountains*

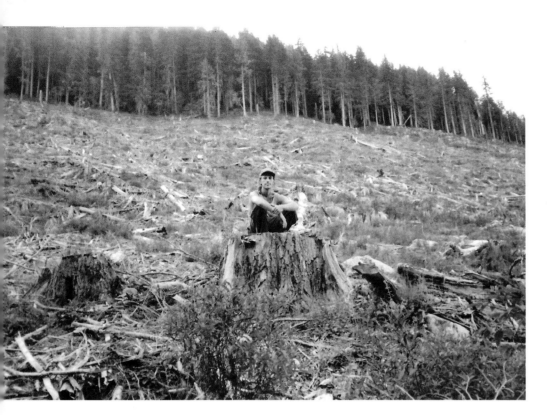

In a clear-cut in the Purcell Mountains on my first trip to the Caribou Rainforest at age twenty-one (Photo by Darcy Ottey)

After several days of being enveloped in the sub-alpine jungle in a landscape totally unsuitable for human movement, we stepped out into the clear-cut, sweaty and bruised but elated that this part of our ordeal was over.

We sat on the edge of the cut and a different awareness rolled over us. The reality of what we had just rejoiced in finding settled in. Stumps spread out in front of us. We wandered down to the landing where logs had been stacked and then loaded onto trucks and hauled off. Only a few years ago this landscape was an untouched primeval forest, and we were happy to see it in this altered state?

The paradox of that experience haunted me for years—driving my curiosity about the effect humans have had on the environment, the tenuousness of my own love of wild places, and how much that love depends on the comfort and stability of the modern world—a world built through the destruction of these very places.

Also brought into focus by this trip was the reality of the lives of the wild creatures that call places like this home. I used this landscape to seek out the opportunity to step outside the human environment into something *wild* and *foreign*, to test myself and my skills, to enliven my life with thrills of the unknown. When I was done, I was going home. For the grizzly bear and mountain caribou, this was home—one of the last places on the planet where they could escape the overwhelming influence of humans.

It's not that grizzly bears prefer landscapes like this. The coast of California probably had one of the

few miles beyond our current location and there were no trails or roads marked on them, but we figured eventually we would hit a logging road.

Over the next day and a half we made our way down the valley. We aimed for occasional small patches of conifers where even the understory of head-height devil's club, a plant well endowed with prickly thorns, was a welcome reprieve from the maddening, intertwined slippery limbs of alders.

Off in the distance we could see the start of thick forest. We made our way slowly toward it. As we got closer we realized there was a large clear-cut swath carved into it. We rejoiced knowing there would be a road punched into the mountains to access it.

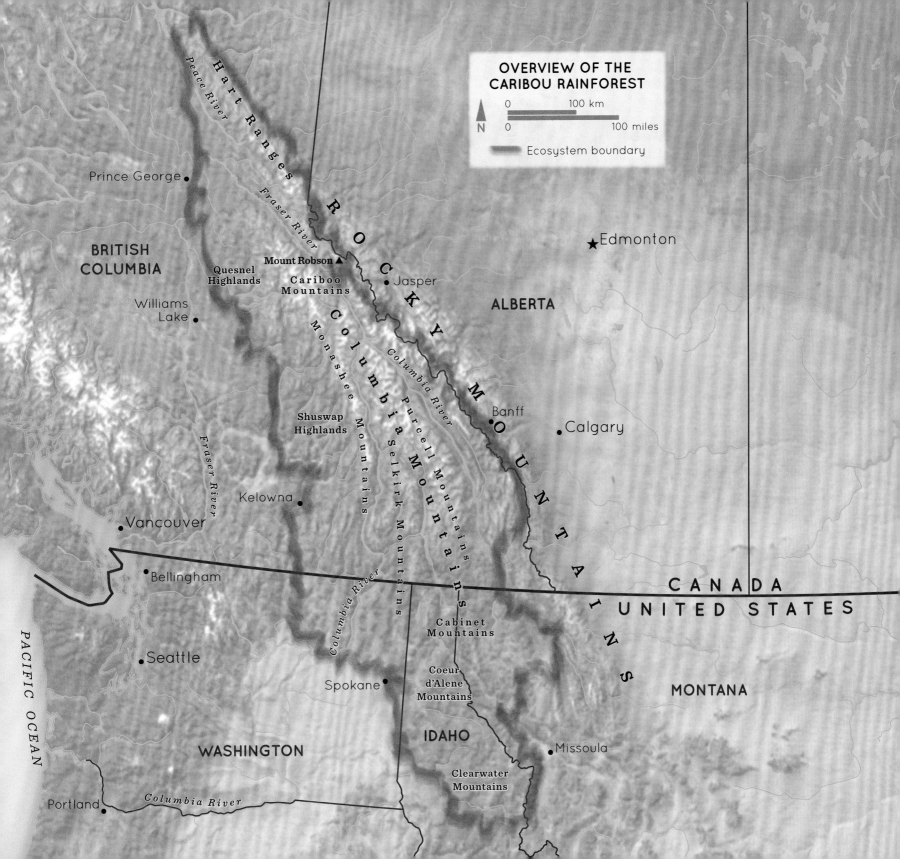

OVERVIEW OF THE
CARIBOU RAINFOREST

0 100 km

N

0 100 miles

━━━ Ecosystem boundary

Peace River

Hart Ranges

Fraser River

Prince George •

BRITISH
COLUMBIA

R O C K Y

Quesnel
Highlands

Mount Robson ▲

Cariboo
Mountains

Williams
Lake •

★ Edmonton

• Jasper

ALBERTA

M
O
U
N
T
A
I
N
S

Fraser River

Shuswap
Highlands

Monashee Mountains

Columbia River

Columbia Mountains

Purcell Mountains

Selkirk Mountains

Banff

• Calgary

Kelowna •

Vancouver •

• Bellingham

CANADA

UNITED STATES

Cabinet
Mountains

Columbia River

Seattle •

MONTANA

Spokane •

Coeur
d'Alene
Mountains

IDAHO

• Missoula

WASHINGTON

PACIFIC OCEAN

Clearwater
Mountains

Portland •

Columbia River

highest densities of grizzly bears found anywhere on Earth before Europeans showed up. Where San Francisco now sits, grizzly bears feasted on shellfish, beached whales, seals, and salmon next to one of the densest populations of indigenous peoples in North America. Now an urban jungle spreads out across that landscape, home to millions of humans but not a single grizzly bear.

The surviving populations of mountain caribou include only those that have made their home in the most remote and environmentally challenging parts of the northern reaches of the planet. The archive at the historical museum in Bonners Ferry, Idaho, which sits in the Kootenay River Valley east of the Selkirk Mountains, includes references to caribou wandering around in the valley, once a teeming mix of swampy forest and marshes. Now, the wetlands are drained and converted to agricultural fields. With roads and development crisscrossing the valley, it is an incongruous place to imagine finding a creature now associated with old-growth forests and remote mountain terrain.

THIS MOUNTAINOUS CORNER of the world has been long in the making, the product of millions of years of plate tectonics, burnished with a healthy dose of ice age glacial carving. The region, defined by

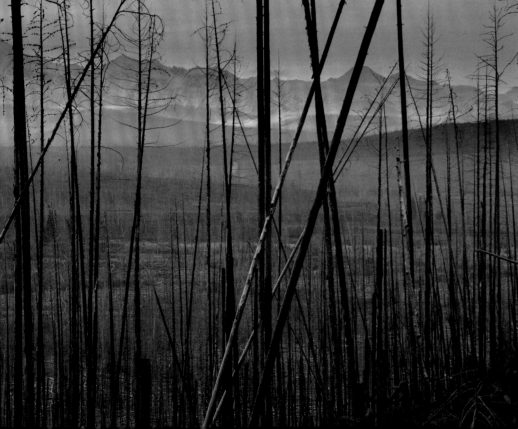

TOP *Avalanches rumbling down from alpine basins make it impossible for forests to get established in their paths. This slide path is in the Selkirk Mountains.*

BOTTOM *Burned lodgepole pine trees in front of the Rocky Mountains in northwestern Montana close to the historical southeastern limit of mountain caribou and the inland rainforest*

LAY OF THE LAND: MOUNTAIN RANGES AND WATERSHEDS

A journey across the Caribou Rainforest Ecosystem reveals what feels like an endless progression of rugged mountains, forested on their flanks, brushed with snow and ice. The myriad mountain ranges and subranges, rivers, and tributaries that make up the region have produced not just a jumbled mosaic of physical geography but also a confusing plethora of languages that has, in numerous instances, bestowed the same piece of terrain with multiple overlapping names and occasional spelling differences, depending on which side of the international border you find yourself on. The voice and vision of the indigenous peoples fades into the language of North America's European colonial settlers. It is the land itself that has laid the foundation for the rich and confusing ecological and cultural story of this region.

The region comprises the headwaters of two major North American rivers and five major mountain ranges. While the mountain ranges generally run north-south throughout the region, the **Columbia** and **Fraser Rivers** both zigzag variously north and south through the region before eventually turning west to the Pacific Ocean. At the northern end of the ecosystem, waters roll into the **Peace River**, heading north, bound for the Arctic Ocean.

The **Columbia Mountains**, which straddle the US-Canada border, are made up of a series of mountain ranges between the Coast Range and Interior Plateau of western British Columbia and the Rocky Mountains. Taking their name from the Columbia River, which flows through the heart of these mountains, the northern portions of these mountains are actually in the Fraser River watershed.

In the west, the Columbia Mountains start slowly. Rising out of the drier interior plateau that sits in the rain shadow of the Coast Range and Cascade Mountains, the rolling forested **Shuswap Highlands**, named after the Shuswap First Nation, and the **Quesnel Highlands**, named after an eighteenth-century European explorer, form the western edge of the ecosystem and the start of the interior temperate rainforest.

East of the Shuswap Highlands, the **Monashee Mountains** form the first of a series of north-south-trending ranges that define the majority of the ecosystem. The southern half of this 330-mile-long (530-kilometer-long) range is lower and more rolling in character than the northern portion, which is punctuated by glaciated alpine summits rising to more than ten thousand feet (three thousand meters). The name of this range, derived from a Gaelic phrase meaning "mountain of peace," was given by a nineteenth-century Scottish prospector who staked a mining claim here.

Next come the **Selkirk Mountains**, named after a Scottish nobleman from the turn of the eighteenth century. Like the Monashees, the Selkirks rise in the north, where they are home to one of Canada's premier national parks: Glacier National Park. Here rainforest-cloaked valleys and massive glaciated peaks form some of the most stunning mountain terrain in North America.

East of the Selkirks are the **Purcell Mountains**. Similar in character to its western neighbors, this range includes a series of glacier-carved granitic spires, the Bugaboos, a world-famous attraction for mountaineers and rock climbers. At the south end of the Purcells in the Idaho panhandle, the **Cabinet Mountains** continue south to the jumble of the Coeur d'Alene and Clearwater Mountains.

Taken together, the southern Monashee, Selkirk, and Purcell Mountains are also referred to as the **Kootenays**, named after the Kootenay River, which drains this region and eventually flows into the Columbia River. The river takes its name from one of the indigenous groups of

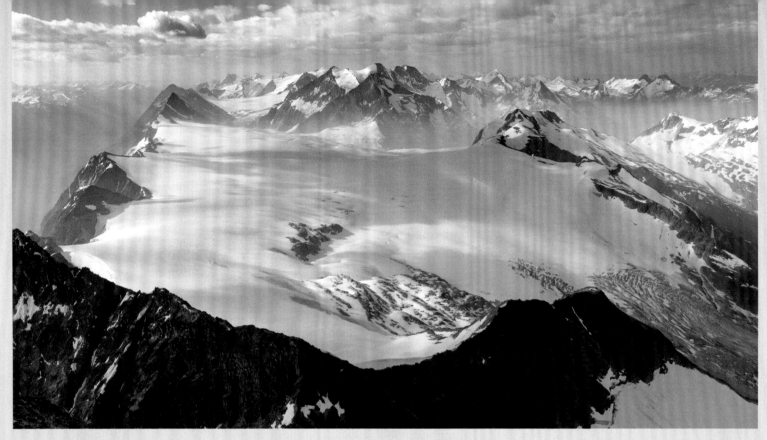

The sprawling Illecillewaet Glacier in the Selkirk Mountains, British Columbia

the area, the Kootenai (spelled *Kootenay* or *Kutenai*, in Canada, but now officially recognized as the Ktunaxa, pronounced tun-AH-hah, using the pronunciation and spelling of the people's own language).

The northern end of these ranges is marked by a hard bend in the Columbia River, which starts flowing north from Columbia Lake in the Rocky Mountain Trench, collecting water from the west slope of the Rocky Mountains as it goes. Eventually, the river turns abruptly south at Big Bend and carves a path between the Selkirks and the Monashees. North of here and east of the Quesnel Highlands, the **Cariboo Mountains** continue north, now in the watershed of the Fraser River. The Cariboos span some 150 miles (240 kilometers).

The eastern extent of the Columbia Mountains is marked by the **Rocky Mountain Trench**, a massive geological fault line that separates the Columbia Mountains from the Rockies.

One of the best known mountain ranges in the world, the **Rocky Mountains** span almost the entire length of North America. In this ecosystem they reach their northern extent, and perhaps their most stunning grandeur, in the collection of national parks along their crest from northern Montana to central British Columbia and Alberta. North of Jasper National Park, the Rockies are referred to as the **Hart Ranges**. The geology of these ancient mountains is complicated, made apparent by the seafloor sedimentary rocks that form the high peaks of the range crowning the center of the North American continent. The western slope of the Rockies and Hart Ranges, which includes the highest peak in the region, **Mount Robson** (12,972 feet, 3,954 meters), forms the edge of the Caribou Rainforest Ecosystem, the eastern extent of Pacific Coastal influences on the climate and plant communities in the continent.

a series of mountain ranges and highlands stacked one after the other, was primarily built from chunks of land brought onto the continent by the expanding Pacific Plate and the buckling, uplift, and magma released by the subduction of that plate under the North American continent. Because of this process, mountains here are made of a wide variety of rock formations including sedimentary, metamorphic, and locally produced igneous rocks. As the edge of North America was built, scrunched together and uplifted by the ongoing collision with the Pacific Plate, erosion began working to create the dramatic relief we experience today. Areas of softer rocks eroded more quickly, eventually forming the lowlands between each range of mountains.

The complex topography of these mountains sets the stage for the creation of an equally complicated collection of natural communities, the most unusual of which are the areas of temperate rainforest in the region and also includes alpine tundra and boreal-like forests with extraordinarily deep winter snowpacks. As with mountain landscapes around the world, elevation is the most significant factor in defining what life is like in any particular location, allowing you to biologically ascend in a few challenging miles of climbing what would take hundreds of miles to achieve moving north over the continent at sea level. The high peaks of these mountains soar beyond 12,000 feet (about 3,660 meters) while the valleys dividing the ranges sit as low as 1,350 feet (about 460 meters) in places. As you climb the mountainsides, plant communities change rapidly. Western redcedar

and western hemlock forests, which define the climax forests (the culminating stage of forest succession) of the Pacific Coast, dominate valleys of the interior. As you ascend, you notice that these forests are replaced by Engelmann spruce and subalpine fir forests, reminiscent of the boreal forests to the north and acclimatized to lower average temperatures and deep winter snowpack. As you continue upward, trees eventually disappear altogether. Above about 8,200 feet (2,500 meters) in the south and 5,900 feet (1,800 meters) in the north, alpine tundra covers the mountaintops and ridgelines of the region's ranges, a similar community of plants and climate to the arctic tundra at the northern edge of our continent. Here cold temperatures, high winds, and long periods of snow cover make life for trees impossible.

The second gradient that defines life in the region, stretching hundreds of miles south to north, is latitude. This mountainous region starts around latitude 46°N in the south and extends to about latitude 55°N in the north. As the mountains march north, average temperatures drop and precipitation amounts increase as the summer drought and arid conditions that define the continental intermountain west of the United States to the south dissipate, replaced by the colder, wetter influence of the climate of the Canadian interior to the north.

Building on these basic gradients, mountain topography adds many other variations that turn what might be a simple progression of ecological communities up the mountainsides into a much more complicated mosaic. North-facing and south-facing

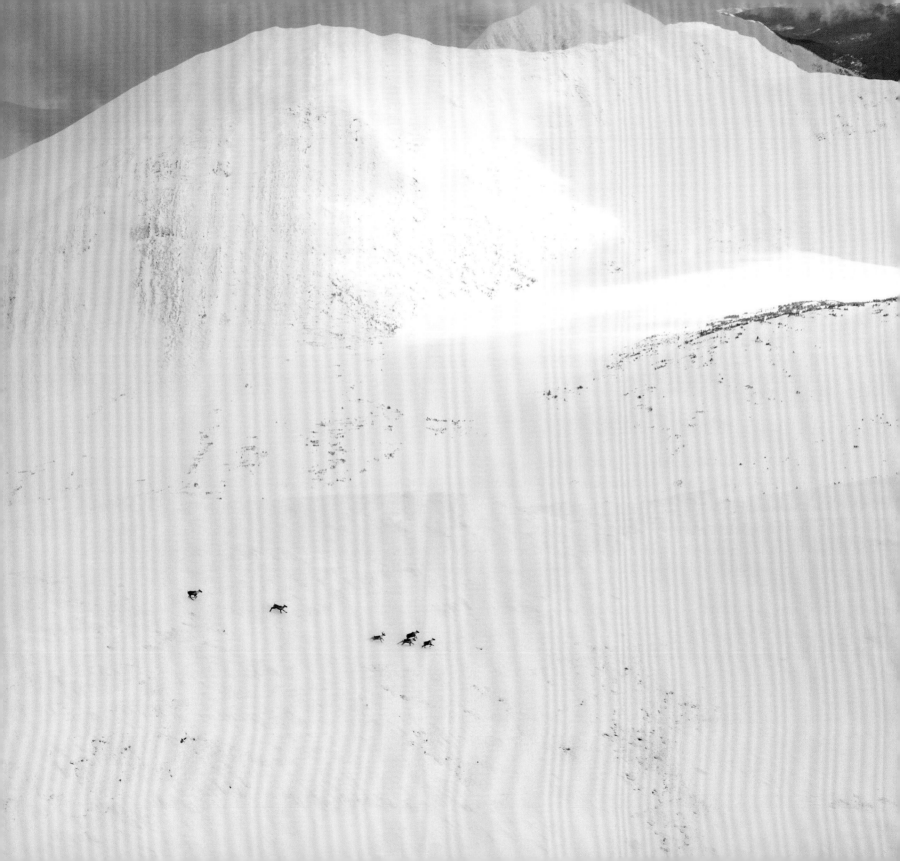

slopes often look drastically different. The former, often steeper from heavier glacial carving, remains shaded, cooler, and moister, while south-facing slopes exposed to more sun are drier and warmer, leading to corresponding differences in the plants.

The prevailing weather patterns bring moisture from the Pacific Ocean into the mountains. Topography wrings this water out of the air as it is forced to rise on its way up the mountainsides, making the windward sides of ranges generally wetter than leeward slopes. Adding to this variation in moisture is the deep winter snowpack and how it drains down the mountainsides when it melts. In the southern portion of the region, summer drought is common, but the tremendous snowpack in the high mountains typically lingers well into the summer, releasing water into the landscapes below. Downhill, concave locations receiving moisture from above can support plant communities requiring far more water than what the sky provides directly. Other places right next to them on drier, convex, and more exposed sites can have completely different plant communities. These juxtapositions create unusual pairings of neighbors like ponderosa pines, an icon of the dry interior mountains of western North America, growing adjacent to western redcedar forests adapted to rainforest conditions.

Deep snow and steep slopes lead to another force, avalanches, that carve out a distinctive feature of these mountains. On slopes where the terrain above commonly produces cataclysmic collapses of the snowpack, a group of specialized plants have adapted

A group of mountain caribou traverses alpine slopes in winter in the Hart Ranges.

to survive. Violent rivers of snow running down the mountainside rip traditionally structured trees out of the ground or clip them off at snow level. If they are uprooted or razed frequently enough, trees can't take root and a different cadre of plants take hold that are more flexible in their approach to the world.

Bane of many a mountain traveler across the region, as I discovered, a dense jungle of alders, maples, and mountain ash, in places with an understory of stinging nettles, fills the gap. The pliable trunks and branches of these twisted trees bend over and are covered easily by falling snow, allowing avalanches to slide over them in the winter. In the summer the flexible trees pop back up in a twisted jumble of limbs seeking sunlight during the brief mountain summer. Often, steep winter slide paths are summer watercourses, so the dense vegetation has a soggy understory of wet ground running over cliffbands lightly covered in vegetation. In rainforest valleys undisturbed by logging, these slide paths, and the edges of meandering rivers and creeks, are often the only place where early successional plants can be found, the forests having firmly established themselves across everything else.

THE RUGGED AND BEAUTIFUL MOUNTAINS of this region attract adventure seekers of many flavors. Mountaineers test their skill on the jagged peaks in a region with some of the most fickle weather on the planet. Winter draws skiers to the famous deep powder snow that blankets the high peaks. Boaters, bikers, fishermen, backpackers, hunters, and snowmobilers

A grizzly bear pads across a wet subalpine meadow in the Selkirk Mountains.

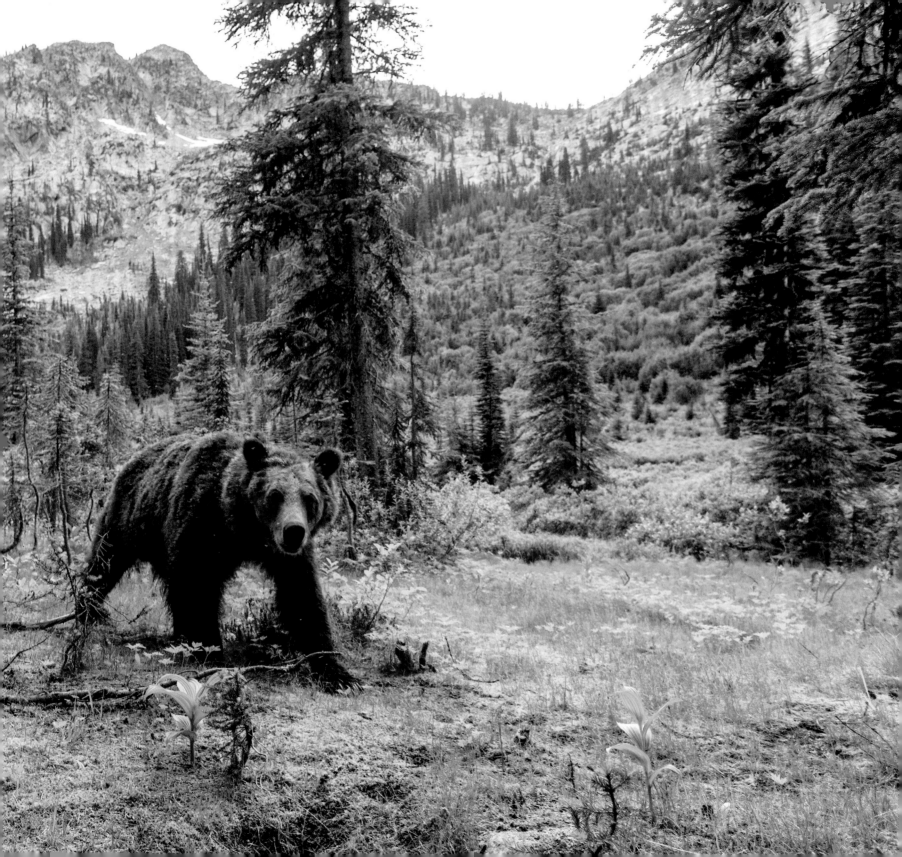

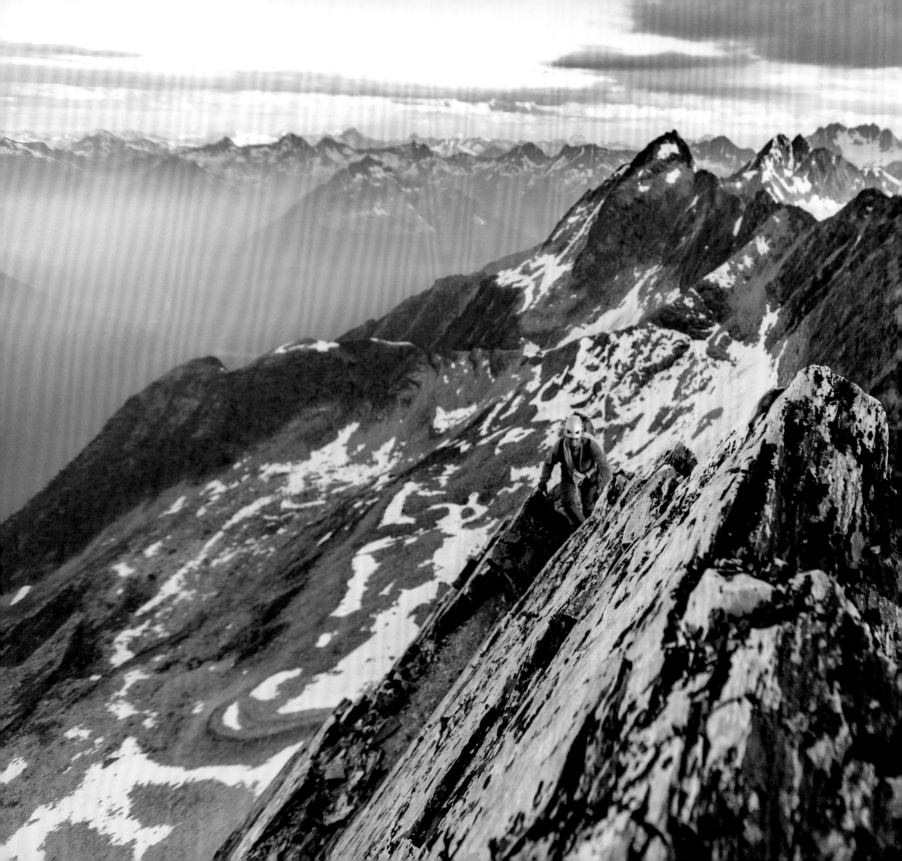

are also drawn to the stunning and dynamic landscape, emerald lakes, dense forests, and magnificent alpine scenery.

How ironic that in our quest to connect with the wild, we are essentially invading the last refuges remaining for some of the creatures that epitomize the wild for us. We get a thrill and sense of rejuvenation, but at what cost and for what in return? Outdoor recreation is often seen as a way of connecting people with conservation. But it is ever more common for the impacts of large numbers of recreationists to create an entirely new set of environmental concerns. Human recreation can displace wildlife. Real estate booms driven by a desire to live and recreate in wild places carve up undeveloped landscapes adjacent to parks. In these mountains, winter recreation is a multibillion-dollar industry that draws tourists from around the world. In British Columbia, helicopter-skiing operations are ubiquitous across much of the region, delivering people to some of the most remote corners of the mountains. With an ever-increasing road system from forestry activities, and more powerful snow machines each year, a growing number of snowmobilers reach deeper and deeper into the mountains every winter.

Access can also be found at the mountain passes that public highways cross. In the southern Selkirk Mountains, close to the Idaho–British Columbia border, Kootenay Pass is vital winter habitat for the remaining southernmost herd of mountain caribou. The Crowsnest Highway goes through the pass. In recent winters caribou have hardly used the pass at

A climber on the north ridge of Mount Sir Donald, in the Selkirk Mountains, one of North America's classic climbs

all, while backcountry ski traffic bustles in the mountains off the highway. Off of the Trans-Canada Highway, at Rogers Pass in British Columbia's Glacier National Park, while thousands of visitors launch trips into the surrounding mountains every season of the year, the only caribou you will find is a stuffed one in the visitors center on the highway. Limiting recreational access to caribou habitat in winter has been recognized as vital for protecting threatened caribou populations. But implementing recreational restrictions has been uneven and unpopular, creating a complicated fracture point between various elements within the conservation and recreation communities.

On a broader scale, the carbon footprint of eco-tourism in the region can be huge. Travelers from across North America, Europe, and Asia venture to this mountain playground, burning large amounts of fossil fuels in the process. In the case of activities like snowmobiling or heli-skiing, the fossil fuel consumption continues right through the duration of the activity. When I asked about this conundrum—engaging in winter sports that are inherently part of the problem poised to destroy winter recreation—the stock response I got from the heli-ski industry and snowmobile clubs was about increasing the efficiency of the machines being used.

If traveling to this part of the world for outdoor fun comes with ecological impacts, staying home comes with its own risks for wild areas and wildlife. With a recreation economy in this region as a viable alternative to resource extraction, communities have economic leverage to push for more progressive land management that will support not just logging, mining, or hydropower but also the wilderness values that attract people from far and wide. When it comes time to elect governments, having an urban population that is familiar with and fond of wild places far from their front door has been seen as an imperative for moving a conservation agenda forward. My own journey to a life focused on conservation started with recreational experiences in the natural world when I was young.

When the thought of losing access to places where we love to play comes up, we feel impoverished, perhaps even denied something critical for our souls. This is part of what drives the anger of snowmobilers being told they are no longer allowed to access their favorite alpine terrain. These feelings are real. We are environmentally impoverished—generations of over-consumption have taken their toll. How does this end? With current-day adventurers scraping out as much as we can get for ourselves, as those before us have done? One heli-ski operator said point-blank that he anticipated he would be able to make it through the rest of his career, dealing with the increasingly inconsistent winter snowpack, but he didn't anticipate much of a future for the industry long term.

When our adventures are done, most of us return to our climate-controlled homes—a world where food and shelter are currently abundant. Our choices ahead are complicated and messy. I choose to see the task as I approach every adventure in the mountains: Thoughtful planning and execution are vital but,

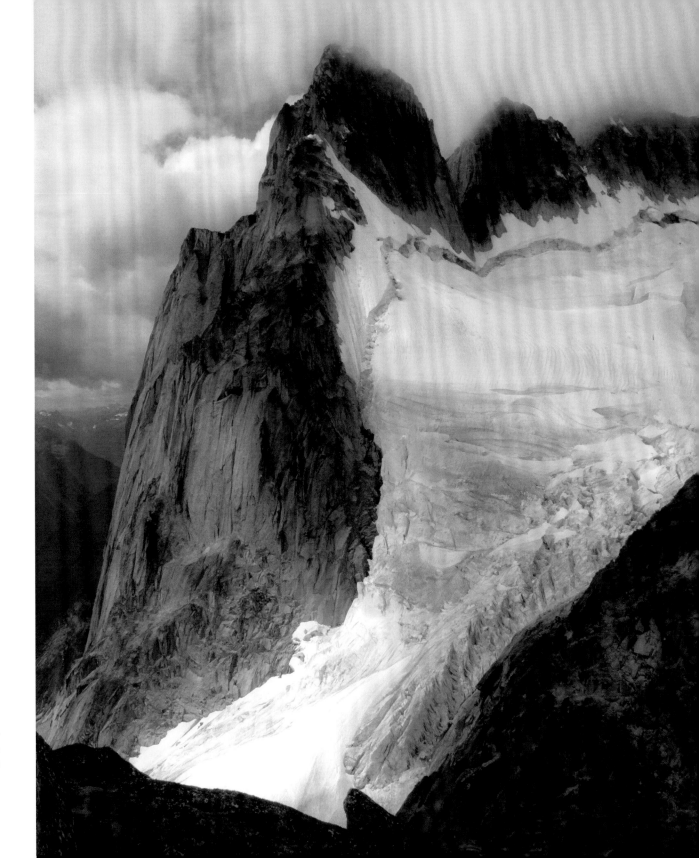

*Howser Spire and a finger
of the Vowell Glacier in the
Purcell Mountains*

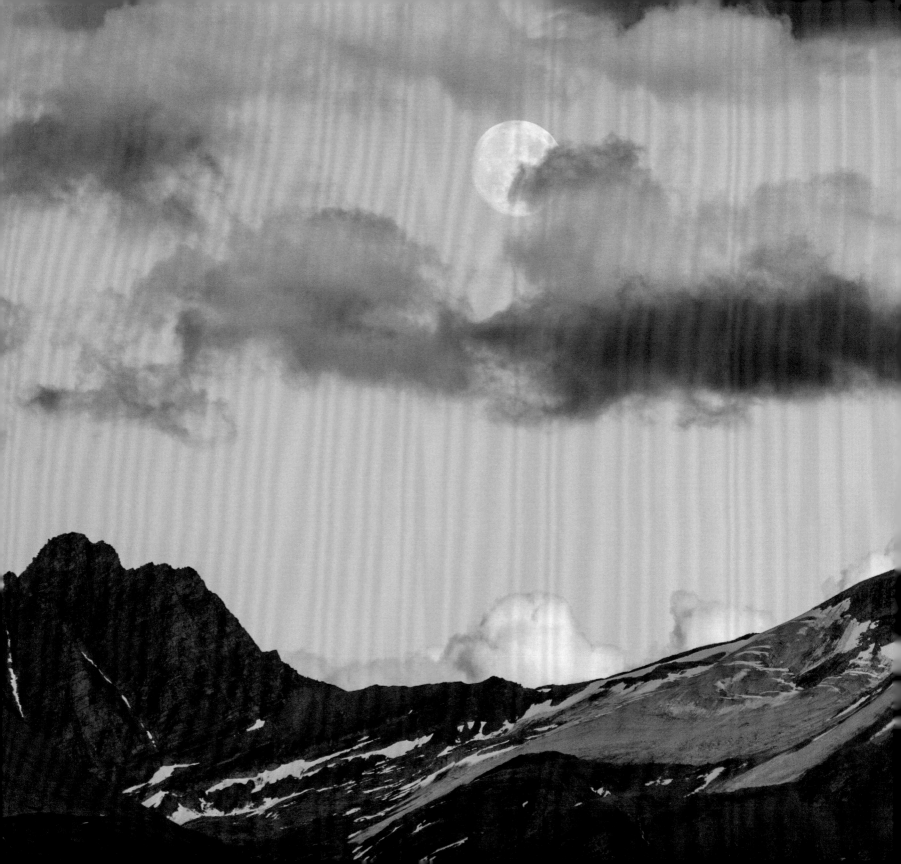

ultimately, to face the challenge, we must embrace the reality that there are forces beyond our control. We can't let that stop us from jumping into the fray, expedition plan in hand, knowing that chances are slim that things will go as planned.

There are good days, the moments when the moon rises over a frozen subalpine lake and the stars twinkle in the bone-chilling air, our toes warm in a down sleeping bag, dinner heating on the camp stove; when we as a society take steps toward managing our own behavior with an eye toward the survival of future generations of people and mountain ecosystems alike. And there are days when the storm rolls in unexpectedly, forcing our retreat, when fear, greed, and self-interest get the better of us and we choose to take more for ourselves today at the expense of everyone tomorrow. Every route comes with risks and opportunities, but the reality is, we are already committed to the journey and the storm is upon us. There is no turning back.

Full moon over a dying glacier in the Canadian Rocky Mountains at sunset

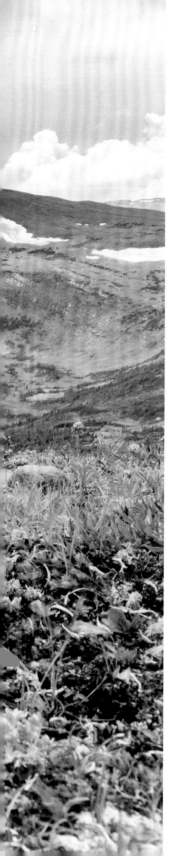

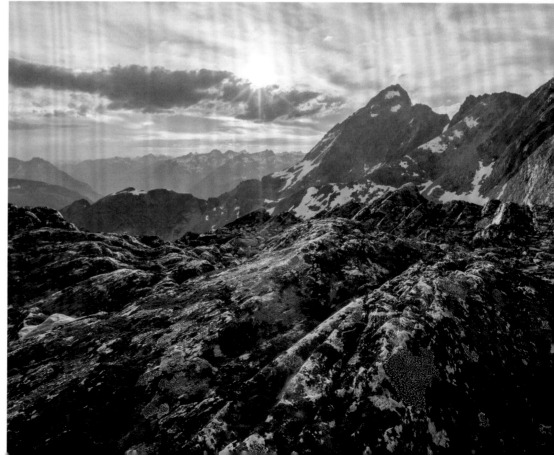

LEFT *Low-growing plants and lichens take advantage of the short summer in the alpine tundra above treeline in the Hart Ranges.*

RIGHT, TOP *The tallest peak in the Canadian Rockies, Mount Robson rises out of dense valley-bottom rainforest.*

RIGHT, BOTTOM *Lichens are all that have returned to this high alpine ridge in the Selkirk Mountains since ice age glaciers retreated.*

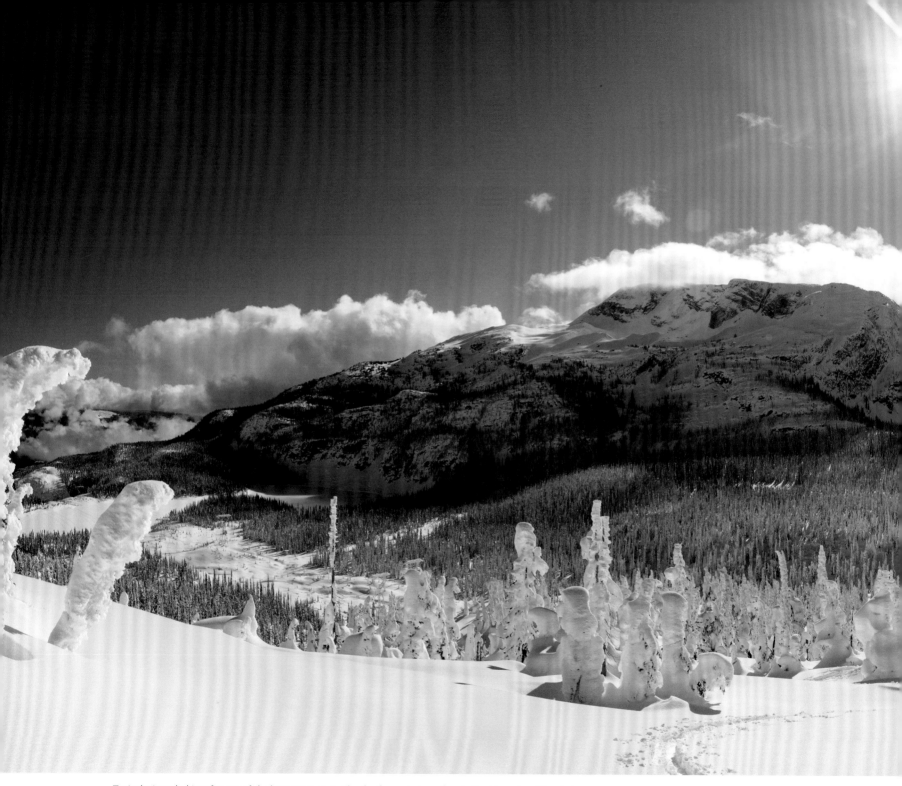

Typical winter habitat for one of the largest remaining herds of mountain caribou in the Monashee Mountains

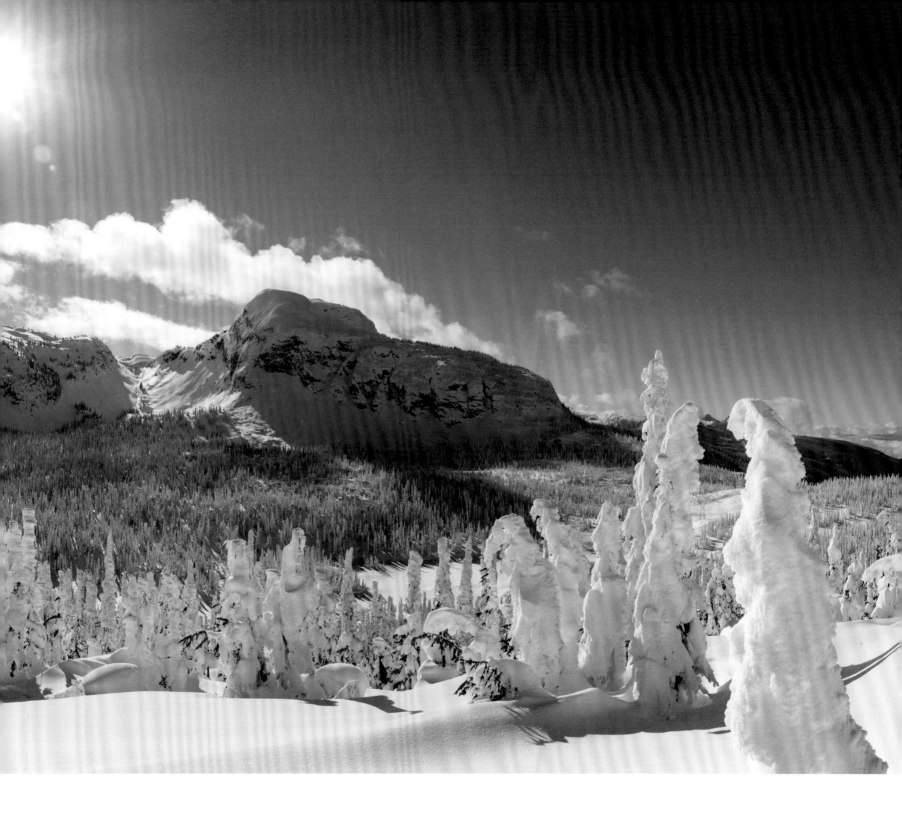

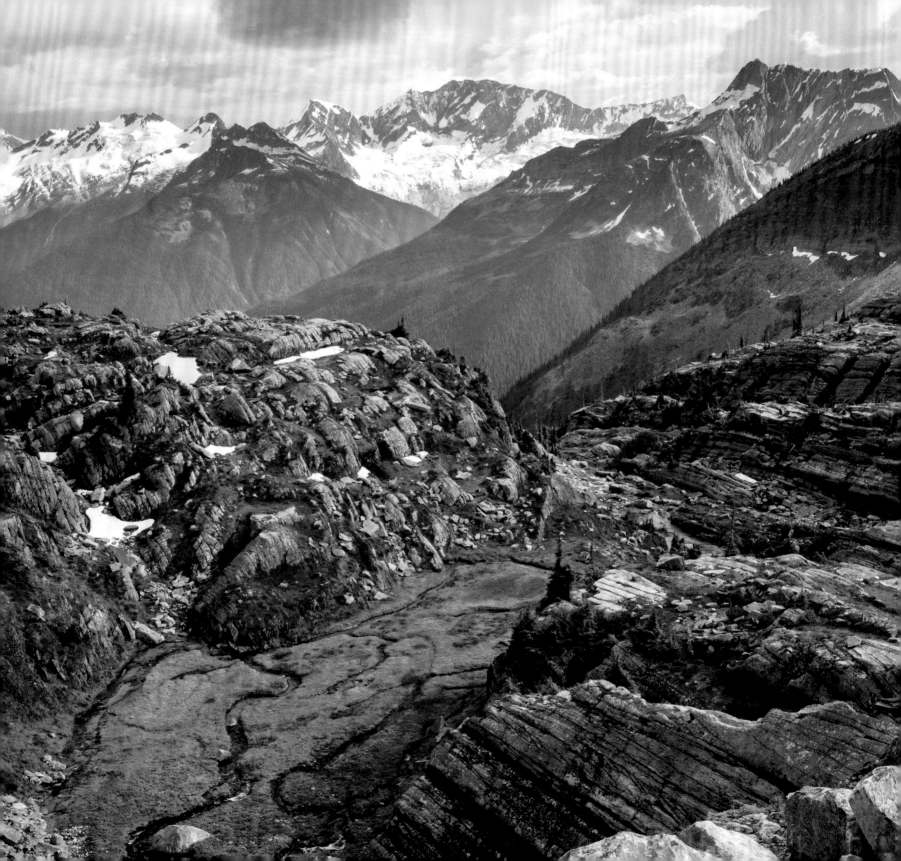

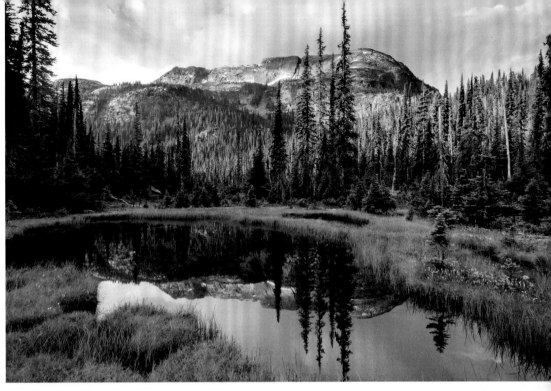

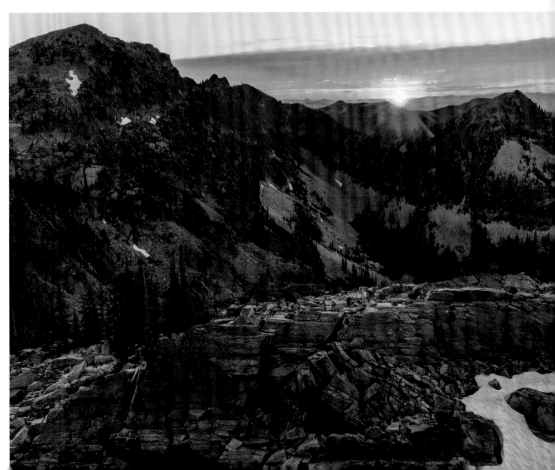

LEFT *A meandering stream wanders across a glacier-carved basin in the northern Selkirk Mountains.*

RIGHT, TOP *Mountains and forest reflected in a subalpine pond on a still summer morning in the Monashee Mountains*

RIGHT, BOTTOM *Sunset in the southern Selkirk Mountains in an area frequented by the last transboundary herd of mountain caribou*

THE CARIBOU RAINFOREST: A FOREST LIKE NONE OTHER

With Marcus Reynerson

The rain had stopped hours before sunrise when we set out early one summer morning from the end of the last logging road in the Upper Seymour River Valley. The North Columbia mountain caribou herd, which summers in the mountains around the headwaters of this river, drew us to this remote location in the Monashee Mountains of British Columbia. Shortly after stepping off the road into the steep uncut rainforest above it, we were soaked as we brushed past water-laden rhododendron bushes and stands of devil's club. Mountain caribou survive in places where few other creatures want to go. Stretched before us was a nearly impenetrable jungle of wet brush, fallen logs covered with rain-soaked moss, and boulder fields slick and steaming from the recent rain, all set on the steeply tilted terrain that defines the sides of the glacier-carved valleys in these mountains.

We made slow progress. Eventually spruce and fir trees began to crowd out cedars and hemlocks, confirming our ascent into the subalpine. After three hours of bushwhacking and scaling forest-covered cliffbands, we gave up on our goal of reaching the ridgecrest above and rested in a patch of sunlight in an opening in the forest. Mist filled the valley beneath us, obscuring the logging road and the patchwork of clear-cuts carved into the forest below. Slowly,

we descended the mountainside, at times needing to grab shrubby cedar trees to lower ourselves on steeper sections.

Just a couple hundred meters from the logging road and the clear-cut below it, we noticed a shed antler lying on the ground. Sinking into the forest floor below the towering trunks of ancient trees, the flat paddlelike tines and smooth curves of the caribou antler almost blended into the sea of fallen branches and forest debris. Picking it up, we noticed fragments of moss clinging to where it had been in contact with the ground. A closer look revealed little grooves where mice and squirrels had gnawed on it for minerals, ultimately delivering the antler back into the ecosystem. A deciduous piece of bone, grown and shed in one year of life, tells a small piece of the story of the reclusive animal that left it behind as it traversed this remote forest. The antler's slow but literal return to the forest that gave birth to it manifests the reciprocal nature of the animal and the forest.

After finding definitive sign of these elusive animals, we looked around us with new eyes, imagining all the stories this forest has to tell.

FOR TREVOR GOWARD, it is not the magnificent trees of the inland rainforest that make this place stand out; it is the lichens that hang from their lofty branches. A self-taught botanist, and now world renowned, Goward, the curator of the lichen collection at the University of British Columbia in Vancouver, and his colleagues put this forested ecosystem on the scientific map. They documented the

As in coastal rainforests of the Pacific Northwest, broad-leafed devil's club dominates the understory in many parts of the inland rainforest.

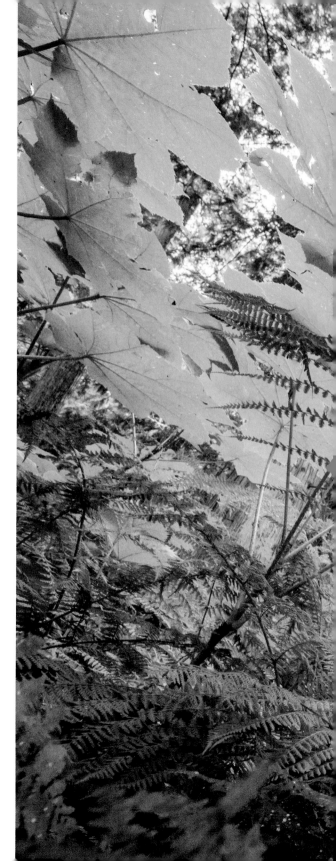

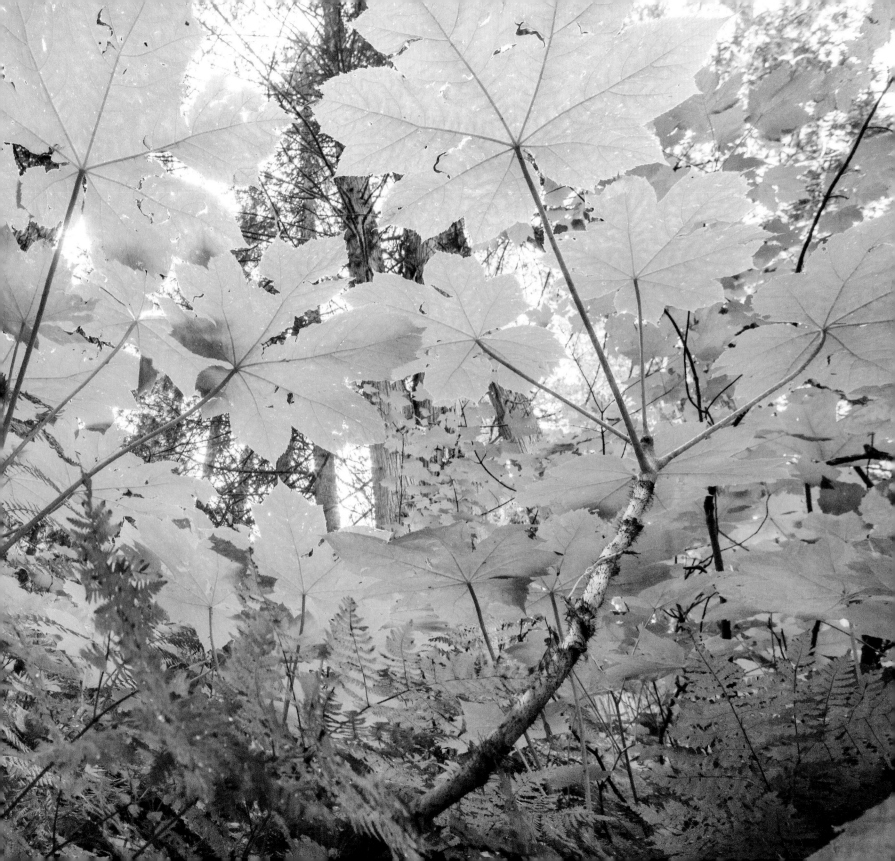

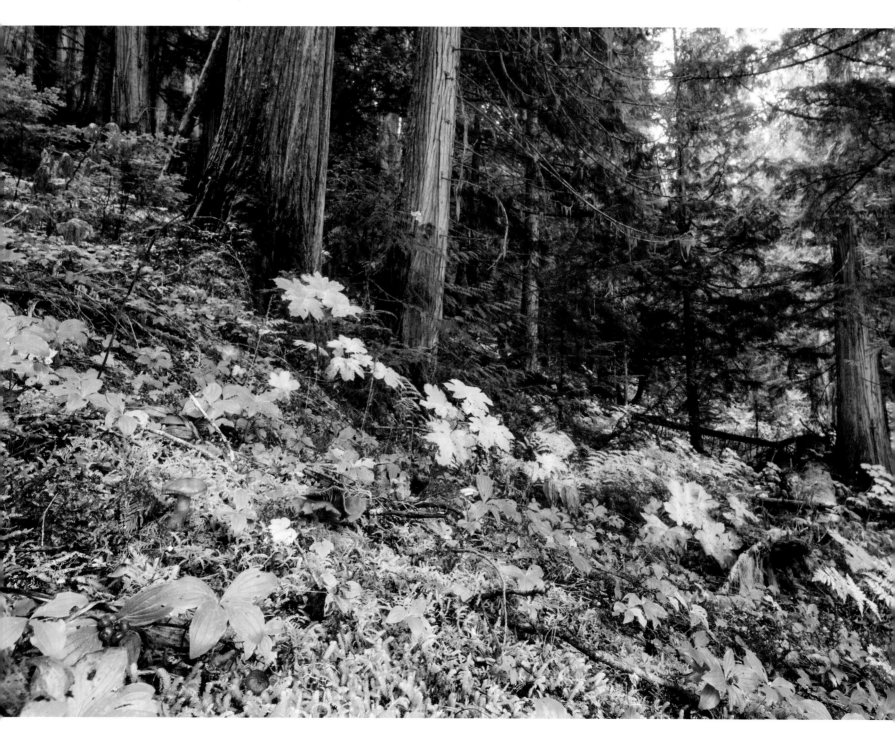

distribution of arboreal lichens found in the coastal rainforests of the Pacific Northwest and nowhere else—*except here,* hundreds of miles inland in the wettest parts of rain- and snow-drenched interior mountains. Their work was foundational for a tireless and ongoing effort to have this place recognized and protected for what it is: one of the most unusual forest ecosystems on Earth.

One characteristic Goward loves about these forests is their wild impenetrability. From his home in the Cariboo Mountains, Goward reflected on the feeling of these forests: "Until recently, this region counted as one of the world's last wild frontiers. It rebuffed our best efforts to settle and subdue it: a timeless place."

Rainforests are ecosystems defined by plentiful rainfall—in some parts of the world, up to 400 inches (1,016 centimeters) annually—as well as by a great amount of vegetative growth. Forested ecosystems cover roughly 31 percent of the earth's land surface, or about 15.6 million square miles (40.4 million square kilometers). Rainforests currently make up only about 14 percent of this area. While rainforests are relatively rare, they provide critical ecological services for the well-being of our planet and play a crucial role in regulating our global climate.

For many, the term "rainforest" conjures up images of a steamy Amazonian jungle, and rightly so, since most rainforests are found within a band roughly between latitude 24°N and latitude 24°S of the equator known as the tropics. Furthermore, in spite of their relative rarity on the planet, tropical rainforests harbor more than 50 percent of all the species of organisms living on Earth today. Currently, tropical rainforests comprise about 12 percent of the world's forest cover, reduced by half from their historical extent.

Temperate rainforests exist farther north and south, between latitude 40° to 60°N and S. Even rarer than their tropical counterparts, temperate rainforests have already been reduced by about half. Currently temperate rainforests make up only 2 percent of forests globally, with small stretches in coastal North America, Chile, New Zealand, Australia, and a few locations in Europe and Asia. The most extensive stretch of remaining temperate rainforest on Earth is found in the northwestern region of North America.

IN ADDITION TO THE MASSIVE AMOUNT of precipitation that rainforests receive, temperate rainforests experience noticeable seasonal temperature shifts and have a much cooler climate than their tropical counterparts. These climate differences result in a wider range of precipitation types than in the tropics, like sleet and snow. On a global scale, biodiversity decreases farther from the equator. And so temperate rainforests harbor fewer species than tropical rainforests do, typically five to ten times less. For example, tropical rainforests can have fifty to two hundred tree species in just a couple of acres, while temperate rainforests typically have one to twenty. All forested ecosystems are known for their ability to convert atmospheric carbon dioxide and sequester it in the *biomass* (the total amount of biotic material) of the forest while returning oxygen to the atmosphere.

OPPOSITE *Red bunchberries punctuate fall colors in the inland rainforest, Cariboo Mountains.*

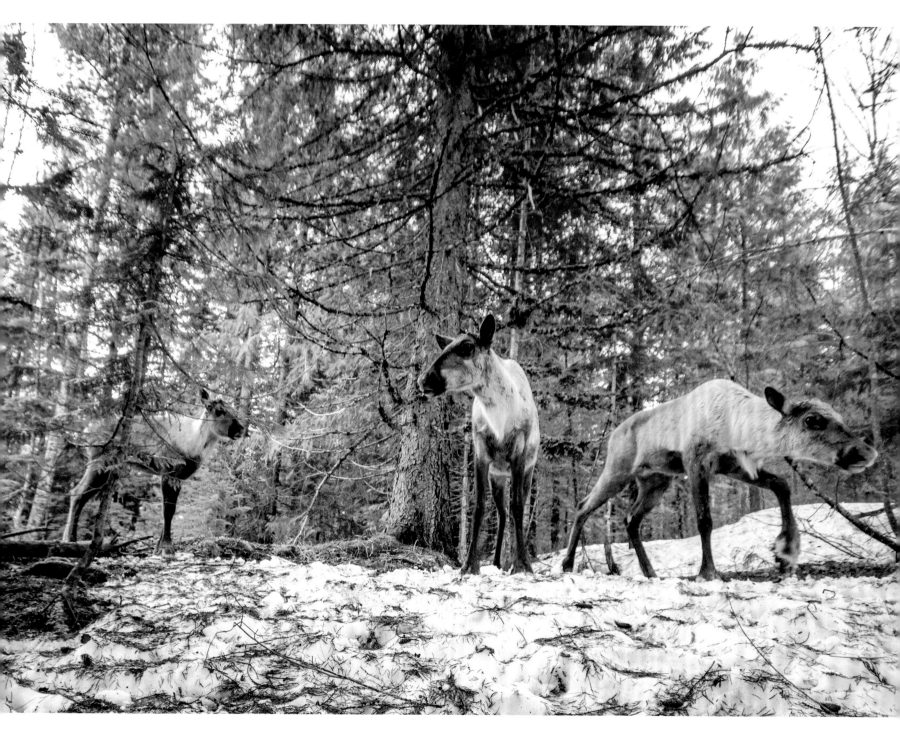

Temperate rainforests, though, are particularly effective at this conversion and sequestration. Because of their slower decomposition rates and a dearth of forest fires resulting from the cool, wet climate, their biomass is greater than that of any other landscape on the planet, including tropical rainforests. This bank of organic material, living and dead, and chock-full of carbon, makes these forests ideal for helping stabilize the global climate, which is now shifting as a result of increasing amounts of carbon dioxide being released into the atmosphere by humans. Tropical forests have up to 250 metric tons of biomass per hectare, whereas temperate rainforests can have close to 1,900 metric tons per hectare.

Still, we need to further refine our understanding of the unique nature of this ecosystem where we found the caribou antler. About 98 percent of temperate rainforest on the planet is coastal. The ready supply of moisture flowing off the adjacent ocean provides the precipitation to create these rainforests. However, there are a few small *inland* areas in certain temperate regions of the world where geographic and climactic factors combine to create rainforest even hundreds of miles from an ocean. But nowhere else on the planet do all the factors come together to produce a rainforest as widespread and *so far* from any coastline in the temperate region of the world—more than 300 miles (480 kilometers) as the raven flies from the Pacific Ocean—as they do in the inland rainforests of the Pacific Northwest.

This inland rainforest drapes inconsistently across the mountain ranges of the region from northern Washington, Idaho, and Montana up into central British Columbia where conditions produce enough precipitation. It spans about 500 miles (800 kilometers), from roughly latitude 46°N in the United States to about latitude 55°N in southeastern British Columbia. The most dramatic expression of this rainforest, where the most rainforest-endemic species can be found, exists in its northern reaches between roughly latitudes 51° and 54°N. Here, winters are long, cold, and snowy, while summers stay moderate and moist. In the southern portion of the rainforest, a short summer drought season is made up for by the slow melting of the winter snowpack that persists well into the summer along with sporadic rains during the growing season.

The climate here is defined by a combination of continental and oceanic influences. Its high latitude and its distance from the ocean allow for the distinct and pronounced seasonal changes typical of continental locations. But the prevailing weather patterns and geography allow for ocean influences to add to the moisture regime. Oceanic air masses dump a first run of precipitation on the coastal ranges of the region, creating the well-known coastal rainforests, such as the Hoh Rainforest in Olympic National Park, in northwestern Washington, and the Great Bear Rainforest of northwestern British Columbia. As the oceanic air masses move east, joining up with continental air masses from the north, they are forced upward by the Columbia and Rocky Mountains, and they dump another load of moisture among these lofty peaks.

OPPOSITE *In spring, mountain caribou descend to the edge of the melting snowpack to feed on shrubs released from the snow and arboreal lichens blown out of trees.*

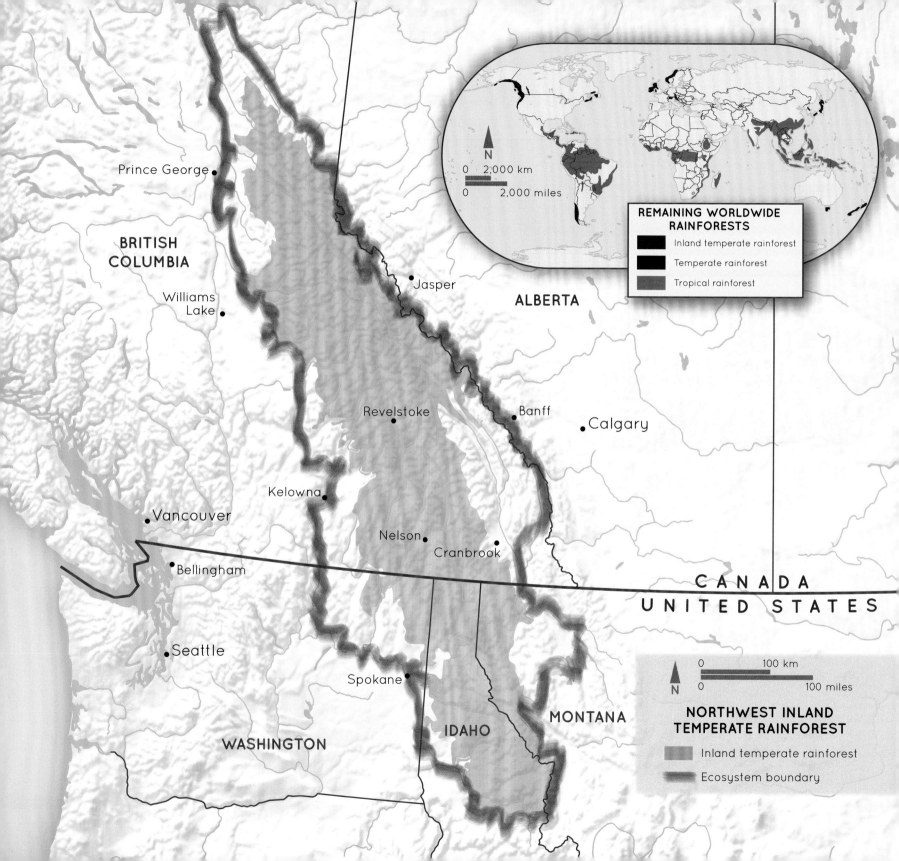

Prince George

BRITISH
COLUMBIA

Williams
Lake

Jasper

ALBERTA

Revelstoke

Banff

Calgary

Kelowna

Vancouver

Nelson

Cranbrook

Bellingham

C A N A D A
U N I T E D S T A T E S

Seattle

Spokane

MONTANA

IDAHO

WASHINGTON

REMAINING WORLDWIDE
RAINFORESTS

Inland temperate rainforest
Temperate rainforest
Tropical rainforest

0 2,000 km
0 2,000 miles

N

0 100 km
0 100 miles

N

NORTHWEST INLAND
TEMPERATE RAINFOREST

Inland temperate rainforest
Ecosystem boundary

Because of the wet, cold climate in the heart of these rainforests, lightning strikes rarely result in fires that destroy large stands of trees. In the absence of fire, trees may be damaged or killed by other factors like insects, disease, snow, ice, and wind. But without regular catastrophic stand-replacing events in this region, vast stands of ancient forests, also known as old growth, developed. Old-growth forests are defined by very old trees, uneven-aged stands of living and dead trees, gaps in the canopy created by different types of low- and high-severity disturbances spread over time, and a wide array of plants, animals, and fungi. In this ecosystem, forests must be undisturbed typically for 150 to 200 years before they begin to develop the characteristics that define old growth.

These forests are a legacy of organisms that colonized and established themselves on the barren land left by retreating ice at the end of the last ice age roughly ten to twelve thousand years ago. However, the current tree association typical of these forests—defined by western redcedar and western hemlock trees—appears to have developed between six and two thousand years ago, depending on latitude, well after the glaciers of the Pleistocene disappeared. These two types of trees are now the flagship species that roughly define the ecosystem. In the northern latitudes, where summer rainfall is more prevalent and major fire events are not common, some of the

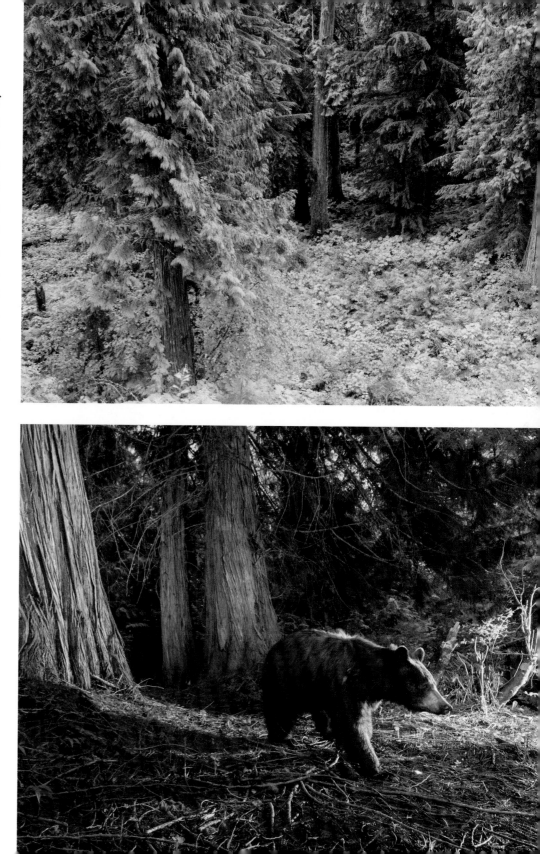

TOP *Temperate rainforests, like those in the Pacific Northwest, contain more biomass per acre than any other terrestrial ecosystem on Earth.*

BOTTOM *A black bear wanders through a western redcedar grove in the Selkirk Mountains.*

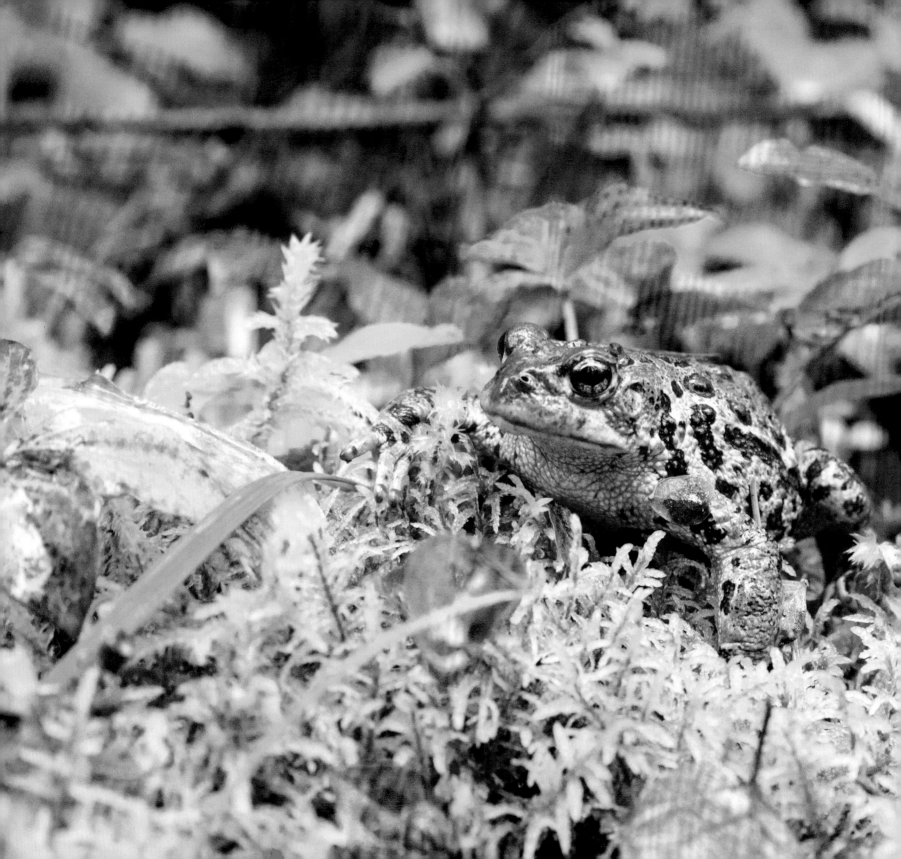

oldest trees alive may represent the second or third generation of their respective species—well over a thousand years old. Farther south, one western redcedar tree in the Incompappleux Valley of the Selkirk Mountains, with a diameter of 128 inches (325 centimeters), is estimated to be more than eighteen hundred years old.

The climax forests of these inland rainforests, similar to their coastal counterparts, are defined today by massive coniferous trees, mainly western redcedar and western hemlock with the addition of Engelmann spruce in the coolest and wettest locations. Douglas fir, western white pine, lodgepole pine, grand fir, and western larch are common species occurring after disturbances or on drier sites. Broadleaf trees like paper birch, quaking aspen, Douglas maple, and black cottonwood play a supporting role. Interior and coastal rainforests also share numerous similar shrub and herbaceous plants including huckleberries, blueberries, rhododendron, thimbleberry, queen's cup (clintonia), and devil's club as well as various lichens and mosses, especially among the epiphytes. The latter are not rooted in the ground but instead attach themselves to the trees in the forest and access most or all the nutrients they need out of the air.

While a century and a half is how long it takes for a forest to *start* to develop into old growth, many stands of trees in the inland rainforest are far older. These truly ancient stands are where the fullest expression of this rainforest can be found. "Many of the forests of the inland rainforest . . . are multigenerational forests. They have been around longer than any one tree could

Western toad populations have declined across much of the southern portion of their range but remain abundant in the Cariboo Mountains and many other parts of the Caribou Rainforest.

possibly live," said Goward, who refers to these forest stands as *antique*. Through his research, he found that many rare plant and lichen species are not uniformly distributed in old-growth forests, but rather tend to be found most abundantly in antique stands.

Antique forests are themselves not distributed randomly. They are typically found in places where water collects, such as the bottoms of deep U-shaped glacier-carved valleys. Another location where antique forest stands can typically be found is the curving base of the steep walls of these valleys where they start to flatten out, referred to as "toe slopes," where moisture running down the valley walls collects. This dance between gravity, land, and moisture creates a perfect environment for a forest community that is truly a physical expression of water. Because of this relationship with moisture, these antique stands escape fire for hundreds or thousands of years, resulting in forest cathedrals that shelter biodiversity with their longevity, sequester carbon with their fire resistance, and inspire humans with their beauty.

AFTER HOURS OF PICKING OUR WAY through the dense jungle, it was jarring to step out of the forest and return to the logging road and clear-cut where we started. What was the discovery of this road and clear-cut like for the bull caribou whose antler we saw in the forest? For countless generations, he and his ancestors had known only endless forest in this remote valley. It took a long time for the fingers of European settlers and, eventually, global capitalism to work their way into this secluded valley. Driving the 43 miles (69 kilometers) of logging road it took to get here, we passed cut-over forests going back decades. Here, at the end, the road had gone in a few years ago and so the trees had come down just recently.

These forests have been significant resources for humans for a long time. Indigenous peoples of this land used these magnificent forests for many aspects of life: homes, canoes, tools, fuel, and clothing. Western redcedar, the current official tree of British Columbia, was particularly revered because it is naturally rot resistant, a critical characteristic for building materials and clothing in such a wet environment.

After European colonization, human use changed drastically. The beginning of commercial logging in the interior dates back to the late nineteenth century when settlers began clearing forests in small enclaves for mining booms. The expansion of the railroads into the interior in the late nineteenth century allowed development to increase slowly. By the mid-twentieth century trucks could access almost any logging site, and further advances in technology including the advent of the chain saw changed the face of timber harvesting. But the lack of road infrastructure and the more easily accessible timber on the coast and farther south on the continent meant that the vast industrial-scale operations going on today did not begin in earnest in the region until the late twentieth century. While the total amount of old-growth forest remaining is up for debate, there is little disagreement that if logging continues at current rates, there soon will be little original forest left in these mountains.

INDUSTRIAL FORESTRY IN THE CARIBOU RAINFOREST

> **Just about everywhere else inland rainforests exist, people cut them down long ago. This one, we're just getting to now.**
>
> —*Trevor Goward*

The western hemlock towered nearly two hundred feet into the cloudy British Columbia sky. The tree, about four feet in diameter and several centuries old, had sprouted in a forest that formed around ten thousand years ago, at the end of the last ice age. It took David Walker, a nimble man with thirty years' experience logging here in the Selkirk Mountains, about two minutes to drop the huge conifer. The ground shook. After Walker turned off his saw, I asked what would become of the old giant. It's going to a pulp mill, he said matter-of-factly.

Log trucks stacked high with ancient cedar regularly rumble down Victoria Road, passing European-style coffee shops and inns, headed for Downie Timber's sprawling mill on the edge of Revelstoke. This national park gateway community is "a resource extraction town with an outdoor recreation veneer," says Michael Copperthwaite of the Revelstoke Community Forest Corporation. Despite burgeoning tourism and a huge amount of previously logged lands slowly recovering, the province has managed to keep cut rates relatively steady.

In 2007, pushed by a coalition of conservation groups, British Columbia adopted the Mountain Caribou Recovery Implementation Plan (MCRIP), which calls for the use of various "management levers" such as habitat protection and winter recreation restrictions. Predator management—specifically a wolf cull, which has seen the demise of dozens of wolves and fractured the coalition of conservation groups that pushed for caribou protections to begin with—has garnered the lion's share of media interest.

Amazingly, while the MCRIP set aside thousands of square miles of forest as caribou habitat, it did not reduce the amount of logging occurring in the region. Kerry Rouck, corporate forestry manager for the Gorman Group of Companies, which owns Downie Timber and several other operations in the region, confirms that caribou protections have not reduced their logging on public lands. According to Rouck, all of the timber being harvested by Downie still comes from previously uncut forest, about half of which is classified as old growth. The rest is composed of mature stands of trees that burned about a century ago.

With second growth not yet ready to be harvested, everyone logging in the heart of the Caribou Rainforest is cutting old growth. A recent audit of logging in mountain caribou habitat by the Forest Practices Board (FPB), British Columbia's independent forestry investigation agency, found that none of the forest cutblocks it reviewed had ever been logged before. According to estimates from two timber companies and the FPB, the province will be cutting virgin timber for the next thirty to forty years before a significant number of stands here are ready for a second cut.

South of the border, while logging has slowed from its heyday with the removal of most of the old-growth forests by the 1990s in the United States, logging of mature second-growth stands, often billed as "salvage logging" operations after fires, or "restoration logging" to reduce fire hazard, continues on state and federal lands in Washington, Idaho, and Montana.

Recent clear-cut in old-growth rainforest in the Monashee Mountains

Ironically, cutting old growth can be a mixed bag for the timber industry. Hemlock trees are often worthless economically (it often costs more to cut and ship the hemlock logs than lumber companies are paid for them), so they are typically pulped to make paper products. The logs are hauled away in part because it's "socially unpopular" to leave them on the ground, says Rouck. Since many accessible stands are now officially protected caribou habitat, timber companies have to go deeper into the mountains to fulfill their quotas, further fragmenting the landscape. "It's pushing us into tougher ground, the back ends of drainages and steeper, more difficult access," says Rouck.

But the losses from cutting hemlock and the expense of accessing hard-to-reach trees are largely offset by a de facto government subsidy. Companies pay "stumpage fees" to the province for trees they cut on public land. These fees are reduced for operations that require building new roads, that are expensive to harvest because of steep terrain, or that contain lots of low-value wood, like hemlock. This incentivizes otherwise uneconomical operations.

The province does its best to accommodate the industry. According to a 2013 FPB report, timber representatives in the Revelstoke area were invited to comment on and influence amendments to biodiversity management plans, which affected caribou habitat and old-growth forest reserves, a full year and a half before conservation groups were informed of the process. A government project reviewing old-growth timber swaps in another part of the interior rainforest lists a representative of the forestry trade group, the Interior Lumber Manufacturers' Association, as the contact person for the project. (The association would not comment on anything involving caribou, however.) British Columbia's so-called "professional reliance" system essentially allows logging companies to police themselves while operating on public lands.

Corporate profits are not the only driver, however. To keep stumpage revenue—more than $1 billion annually—flowing, the province actually encourages companies to log in mountain caribou habitat. If a company doesn't fulfill its quota, the province will give logging rights to that particular swath of forest to another firm.

After David Walker felled that hemlock tree in the northern Selkirks, it was trucked to a reservoir on the Columbia River. It was then floated to the Celgar pulp mill in Castlegar, British Columbia, about 200 miles from where it was cut. Curious about what would become of it, I perused Celgar's promotional materials. I learned that Mercer International, a US company, owns Celgar and boasts of using only wood from internationally certified "sustainable" forestry operations. As for the pulp it produces? It is sold in North America and Asia to make, among other things, "hygiene products," another name for toilet paper.

Hydropower development has also taken a significant toll on the rainforest. The Grand Coulee Dam on the Columbia River ended salmon runs to the entire southern portion of the ecosystem after its construction in 1942. Upstream from there, the Duncan Dam (1967), Hugh Keenleyside Dam (1968), Mica Dam (1973), and Revelstoke Dam (1983) filled valley bottoms and toe slopes that were all inland rainforest. At the northern end of the rainforest in the Hart Ranges, BC Hydro constructed the W. A. C. Bennett Dam (1968) on the Peace River. The resulting reservoirs create significant habitat fragmentation for numerous species that depended on historically connected tracts of forest as habitat.

Mining for gold, coal, and silver in the rainforest was one of the earliest forms of colonial resource extraction starting in the nineteenth century. Contemporary open-pit coal mines dwarf the impacts of historical operations in the region. Open-pit mining involves stripping off the natural vegetation and topsoil. Explosives and massive excavation equipment are used to uncover deposits located hundreds of meters beneath ground level. In addition to the drastic landscape change, these areas are affected by road development, heavy machinery use, and tailings ponds that can cause significant aquatic pollution. Additionally, the construction of an array of processing infrastructure that is needed to transform

TOP *Raindrops glint on a tiger lily (*Lilium columbianum*) blossom in the Selkirk Mountains.*

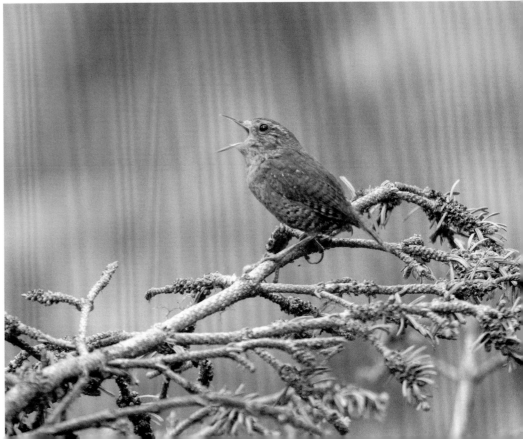

BOTTOM *The song of the Pacific wren echoes through the rainforest.*

minerals into usable products also has significant impacts regionally.

Coal is extracted from parts of the rainforest and ultimately burned, pumping the carbon locked away there into the atmosphere. Climate change, a global issue, shows its face very clearly here in the Caribou Rainforest, an ecosystem that evolved over millennia to thrive in a cool, moist environment. Models for the Caribou Rainforest predict warmer temperatures and a longer drought period during the summer months. Summer drought will likely be exacerbated by a smaller and quicker-melting snowpack from more winter precipitation falling as rain rather than snow.

With tragic irony, the impacts are exponential. While the moist pockets that gave shelter to these forests begin to warm and dry up, parts of the forest that have historically burned only rarely will be more vulnerable to catastrophic fires. The vast amounts of carbon that have long been stored in these deep, cool pools of green forest could be released, further perpetuating a continual cycle of warming into the foreseeable future.

LIKE THE RAINFOREST emerging at the confluence of geography, latitude, and climate, language and particularly names are emergent properties of the lifeways, values, and experience of a culture. Humans, being the complicated and flexible creatures that we are, know this fact and bend names to our interests, at times consciously and at other times obliviously. The British Columbia Ministry of Forests, Lands, Natural Resource Operations, and Rural Development refers

Venerable coral lichen (Sphaerophorus venerabilis) is one of several species of lichens that exists only in old-growth rainforest stands.

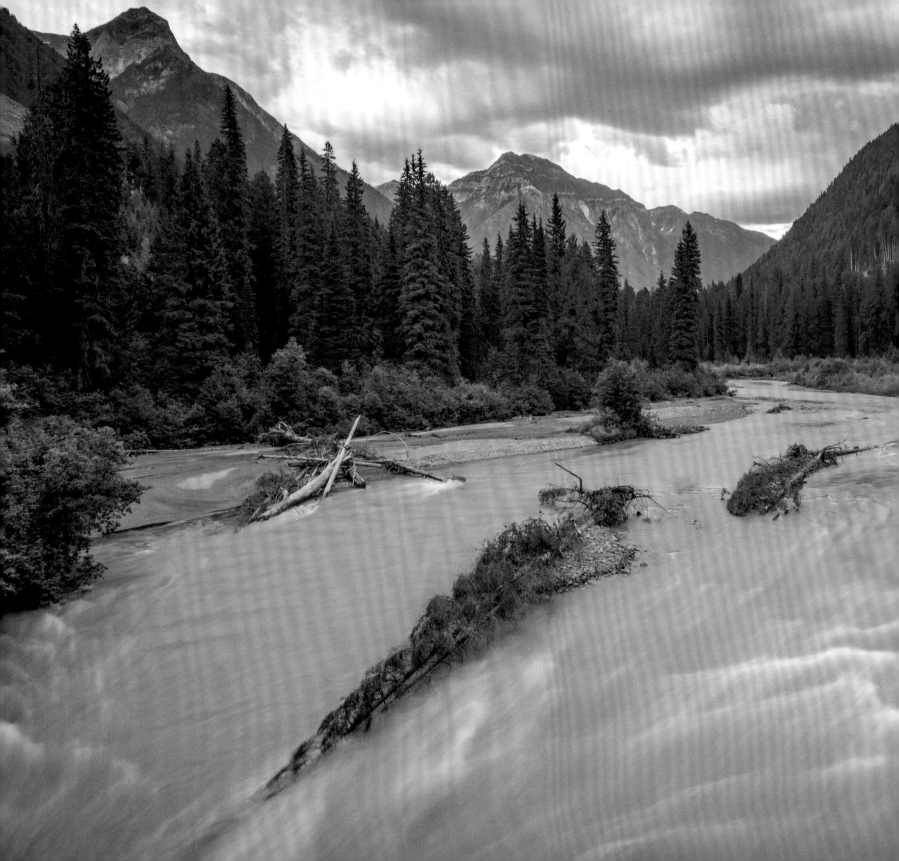

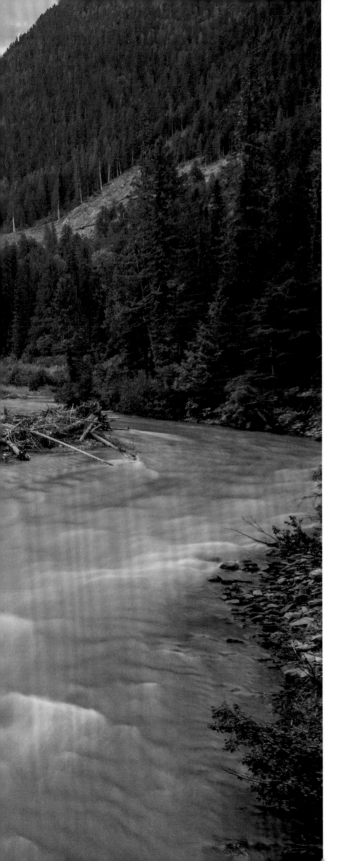

to the inland rainforest as the "interior wet belt." The timber industry labels old-growth forests as "decadent," seeing their slower growth rate and numerous dead, damaged, and rotting trees as less valuable resources than even-age stands of faster-growing trees. Advertising campaigns for the ecotourism industry in the region refer to the landscape as a "playground," while the mining industry calls everything on top of the minerals they seek to extract as "overburden."

Goward and his colleagues demonstrated that these forests were indeed not just wet forests but true rainforests, deserving of the recognition and protection that all rainforests remaining on our planet need. "The name does not do everything, but it does bring people together. Naming it the 'inland rainforest,' aside from calling it what it actually is, sent a missile to the timber industry," said Goward, challenging the ubiquitous cultural steering of this industry in the region. It was an appeal to people far and wide who find it hard to understand what is so important about a "wet forest" but intuitively can relate to and find cause to protect a "rainforest."

Circling back to the antler we found in an old-growth stand of inland rainforest, it's no coincidence that the range of this rainforest overlies so well with the range of mountain caribou. This rainforest, unlike any other on planet Earth, set the stage for the emergence of an animal intimately connected to the complexity of the forest itself. Mountain caribou aren't terribly talkative, but they too have a name for these primeval forests—home.

Downie Creek flows out of the northern Selkirk Mountains.

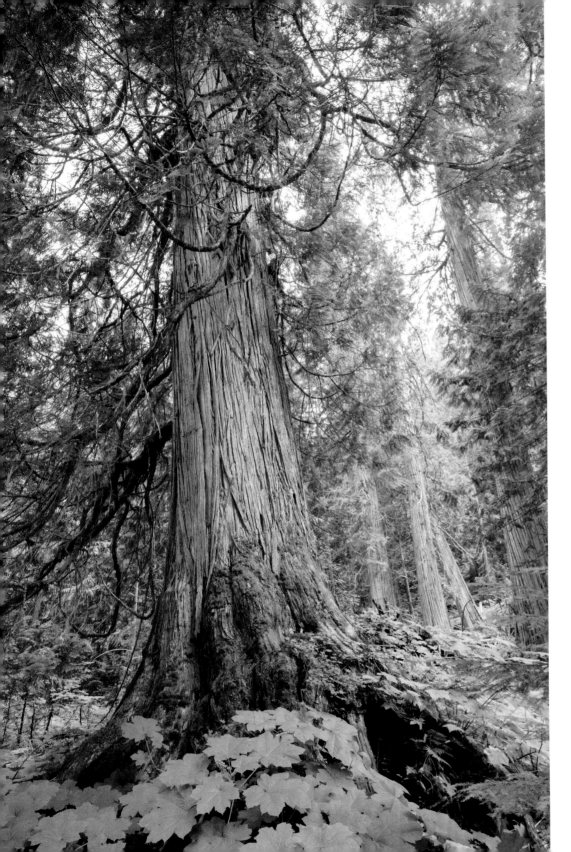

LEFT *Western redcedar
trees can live for centuries in
undisturbed locations in the
rainforest.*

RIGHT *A Coeur
d'Alene Oregonian snail
(*Cryptomastix mullani)
explores the rainforest.

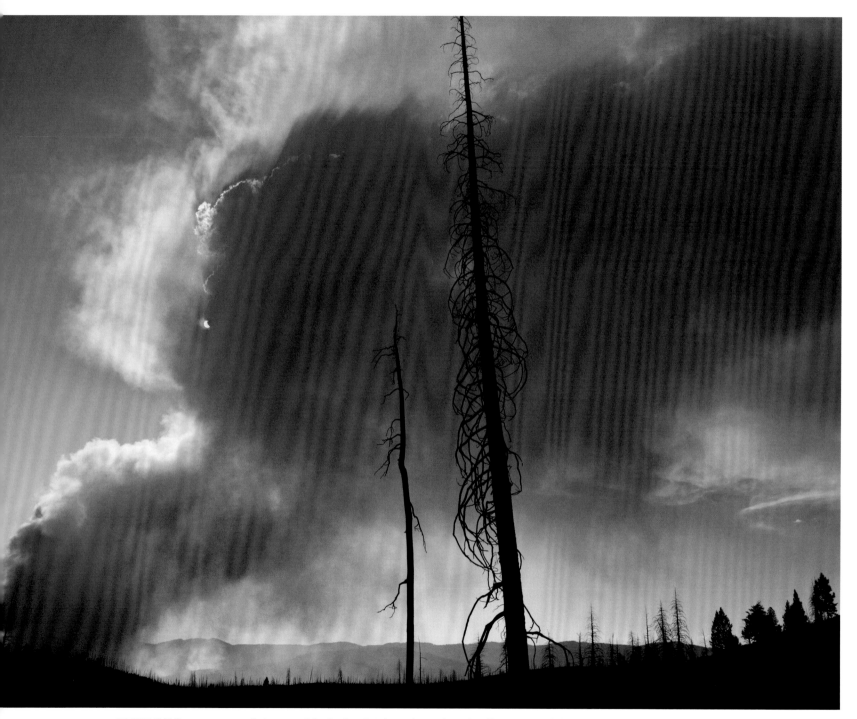

ABOVE *Wildfires occur naturally in parts of the Caribou Rainforest, but in the wake of human-caused climate change, they are increasing in frequency and scale in places that have historically rarely burned.* OPPOSITE *Mountain lions can be active during the day or at night.*

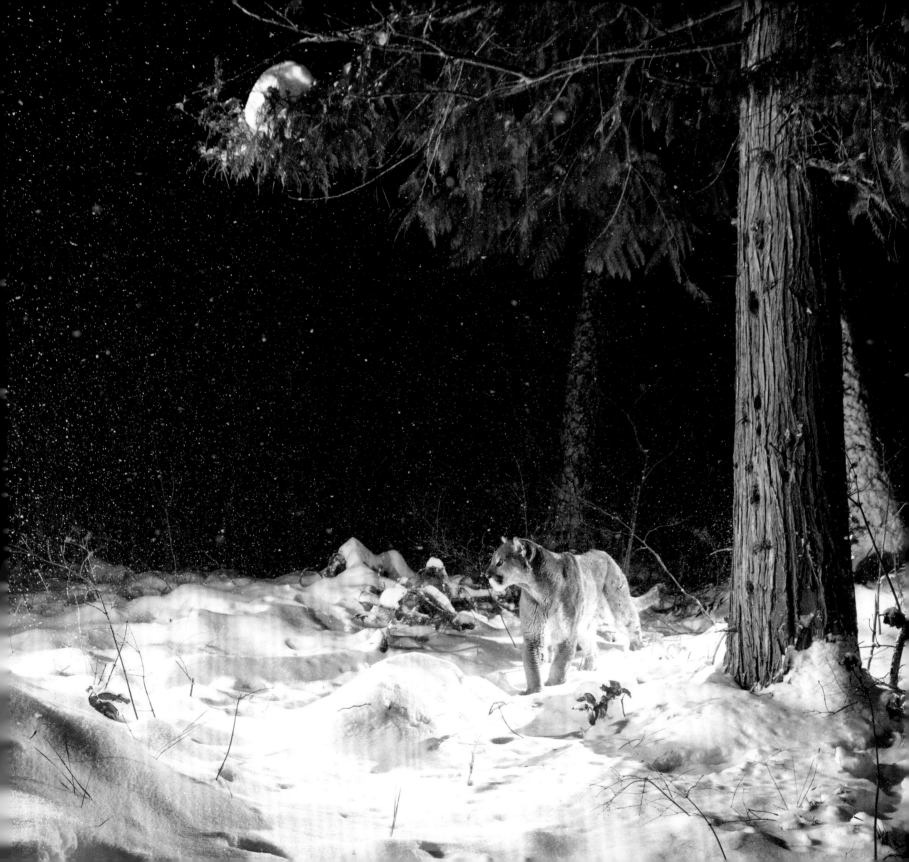

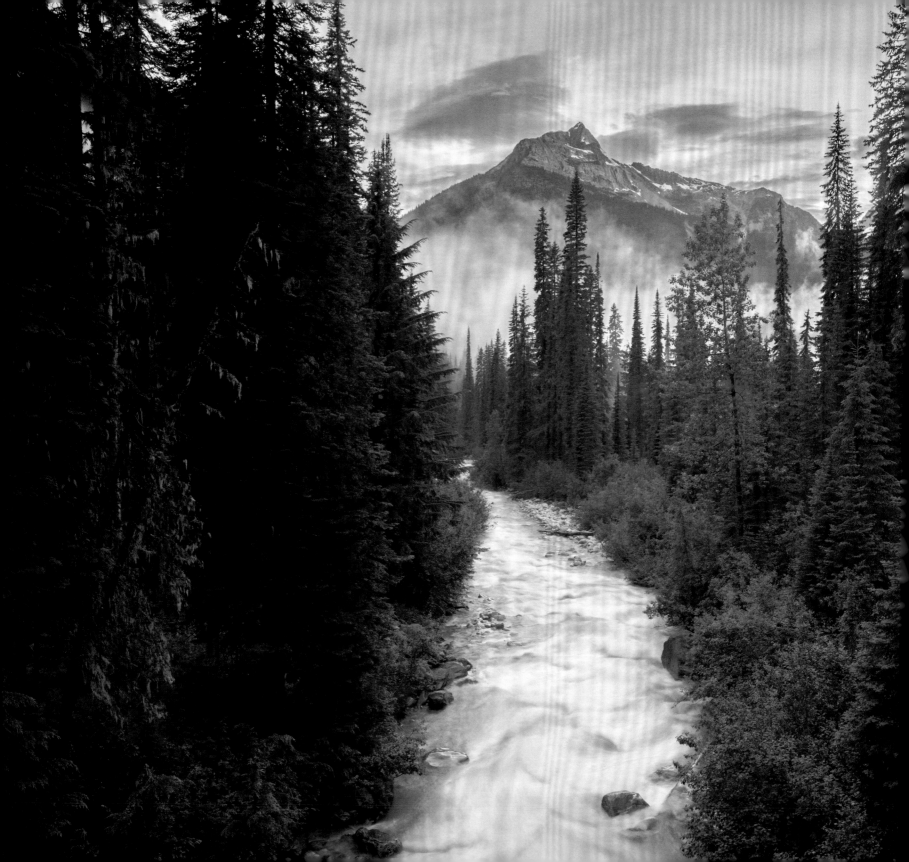

*Sunset over the Illecillewaet
River in the Selkirk Mountains*

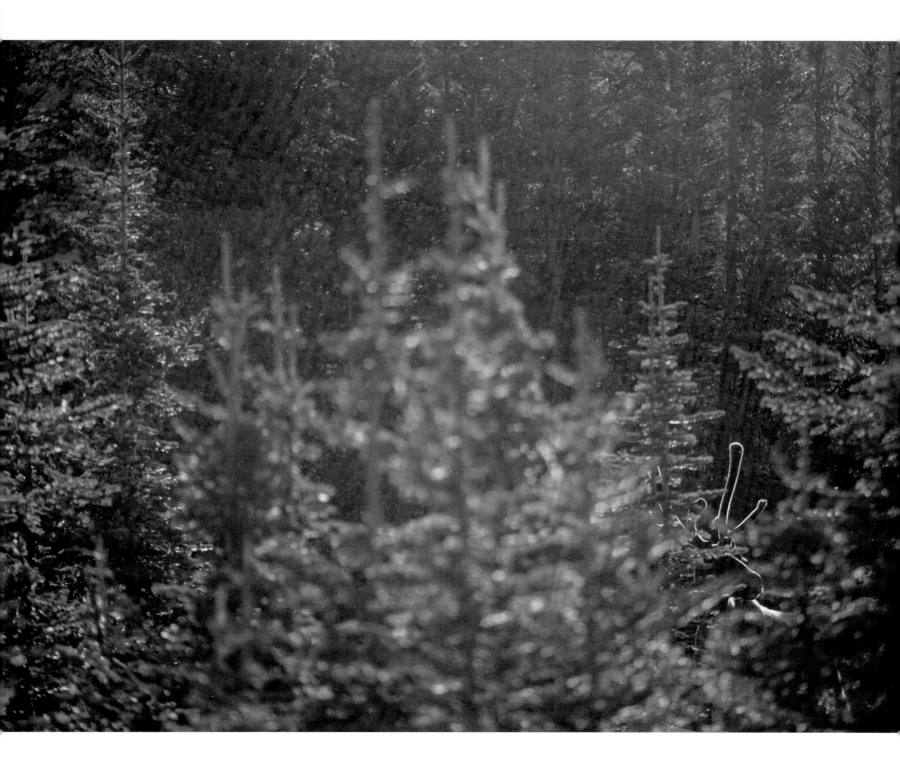

MOUNTAIN CARIBOU: GHOSTS OF THE RAINFOREST

"They really do exist," I thought to myself. On my camera screen, I gazed at the image of a female mountain caribou captured on a camera trap set in the southern Selkirk Mountains in British Columbia not far from the Washington–Idaho border. In the video clip the female in the foreground walks across a wet meadow. Beyond it, another female walks along the edge of the subalpine lake, followed by a playful calf. After more than a year of effort, we had finally captured images of some of the last few animals remaining in the southernmost herd of mountain caribou in western North America, which has now dwindled to less than a dozen animals.

It's no wonder some refer to mountain caribou as "ghosts" of the forest. I have spent many years documenting rare wildlife in this part of the world, and these caribou were every bit as tough to track down as the first few wolves scattered across Washington State when they returned there after decades of absence, or the wolverines of the North Cascades, where a few dozen animals cover hundreds of square miles of rugged high-elevation wilderness.

It's not just their low numbers that make these caribou elusive. Being hard to find is a cornerstone of their survival strategy. It's a strategy that is distinctive among the hoofed animals of the region.

OPPOSITE *Mountain caribou use the sprawling forests of the region as a refuge from predators.*

In the Caribou Rainforest, the hoofed mammals that caribou overlap with the most are moose and deer. Both moose and deer have adapted to living in close quarters with large carnivores. Moose are big and foul tempered, two excellent defense strategies for dealing with predators. A moose that stands its ground with a pack of wolves can usually walk away from the encounter. As any deer hunter will tell you, mule deer and white-tailed deer are extremely hard to surprise in the forest. Without the mass or disposition of moose to defend themselves, deer rely on constant vigilance to detect danger early paired with exceptional agility to evade a predator once detected. Female white-tailed deer and mule deer both typically breed for the first time at one and a half years of age. Moose cows first breed at one and a half to two and a half years of age. Both moose and deer often give birth to twins in the spring if conditions are favorable, increasing the odds of survival of some young in a predator-rich environment.

Mountain caribou take a different approach to dealing with predators—they avoid them. The sprawling, dense rainforests that sprang up after the retreat of the ice at the end of the last glacial period in this part of western North America were the perfect place for caribou to disappear. Moose stuck to riparian habitat and the edges of the forest. Deer were historically absent altogether from much of the rainforest. Wolves and mountain lions followed suit with very limited populations in the rainforest, their fortunes tied to these hoofed animals that are their primary prey. Meanwhile, the caribou learned how to become

A cow in a subalpine wet meadow in summer in the southern Selkirk Mountains

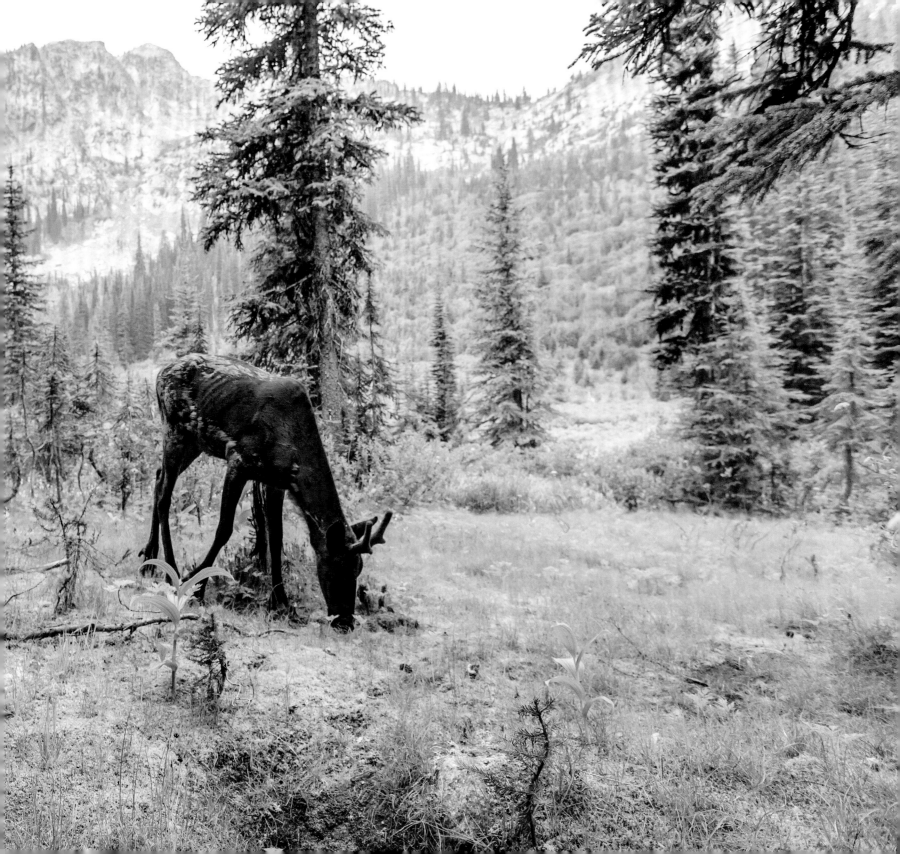

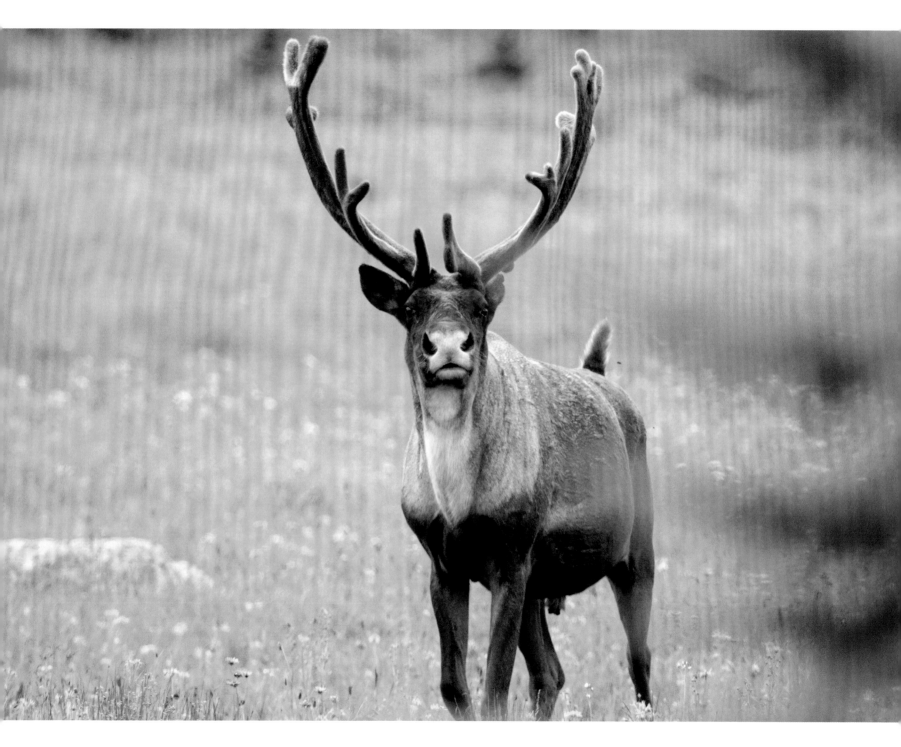

specialists of the magnificent forests themselves. How could they survive here where other hoofed mammals could not? One part of the answer hangs in strands over the boughs of the ancient trees of the rainforest—lichen.

To survive here, mountain caribou adopted a diet of arboreal lichens that only grow in abundance in forests close to a century old or older. Adopting this food source flips the scarcity of resources other large mammals discover in old-growth forests on its head. Lichens can be found spread out across the forest, and as the forest ages, this food source increases in abundance. At the same time, as forests mature, early successional plants, which deer and moose populations feed on, dwindle, leaving a rainforest fortress covering thousands of square miles as practically the sole domain of the caribou.

You won't find massive herds of mountain caribou banding together as you will caribou of the tundra; mountain caribou travel in small groups much of the year. Barren-ground caribou adopt the classic survival strategy for hoofed mammals in open country: they form large herds where the risks to individuals in the group diminish and the chances of avoiding detection are low. In forested environments where avoiding detection by predators is possible, mountain caribou spread out across the forest in smaller groups of individuals, making their presence even harder to detect.

Mountain caribou had one more challenge they needed to sort out to make this novel game plan work—the epic deep snowpack of these mountains.

The open treeline forests of the alpine parkland can have some of the heaviest lichen loading of any area in the region. But mountain caribou's preferred food, black hair lichens (genus *Bryoria*), can't grow on a tree below where the snowpack sits in the winter. With winter snows in this part of the mountains often in excess of ten feet (three meters), food is out of reach to the caribou here without the snowpack on the ground. To work around this challenge, the caribou developed a unique double migration pattern up and down the sides of the mountains in parts of their range, revolving around accessing food while avoiding predators. Their large feet act like snowshoes, allowing them to walk in deep snow where predators cannot easily travel.

Late winters are spent in high-elevation forests feeding on tree lichens, safely separated from the rest of the large mammals of the region that stick to low elevations where snow depths are shallower. In the spring as snow melts at lower elevations, mountain caribou descend to take advantage of the fresh forage and moderate temperatures, supplementing their diet with lichens blown out of the canopy of the rainforest trees. Historically the widespread unbroken low-elevation forests allowed them to continue to avoid predators as they spread out across the landscape, making it difficult to predict or detect their presence.

As the snowpack retreats up the mountains, the caribou head back up. In late spring, pregnant cows seek out remote and inaccessible locations to give birth. Summers are spent dispersed across high

OPPOSITE A bull with antlers in velvet in the Rocky Mountains

elevations again, feeding in wet subalpine meadows and forests for the summer. With the onset of autumn snow up high, caribou once again retreat to lower elevation forests, feeding on windblown lichen and small shrubs while waiting for the snowpack to build up in the high mountains. Once the snowpack is deep enough for caribou to access epiphytic lichens again and put a greater distance between themselves and predators, they return to treeline.

Across their range mountain caribou have adapted this general pattern to the specific landscape they find themselves in. Precipitation levels are highly variable, affected by the mountainous geography of the region that creates exceptionally wet forests in some areas and drier sites in others. In drier areas, caribou encounter pine forests rather than rainforest. Luckily these stands are incredibly productive for both tree lichens and ground lichens, so at lower elevations caribou seek out stands of older pine forest.

On the southern edge of their range in Idaho and Washington there are historical records of caribou in the valley bottoms and lowlands, but the remaining animals in southern herds come down only as far as middle elevation forests, rather than all the way to the valley bottoms that have now been converted into agricultural fields, flooded with hydropower dams, and that contain a variety of other human infrastructure and greater numbers of deer and predators.

In places with high winds above treeline and lighter snowpacks, such as the Rocky Mountains, some alpine tundra slopes might stay relatively snow free. Caribou seek out these locations as well,

using their hooves and antlers to crater through any snow to access ground lichens for parts of the winter, a common strategy for caribou in other parts of the world where winter snowpacks don't reach the depths typically found in this region of the world.

To avoid predators, mountain caribou adopted a diet of relatively nutrient-poor foods and the skill to survive in the high mountains in the winter, a feat no other large mammal has accomplished. Because of the challenges of their environment, however, mountain caribou reproduce more slowly than moose or deer. Females typically do not breed until age two and a half—older than moose and deer. Single calf births are by far the most common, again significantly reducing their reproductive rates among their peers. However, because they have traditionally lived in places with very low predation rates, their slow reproduction rate wasn't a survival issue before now.

Another consequence for mountain caribou seeking out places with low predator risk is what biologists refer to as a "subdued predator response." The hypervigilance of species that live with a constant threat from predators, such as deer, was maladaptive for caribou. The threat of starvation in a nutrient-poor and climatically challenging landscape was their focus. Mountain caribou are often noted for their curious behavior when encountering predators. Rather than turn and flee at the first signs of danger, a caribou might linger a bit longer to investigate. Human hunters have appreciated this behavior because it often makes them easier to hunt and kill than moose, deer, or elk. Other predators can

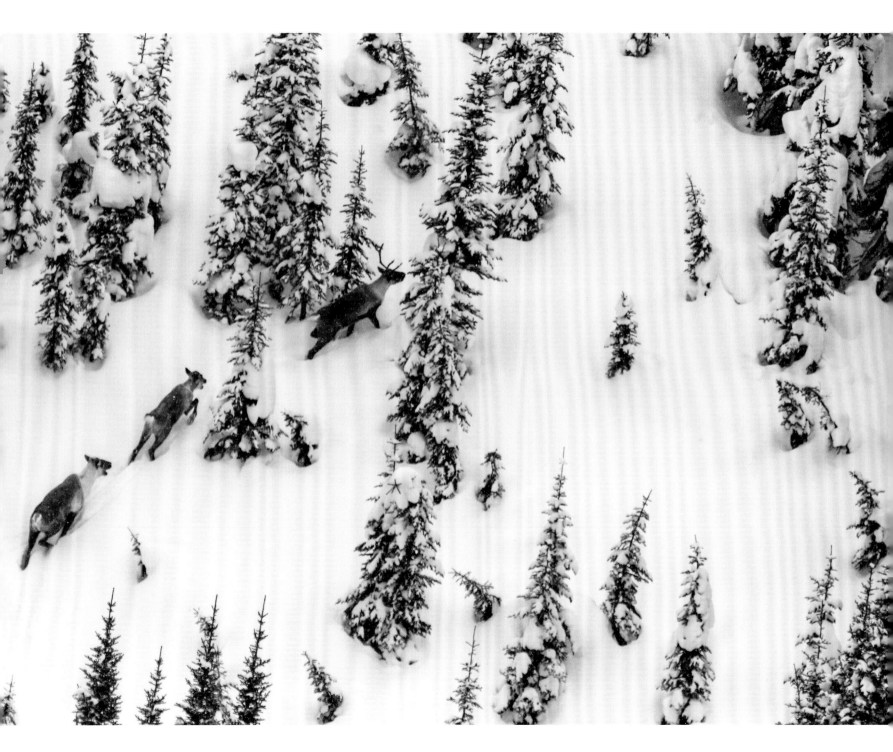

take similar advantage of this quirk. In the big picture of their survival plan, though, the ability to survive in a landscape with few predators has allowed mountain caribou to occupy a relatively unpopulated ecological niche, outweighing their lack of predator responsiveness.

TO SURVIVE, MOUNTAIN CARIBOU REQUIRE mature forests covering mountain ranges with massive elevation relief that receive large amounts of precipitation, including a consistently deep winter snowpack. Specialists of this distinctive landscape, mountain caribou represent an amazing example of the tenacity of life on Earth. Their behavior, passed down as part of these herds' cultural knowledge, illustrates the process of evolution. Here, a species that lives across the northern hemisphere encountered and adapted to distinctive circumstances that require a unique lifestyle.

Beautiful in their complexity but tenuous in their nature, creatures like the mountain caribou have built lives carefully strung across the top of an intricate web of ecological relationships. These relationships encompass everything from the prevailing weather patterns of their home caused by the global jet stream, down to the dispersal and growth patterns of the unique association of fungi and algae that we call lichens. While mountain caribou built a life lived gingerly across this interrelated network, the modern human survival strategy has begun to upend these relationships across the ecosystem.

Caribou tracks along the edge of a lake in the Rocky Mountains

Ironically, as the human world has become ever more complex, requiring greater and greater levels of specialization in many peoples' work lives, our changes to the natural environment have rarely favored the specialists. Across the globe, we find cases of the specialist organisms, such as mountain caribou, running afoul of human-caused changes in the modern world. In our minds many of these species are emblematic of the ecosystem on which they depend—the polar bear of the Arctic, pronghorn antelope of the open grasslands, and the sage grouse of the retreating sagebrush sea of arid western North America, to name just a few.

Because of their sensitivity to the ecological conditions of their environment, specialist species are often the bellwethers of environmental change. The original insult to mountain caribou populations in the 1800s was overhunting by European colonists to the region. But hunting of these animals was terminated in the 1990s in Canada and well before then in the United States. Their continued decline stems from more systemic problems in their ecosystem. Conservation ecologist Greg Utzig likens mountain caribou to the canary in the coal mine of the entire ecosystem their lives are dependent on: "We are watching them disappear and they are an indicator that the large intact forests that were here originally are disappearing. [Their disappearance is] a sign that the ecosystem is beginning to break down because of our impacts."

The insults to this ecosystem are many and varied. Most of the changes have affected caribou by

One of the last mature bulls in the Southern Selkirks herd at a mineral lick in the forest in summer

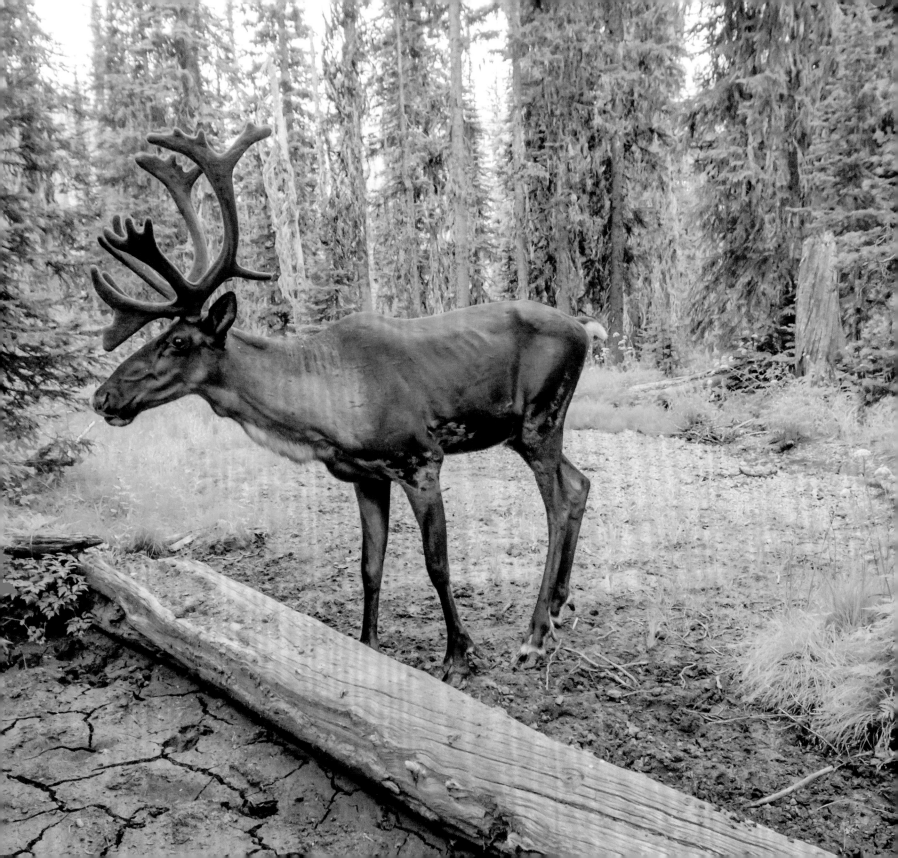

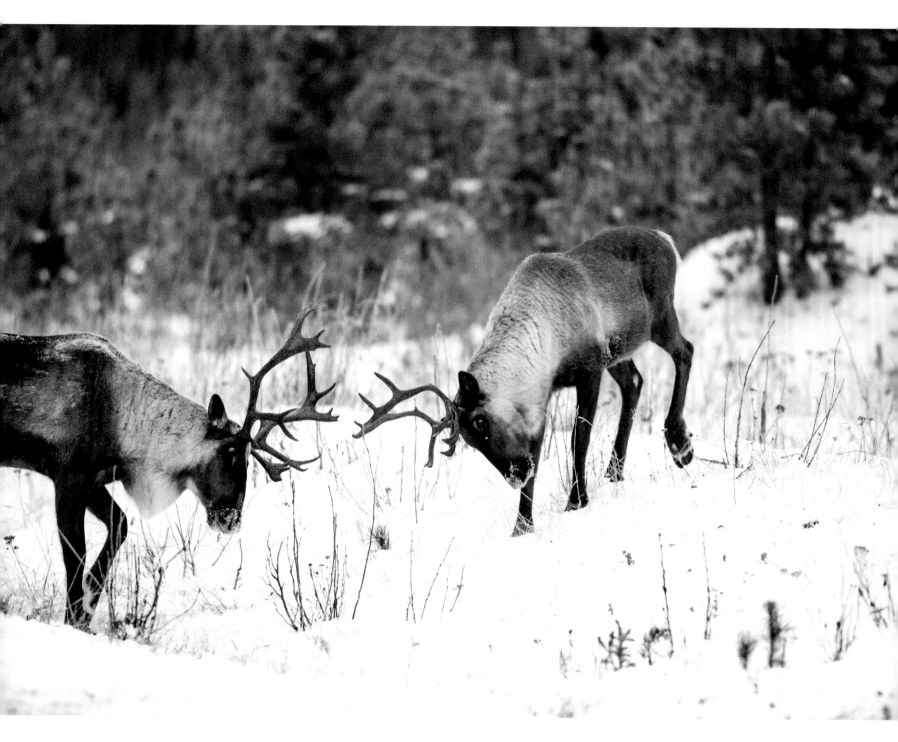

degrading the quality of the refuge they can find from predators. The primary culprit in most of the rainforest, logging has converted large stretches of mature stands of trees into fragmented early successional forests. These younger stands provide habitat for deer and moose, and their associated predators, who were previously excluded.

Other human infrastructure and resource extraction adds to the toll on the integrity of the ecosystem. Massive hydropower projects have flooded valley bottoms, affecting migration routes and permanently removing critical spring and early winter foraging habitats. In some areas open-pit coal mines have been punched into the heart of caribou winter range, literally obliterating the forest and turning the area into a biological wasteland for millennia to come.

Second only to resource extraction is recreation. Winter is the most challenging time of year for caribou to survive. Snowmobilers and backcountry skiers often seek the open forests caribou prefer, and can push caribou from gentler slopes into areas more prone to deadly avalanches. We humans, with our economy built unsustainably on massive consumption of fossil fuels, have excess power and calories to burn. Caribou have none. Displacement can spell the difference between a winter barely survived and death by malnutrition, or lower survival rates for calves born to stressed mothers.

The ultimate environmental result of modern human material culture is climate change. For the Caribou Rainforest, the changes in the climate caused by humans will likely be vast. Forest fire frequency in this ecosystem is increasing dramatically, with models suggesting the average area that will burn annually could increase between three and thirty times historical levels, depending on the location within the rainforest. Such a dramatic increase will almost certainly further dwindle the mature forests of the region. Increasing oscillations in weather and snowpack could be another strike against caribou, since deep snows kill lichens lower on the trees and lower-snowpack winters make the upper sections of the trees harder to reach. Temperature and precipitation level shifts paired with fires could obliterate large sections of the ecosystem as we know it, sending the region into centuries of oscillation. What will materialize out of this disruption is unpredictable. Will mountain caribou be one of the creatures that makes it through? It's hard to predict, but given their limited numbers and refined ecological tastes, it appears unlikely.

The mountains and forests of this region are vast. Some have made the case that between the areas designated as parks, inaccessible currently for logging because of steep or unstable terrain, and the areas already reserved for caribou by the provincial government in British Columbia, a huge amount of the landscape has been set aside for conservation. Accounting is a tricky business, however; the total area may not be as important as the quality and configuration of these areas, much of which is currently defined by economic interests more than ecological values. Mountain caribou don't seem to care about the numbers. As the ecosystem they are a manifestation

OPPOSITE *Two bulls square off in fall snow in the Hart Ranges.*

of continues to endure incursions, mountain caribou stand on the verge of blinking out of existence.

CHRIS RITCHIE IS RESPONSIBLE for overseeing mountain caribou recovery efforts for British Columbia's Ministry of Forests, Lands, Natural Resource Operations, and Rural Development. In the summer of 2016, over the phone from his office in Victoria, BC, Ritchie admitted that the province is failing to meet its own goals for caribou recovery. Since the recovery plan was initiated in 2007, numerous herds have continued to decline, at least two are gone, and four others are down to fewer than ten animals each, making their recovery highly unlikely. At the time I interviewed him, according to their census numbers, not a single herd's population was increasing. As of 2017, according to the province's own numbers, the population had declined more than 25 percent since the current conservation measures were established in 2007.

With no plans to curtail logging and habitat fragmentation, Ritchie said the province will focus instead on "really heavy, expensive long-term management," such as killing wolves and reducing moose and deer populations through hunting and other methods in order to maintain a predator-prey balance that caribou can survive.

As various herds disappear, the forest protections that currently exist for their home range will, in at least some instances, be removed or applied elsewhere. When the George Mountain caribou herd died out in the 2000s, for example, the province decided that it was impossible to reestablish it and removed habitat protections for the area.

There may still be hope for the caribou, however. In 2011, a British Columbia court ruled that resource extraction in the West Moberly First Nations territory violated Canadian treaty obligations, which allow that nation to hunt caribou on these lands. British Columbia altered local plans to settle the lawsuit. Meanwhile, Canada's federal government is revising its mountain caribou conservation strategy, which is likely to end up stronger than British Columbia's. If that happens, the Canadian government could force British Columbia to comply with federal guidelines through a "protection order" under the Species at Risk Act. The scale of such a protection order would be unprecedented in the history of the act.

THE LIFE HISTORY of these caribou evolved right along with the forests themselves, following the retreat of the last ice age starting about twelve thousand years ago. If these caribou disappear, the possibility of restoring the population with caribou from anywhere else in the world, unaccustomed to the annual dance through the landscape required to survive here, appears thin. While debate rages on about the best ways to keep caribou alive on the ground in the short term, everyone realizes the true problem is that the functional ecosystem they evolved in is being torn to pieces by humans.

There are two paths to go down when attempting to defend the survival of an animal such as mountain caribou. One is to deal with this animal as a discrete

OPPOSITE *Each spring, mountain caribou migrate down to valley bottoms to feed on greening shrubs while they wait for the snow to melt at higher elevations.*

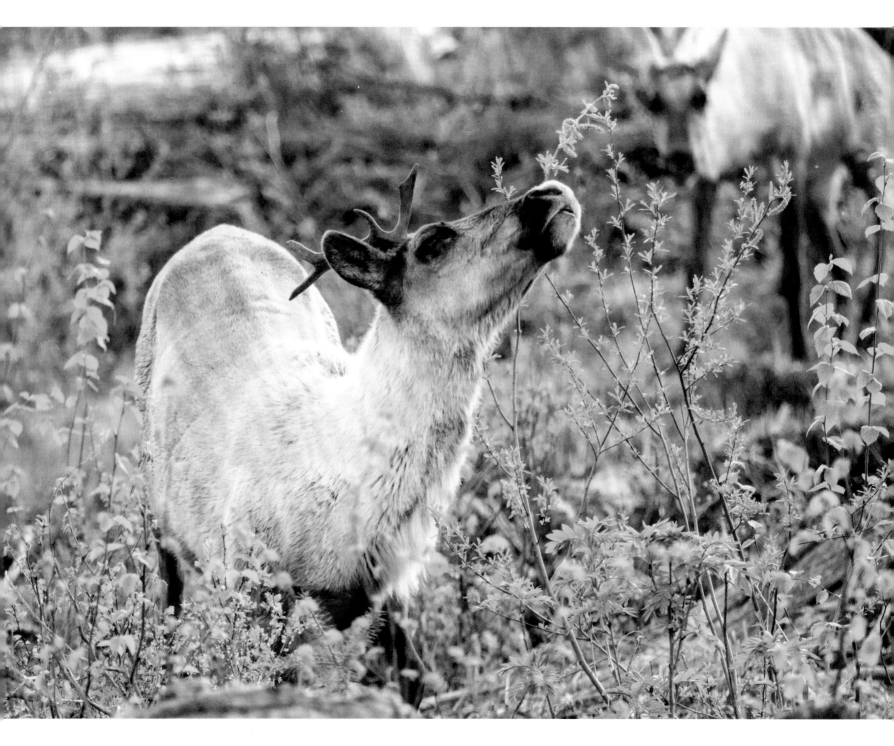

entity. Indeed this formulation is codified into law through legislation like the Endangered Species Act in the United States and the Species at Risk Act in Canada. One of the first tasks in applying protection for an animal is to identify the species of concern as a discrete entity that is threatened with extinction. The concept is hardwired in how we see and discuss creatures—the whole concept of a "species" defines an organism as unique and separate from any other living thing on the planet.

Australian conservation biologist Graeme Caughley authored a paper in 1994 laying out a prescription of sorts for dealing with species being threatened with extinction, like mountain caribou, where the "population is in trouble because something external to it has changed." Scientists must "discover the cause of the decline" and then "prescribe its antidote."

For mountain caribou, the primary "cause" is that their refuge habitat has been fragmented, leading to unsustainable predation rates. Possible "antidotes" include management activities, such as capturing pregnant females and putting them in enclosures before they give birth to protect cows and calves from predators. We can also kill the predators that prey on mountain caribou or kill the competing prey species that drive predator numbers up. We can provide supplemental food for caribou in the fall to increase their chances of survival in the winter. All of these actions can artificially prop up the numbers of mountain caribou and potentially prevent them from disappearing. If we consider mountain caribou to be just a species of animal in a distinct geographic range, these

A calf follows its mother closely in the large enclosure of the Klinse-za maternal penning project in the Hart Ranges, spearheaded by the West Moberly and Saulteau First Nations to protect their remaining caribou populations.

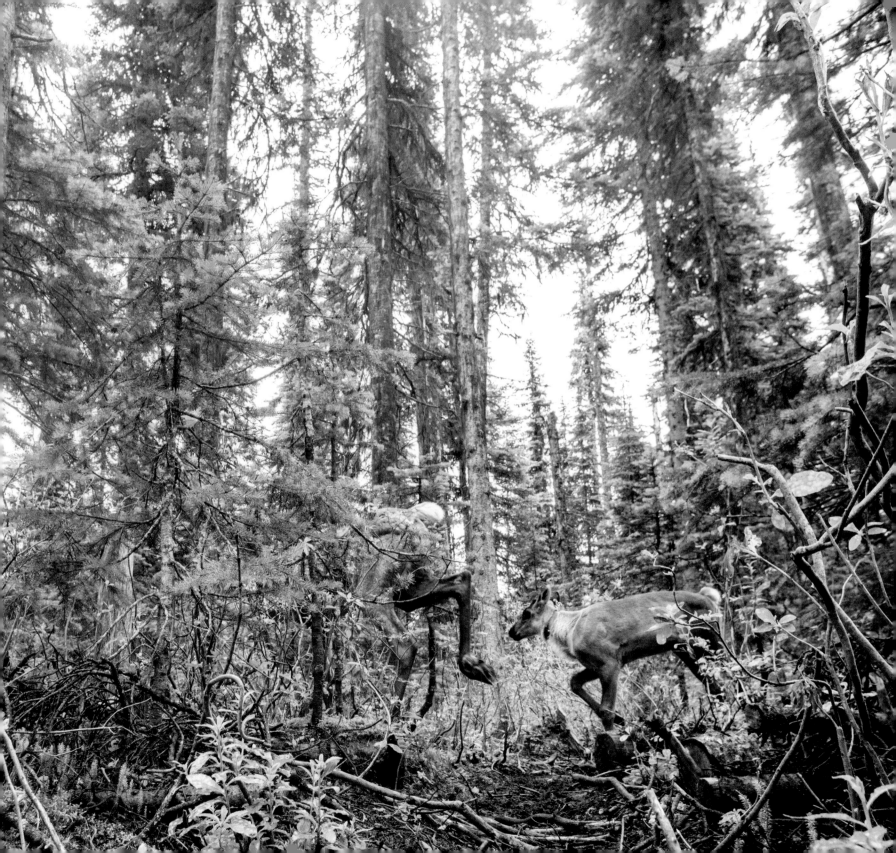

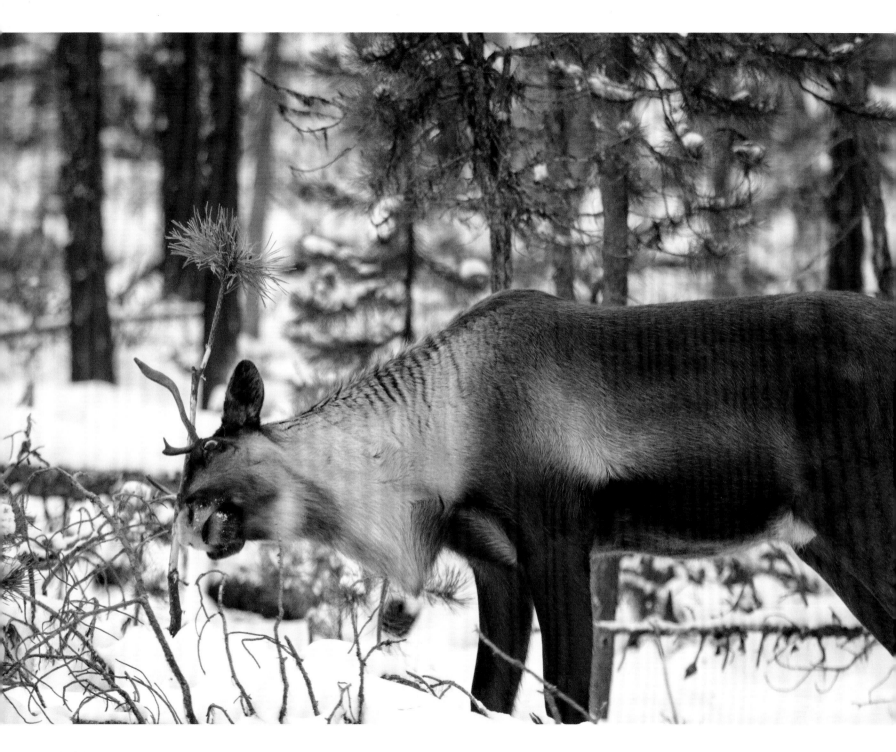

activities, if carried out in perpetuity, could possibly preserve the population.

The second way for us to approach mountain caribou survival requires a fundamental shift in thinking for our society—viewing mountain caribou not as just a group of animals that can be kept alive by artificially modulating their environment, but as a process that emerges out of the natural functioning of an ecosystem. Ecosystems have emergent characteristics that arise out of the relationships among the parts—not out of any one constituent part. From this perspective, the entity we think about as "mountain caribou" is not an animal; it's a relationship between animal and landscape. You can't take mountain caribou out of these mountains, put them somewhere else in the world with less predation pressure, and say you have saved the species. These animals are defined by their unique relationship with this specific land.

Unfortunately legislation and management agencies are generally still stuck in an old conservation paradigm—one that approaches problems like mountain caribou conservation as a species-level issue that can be fixed by prescribing an antidote that stops the decline even if it doesn't address the ecosystem. Success is measured by numbers of animals and the

OPPOSITE *A cow scent marks a sapling in fall with her antlers. Caribou are the only members of the deer family (Cervidae) for which both males and females have antlers.*

TOP *Like mountain caribou, Clark's nutcracker, another high-elevation specialist in this region, is threatened by climate change.*

BOTTOM *The Caribou Rainforest is home to elephant's head lousewort (*Pedicularis groenlandica*), which grows in wet subalpine meadous that caribou frequent.*

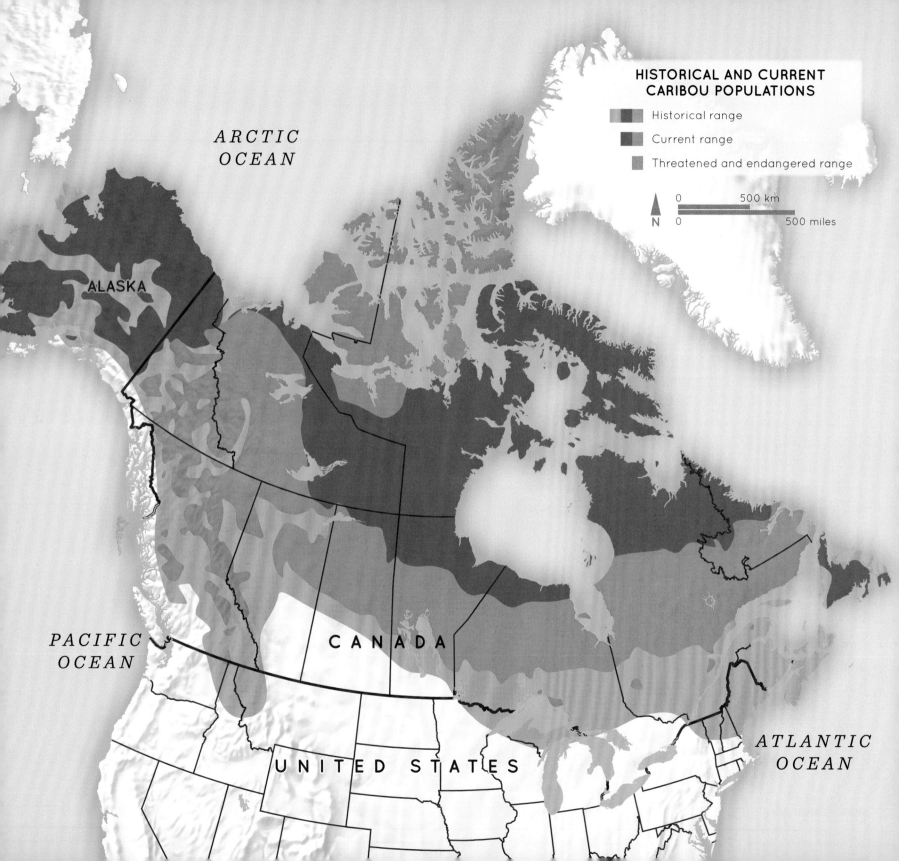

ARCTIC
OCEAN

HISTORICAL AND CURRENT
CARIBOU POPULATIONS

Historical range

Current range

Threatened and endangered range

0 500 km

N 0 500 miles

ALASKA

PACIFIC
OCEAN

CANADA

UNITED STATES

ATLANTIC
OCEAN

likelihood the population will survive into the future. There are no criteria to gauge whether their behavior or ecological relationships have been preserved. British Columbia officials acknowledge that their current conservation planning will require intensive, long-term, possibly indefinite, interventions into the lives of these animals for them to survive, managing everything from pregnant caribou to predators and other hoofed mammals, and even possibly attempting to control forage plants for competitors through wide-scale applications of herbicides across the landscape. These actions would be paired with the continued industrial-scale logging across the rainforest. While it is unclear that these interventions will preserve caribou, they acknowledge that the relationships that gave birth to mountain caribou have collapsed.

Besides mountain caribou, the Caribou Rainforest has many other emergent characteristics, including: a steady supply of clean water flowing out of the mountains, a bank of sequestered carbon that the forest pulls out of the atmosphere and stores in its biomass, and a local climate that is cooler and moister than it would be if the forest were removed. To protect emergent characteristics of ecosystems, we can't think of them as a shopping cart of items we either like and want to keep or don't care about and can discard. Instead, we must attend to the processes that create them all.

IF WE CHOOSE A SHOPPING CART approach, we will discover how hard it is for humans to

Despite more than a century of mining and logging in the Coeur d'Alene Mountains in Idaho, patches of old-growth rainforest have survived in deep canyons and other inaccessible locations.

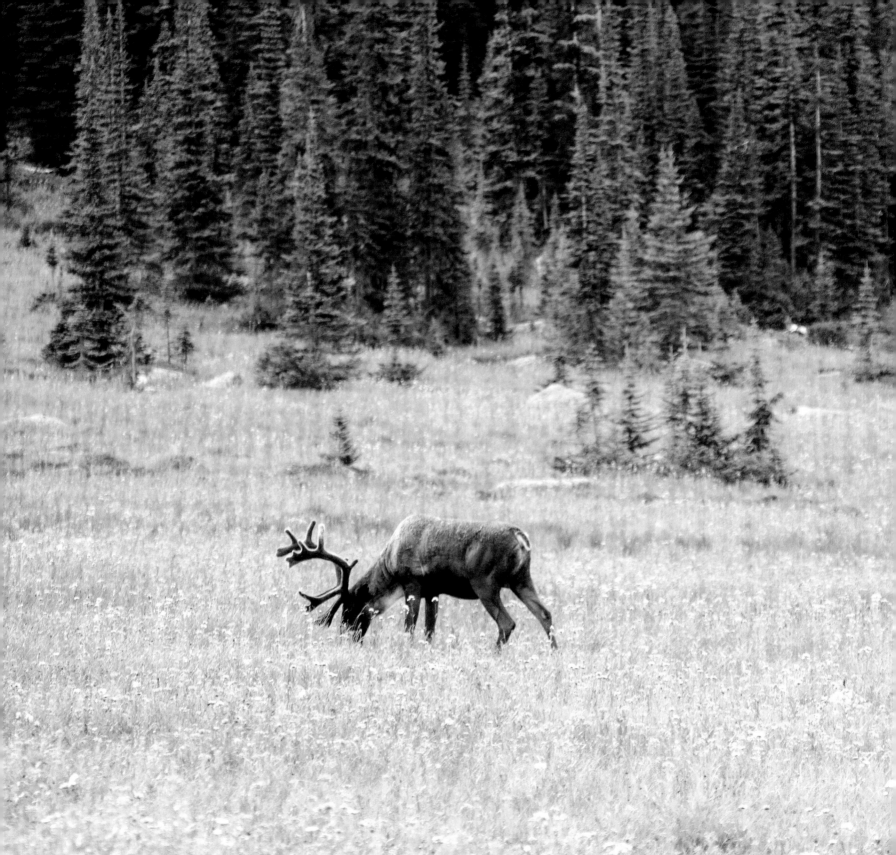

replicate all of the specific ecological relationships that species such as caribou require without addressing the ecosystem itself. When ecosystems fail, humans find themselves attempting to provide services, at great expense, that once flowed freely from the ecosystem itself. If we decide we want a steady supply of clean water but there are no longer any glaciers and ancient forests to act as sponges soaking up moisture and releasing it slowly over time, we are accepting the responsibility of managing water storage across entire mountain ranges in perpetuity. Are we prepared to replace the carbon sequestration carried out by old-growth forests with some technology we must devise and manage ourselves? Are we committing to a Noah's Ark–scale project to bring the other creatures we share this planet with along with us through the biological cataclysm we are creating? Human ingenuity is vast, perhaps matched only by our arrogance.

WESTERN SCIENCE IS, in many ways, still in its infancy in understanding how ecosystems and Earth systems work. However, on the scale of the inland rainforest and mountain caribou, there are some clear directions for supporting the healthy functioning of this biological community. The massive scope and distribution of these forests is a key part of the community itself. Protecting the functionality of this ecosystem requires maintaining (and now restoring) large swaths of old-growth forest.

Terrestrial ecosystems don't typically have solid impenetrable boundaries. As such, our management

A bull feeds in a wildflower-studded wet meadow in summer, Rocky Mountains.

needs to reflect that what happens outside the ecosystem can have profound effects within it. Maintaining buffers around critical habitat can help mitigate these effects. In the case of mountain caribou, we must look at forests many miles from where a caribou ever sets foot and understand that how we manage that piece of ground will have profound impacts on the adjacent forest and, therefore, the caribou. On a global scale, efforts to mitigate climate change are integral to the future of this ecosystem in particular.

Ecosystems vacillate widely under any circumstances. With the increasing disturbances humans have introduced into the world, these oscillations are predicted to increase. To accommodate these fluctuations, we need even larger habitat buffers and set-asides to allow the organisms contained within ecosystems to adapt to the changes occurring around them. For mountain caribou, one example would be maintaining low-elevation forests that caribou use sparingly but which become vital during periods after extreme snow events that kill lichens up high. Once logged, these forests become a breeding ground for competing ungulates and predators.

In many places across their range, if mountain caribou are to survive, humans will have to employ invasive efforts to carry them through in the short term—a reality that stems from decades of neglect of the underlying ecological dynamics at play. In the long run, these actions will be little more than preserving a glorified zoo animal if we do not tend to the ecosystem as a whole.

In springtime, cows, yearlings, and subadult males travel together, Selkirk Mountains.

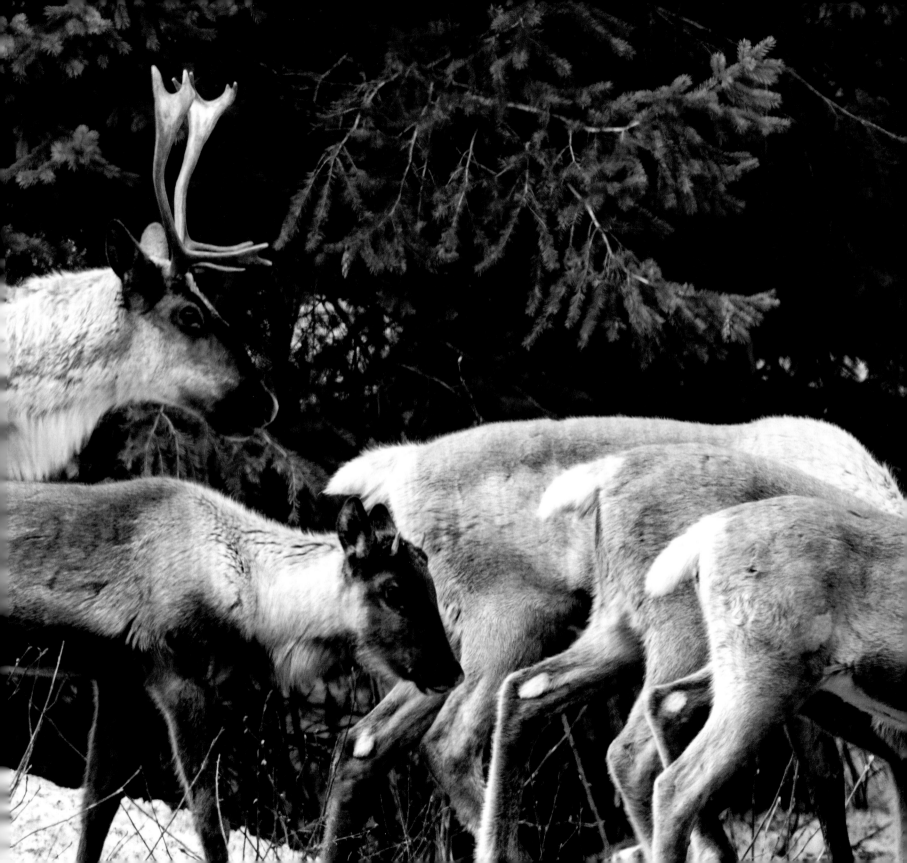

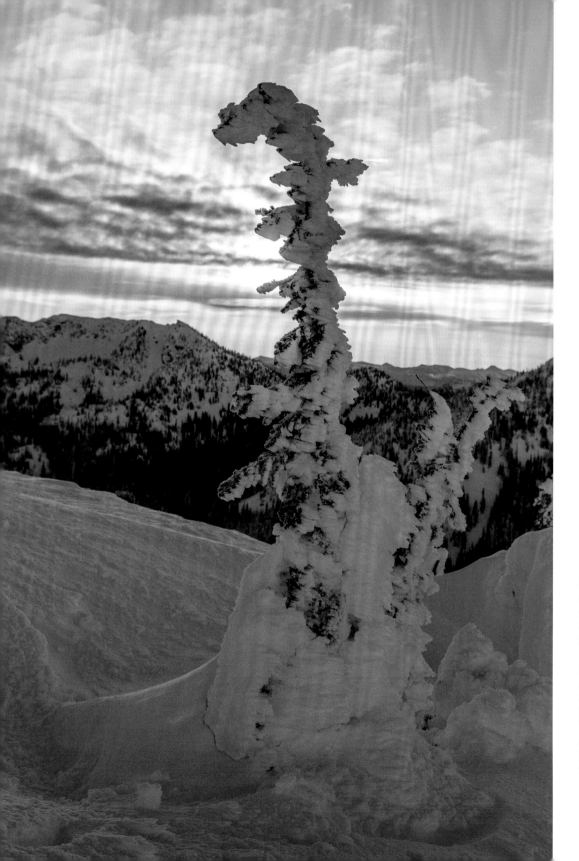

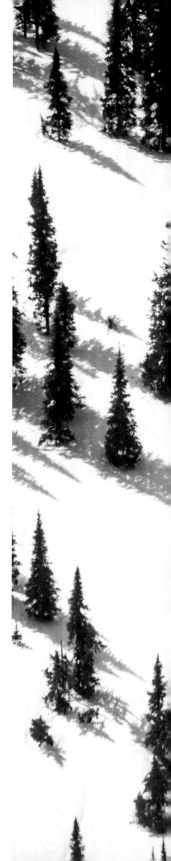

LEFT *Created by strong winds and fog, rime ice builds outward on the leeward sides of objects at high elevations, Selkirk Mountains.*

RIGHT *Researchers census mountain caribou in late winter, when they can be found in open high-elevation forests. This handful of creatures is all that remained of the Southern Selkirks herd in the winter of 2017.*

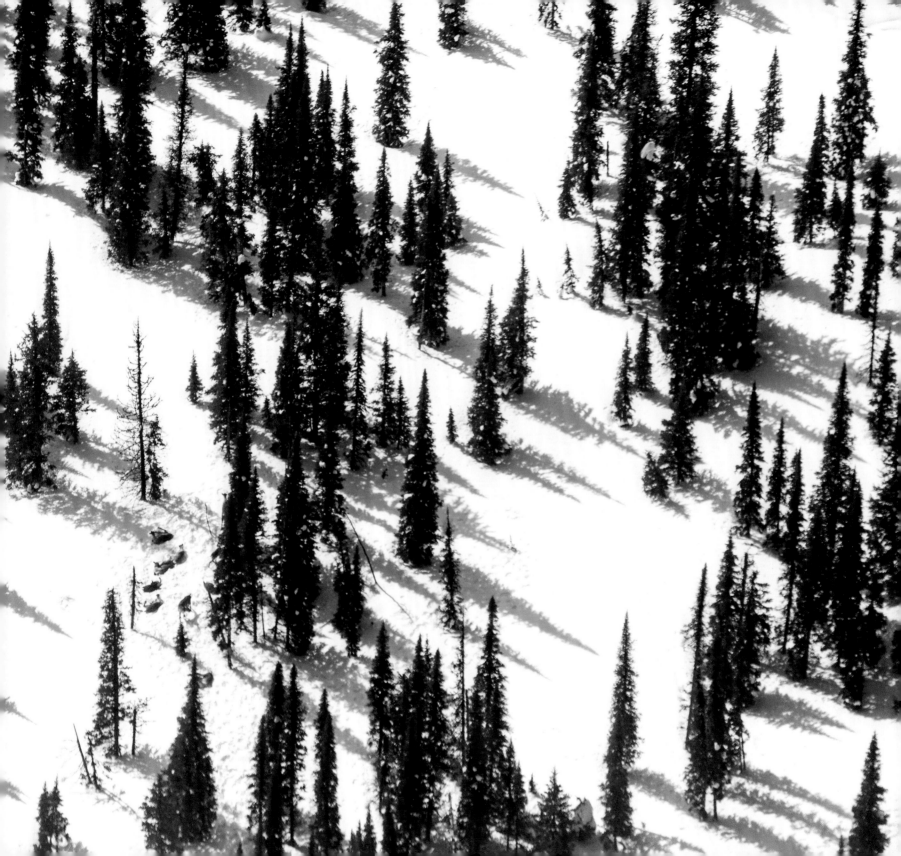

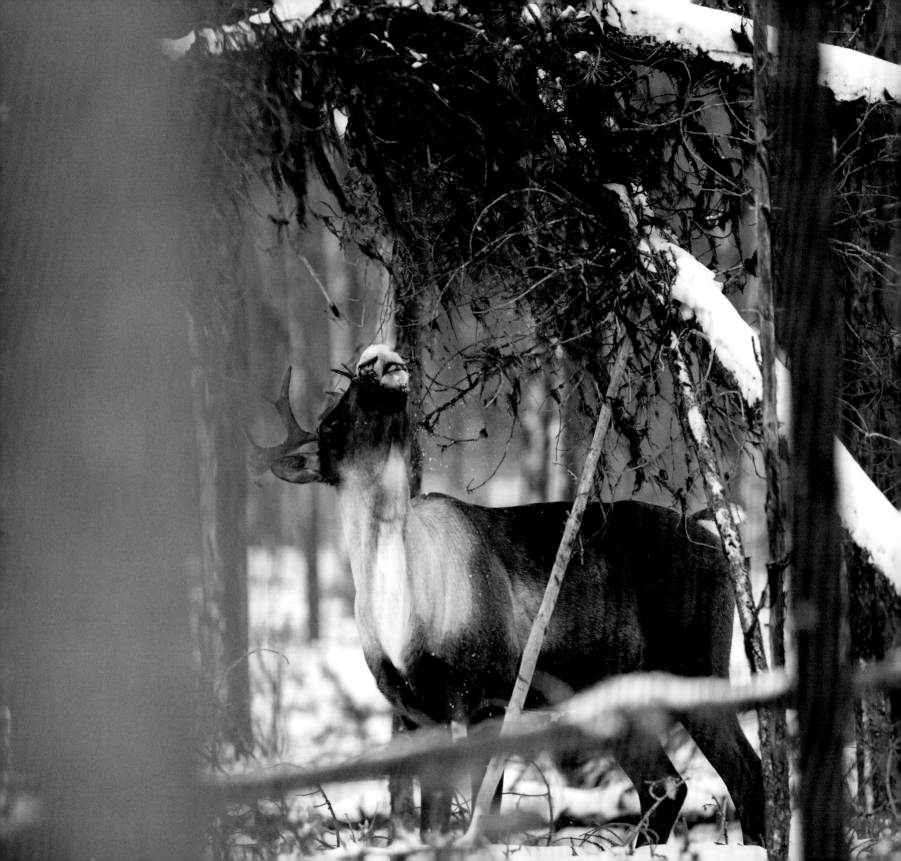

LEFT *Black tree lichens (Bryoria) make up the majority of the mountain caribou diet in winter.*

RIGHT *In the subalpine, the winter snowpack can be ten feet deep or more. Mountain caribou must wait until the snow builds up high enough for them to reach the lichen, their primary food source in winter.*

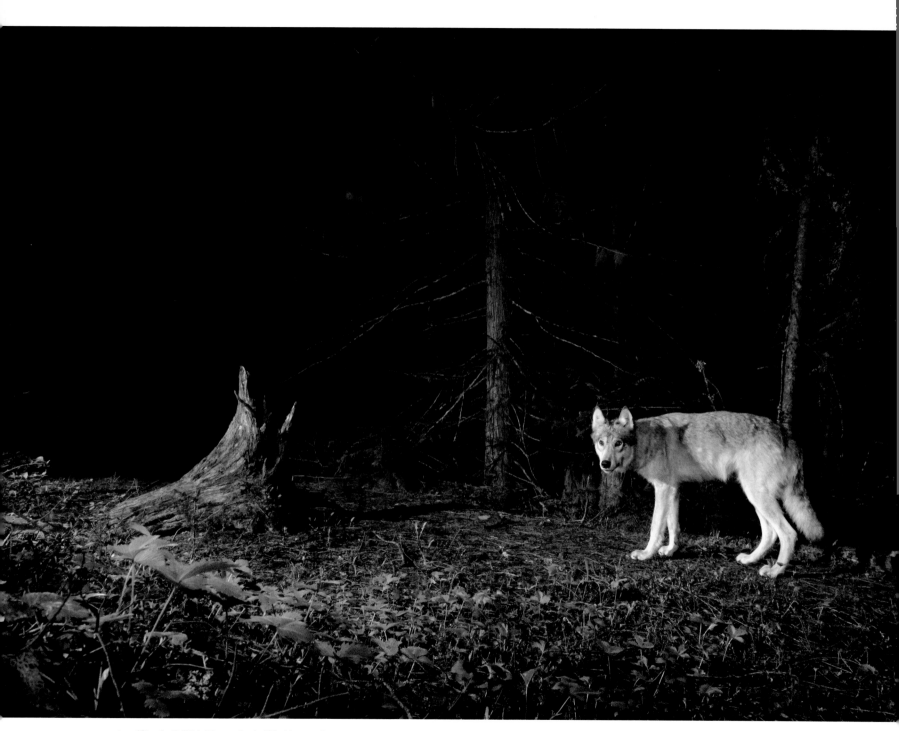

A wolf in the Selkirk Mountains in Washington State

The remains of a bull moose that was killed and fed on by a pack of wolves in the Selkirk Mountains in Washington State

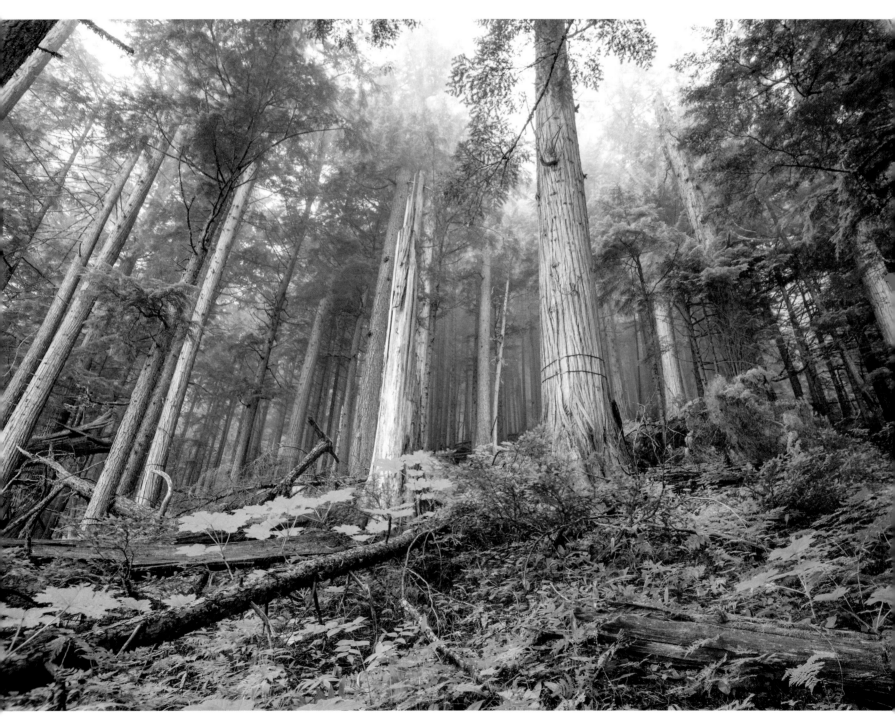

This ancient forest in the Selkirk Mountains was clear-cut shortly after this photo was taken. The metal straps around the cedar tree keep the trunk from splitting when it is felled. The hemlock trees went to a pulp mill to make paper products.

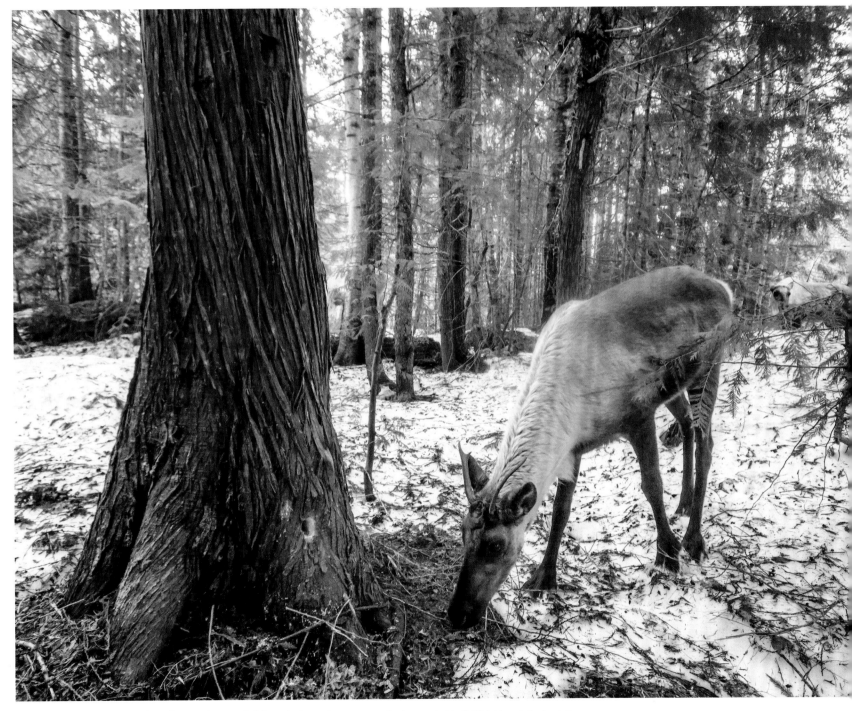

A mountain caribou forages where the snow has receded from the base of a western redcedar tree in the Selkirk Mountains in spring.

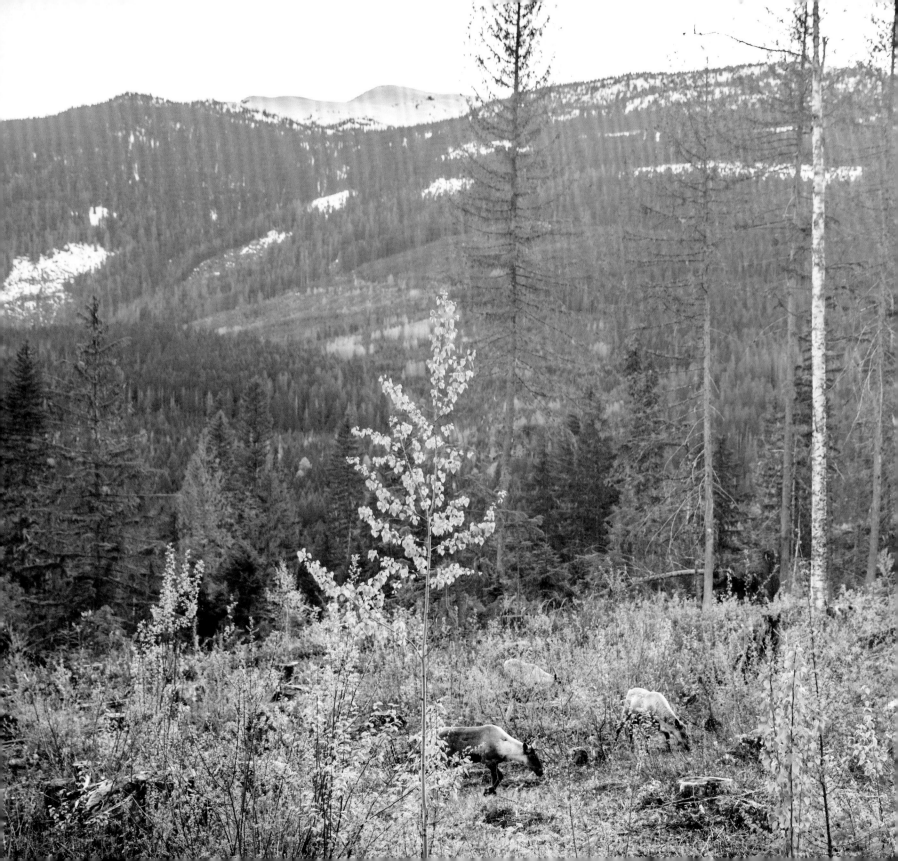

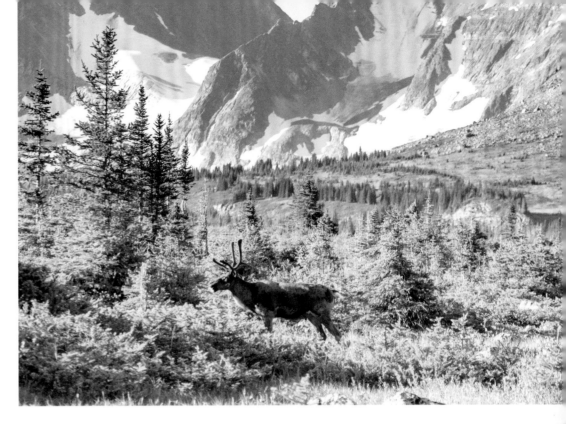

LEFT *Where old-growth forests have been logged at low elevations, mountain caribou face greatly increased threats from predators while they forage in clear-cuts like this one in the Selkirk Mountains.*

RIGHT, TOP *Young trees invading a high-elevation meadow and receding glaciers in the Rocky Mountains hint at the effects of climate change on mountain caribou habitat.*

RIGHT, BOTTOM *Many herds of caribou can no longer sustain their population. The industrial extraction of resources has destroyed their refuge habitat, resulting in lower rates of survival for calves.*

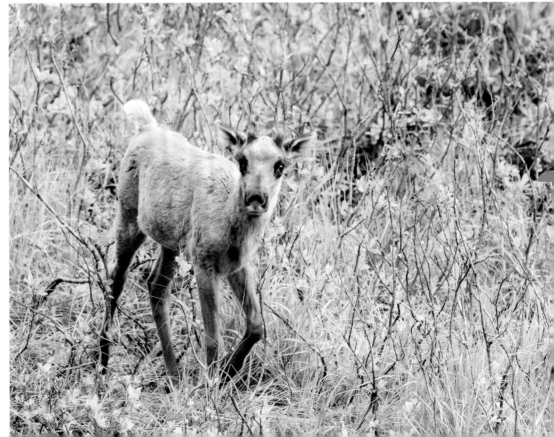

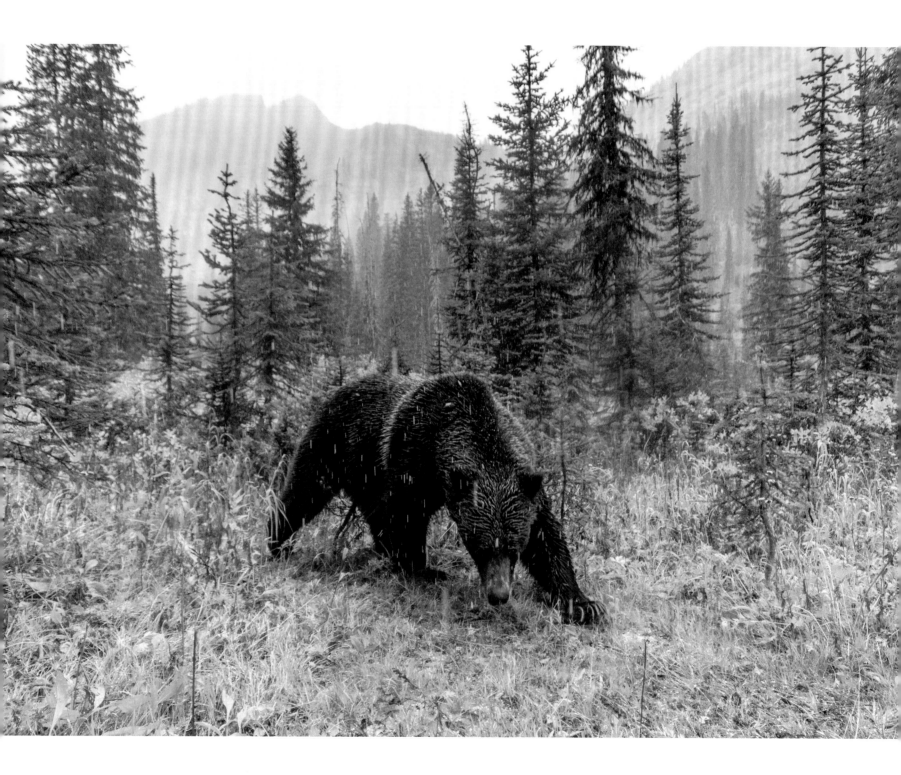

WILDLIFE OF THESE MOUNTAINS: A LABORATORY OF EVOLUTION

Silhouetted by the first rays of sun cresting the mountains, a mother grizzly and her cub slip out of the subalpine forest into a small wet meadow. Too close to move without disturbing them, I don't bother reaching for my camera. Instead I bask in a moment of grace, experiencing an intimate moment in the lives of creatures most humans in the modern world will never get to see in a wild setting.

Photographers call the time right around sunrise and sunset the "magic hour." Most mornings like this one yield nothing but mosquito bites as the sun warms the cool morning air, but the possibility of catching a brief glimpse of one of the elusive creatures of this ecosystem inspires my rapid response to my alarm going off at 4:00 a.m. on summer mornings in the field.

OPPOSITE *Grizzly bears in the southern portion of the ecosystem, such as this one in the southern Selkirk Mountains, are considered threatened in Canada and endangered in the United States.*

The bears don't notice me as they traverse the bog and reenter the forest on the far side. As quickly as they appeared, they are gone again, into a sea of spruce, fir, and mountain hemlock. Beyond where they disappeared into the trees, the dark subalpine forest stretches away for miles through the mountains.

Tracking down rare and widely dispersed creatures in these mountains is a task not lightly undertaken. Weeks of fieldwork might yield a few fleeting glimpses. Months of planning and two weeks of twelve-hour days in a blind yielded a five-second view and one photo of a wolf in the Selkirk Mountains in Washington when I was documenting the return of this creature to the state. In return for a careful stalk into a flooded wet meadow and hiding in a clump of alders in water over my knees, I was rewarded with another single photo and less than a minute of watching another young wolf's indecision over whether a chunk of a deer it had cached would be safe from its packmates. Searching for mountain caribou on my first summer outing for this project yielded three encounters in twenty-eight days. The mosquitos were fierce that July, apparently similarly deprived of warm-blooded mammals most of the time.

For some reason I relish projects involving elements like these—steep terrain, thick brush, wet feet, numb fingers, bottomless loose snow, subjects few in number and spread out across a vast and uninviting landscape, unreasonable quantities of precipitation. Far more often than not, while fieldwork is always an adventure, long preparation and lots of sweat yields nothing as far as your quarry goes. When the raven calls, telling you the wolf is near, and the creature steps from the forest, you relish the moment, knowing how fleeting this encounter with the wild is.

The desire to pursue and track down wildlife is primal for humans. We have been doing it as long as we have been a species. Originally, our survival depended on it. "We've hunted forever; that's why we are here," said Brian Glaicar, a hunting guide in the heart of the Caribou Rainforest. "I feel bad for people who don't understand it because I feel that they have lost touch with where they came from." Today, our relationships with wildlife, if not the animals themselves, still nourish us. In humans young and old, urban and rural, fear and fascination mingle in our dreams and actual experiences with our wild neighbors.

"What is the value of a caribou?" asked Kerry Rourk, corporate forestry manager for the Gorman Group, which owns multiple logging operations in the Caribou Rainforest, when I interviewed him in 2016. He reflected on flying over the public lands in the Monashee Mountains where Gorman has tenure to log, and realizing that while there were large tracts of forest still uncut, much of it was off-limits to logging because of caribou habitat protections. "You ask the rhetorical question: 'What's that costing the province to have caribou on that piece of ground?'" He continued, "Aside from the intrinsic value and the Species at Risk [Act] and all that good stuff that we all take near and dear to our heart, there is an economic side to it too that we consider, discuss. It's always picking away at you."

OPPOSITE *Spawning kokanee in a tributary of Kootenay Lake*

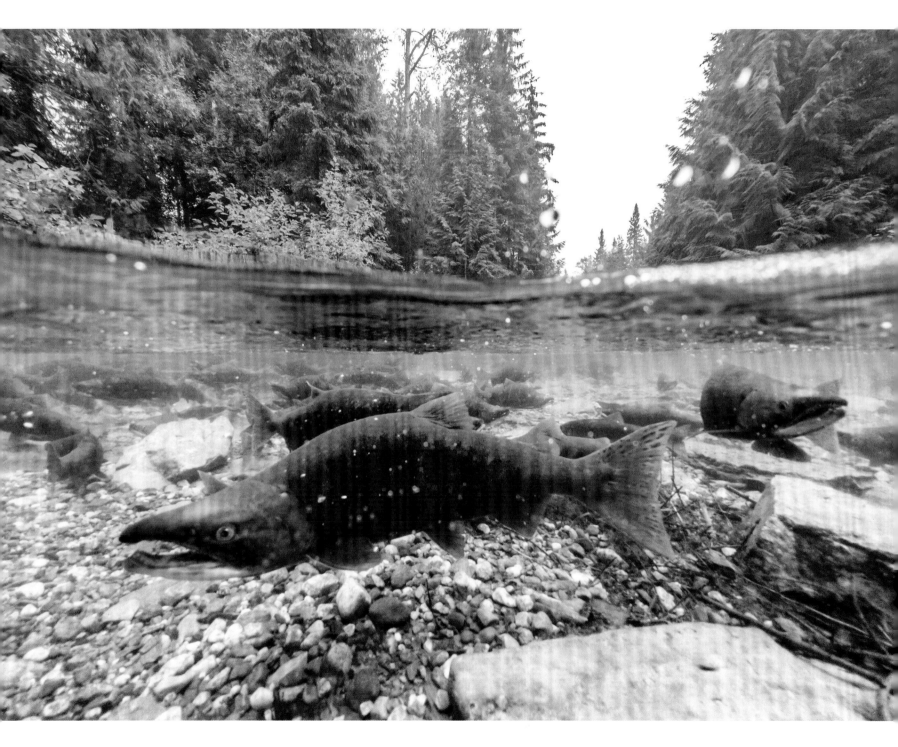

Is the value of other species best described in the context of the economic value of their habitat to humans or themselves? Or is there intrinsic value in the lives of other species? As a species, we ourselves evolved in the presence of a wide array of other creatures, animals that show up in our dreams, our art, our stories, in ancestral and modern spiritual practices. Their lives and ways of being have carved a trail through our collective soul as a species. Beyond the intrinsic value of living creatures, for humans there is more at stake in the potential loss of so many species across the planet for our kind than just the monetary value of the trees that make the walls of their homes, and ours.

WHILE THE GRANDEUR of the lofty peaks and the magnificent ancient forests of this region announce themselves boldly, the animal kingdom is typically more fleeting in its presentation across the Caribou Rainforest Ecosystem. Dense forests cater to creatures with a fondness for obscurity. Steep terrain, dense brush, and foul weather satisfy those who wish to be left alone. Frigid winters and tremendously deep snow separate out the wheat from the chaff in the world of wildlife. The Caribou Rainforest is not an easy place for humans *or* wildlife to make a living.

Still, these mountains are rich in resources as well as challenges. Creatures large and small have developed ingenious strategies for meeting their needs, and they thrive in this mountain rainforest. While few species have tied their life histories quite as intimately to the distinctive circumstances of this

Two hoary marmots play fight in the talus field they call home, Selkirk Mountains.

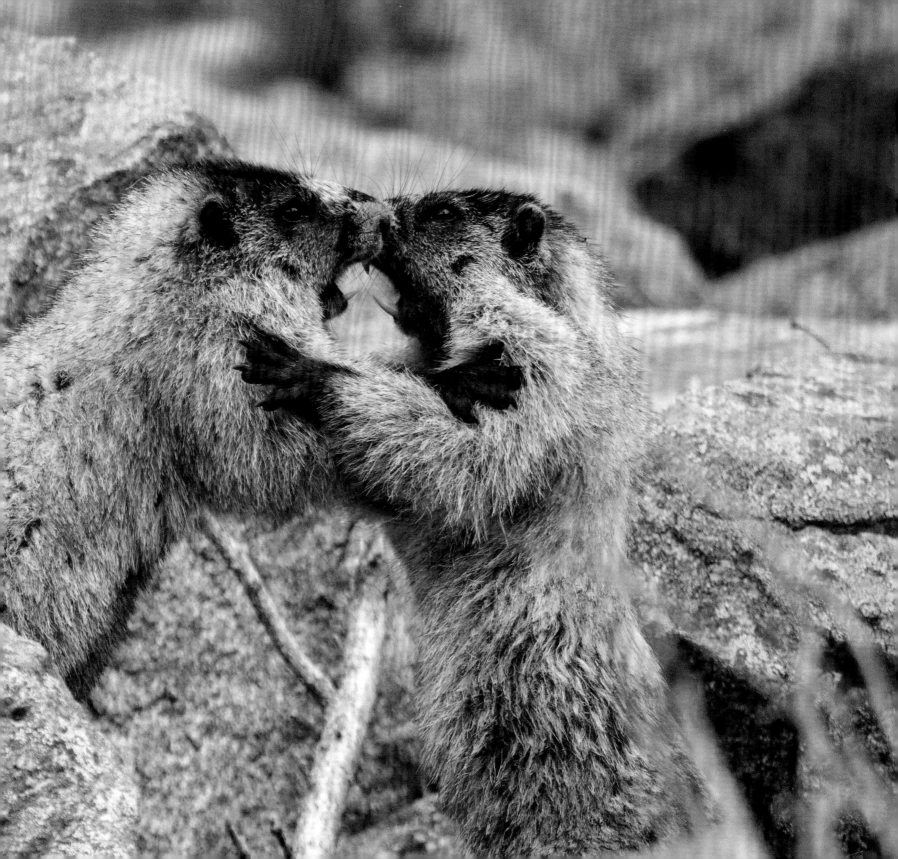

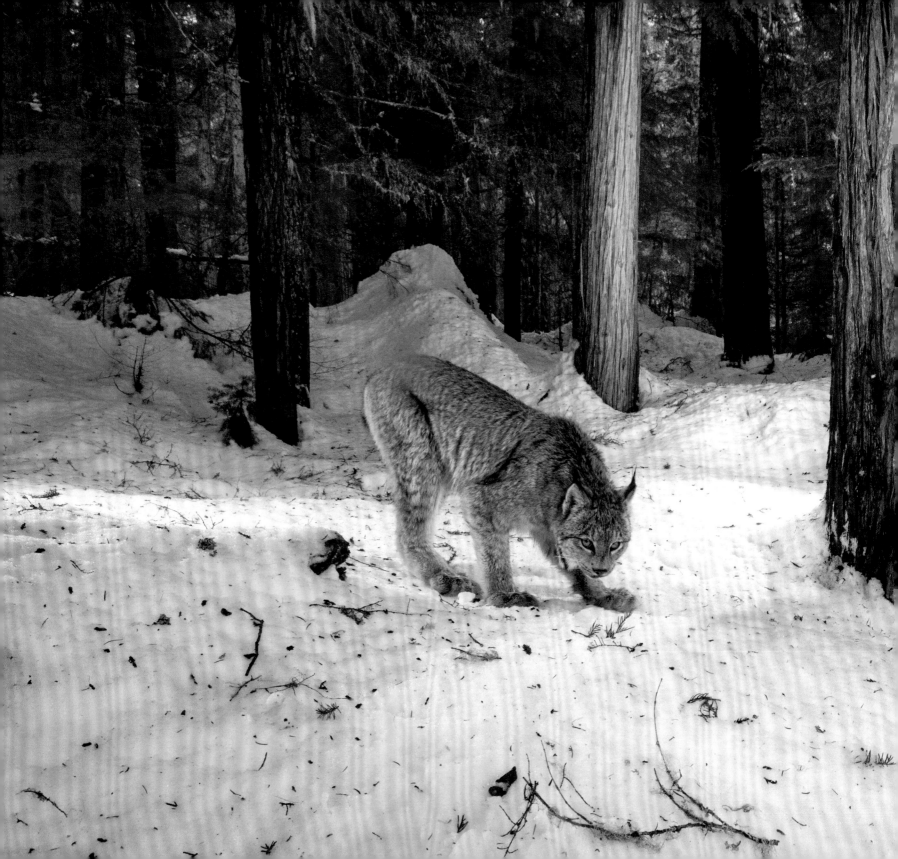

region as the mountain caribou have, a cadre of furred, feathered, and scaled animals have sorted out how to make opportunities where others find obstacles, molding themselves to fascinating ecological niches up and down the mountainsides.

The salmon that still return to the headwaters of the Fraser River each year to spawn and the harlequin ducks who fly hundreds of miles from the coast to breed along the region's streams make use of the relative quiet of these mountain forests to avoid competitors and predators from marine and coastal landscapes and thus increase the odds of survival for their young. Some creatures, like the mountain goat and pika, are specialists of the high mountains. Others like the Canada lynx and white-tailed ptarmigan, whose range extends south through these mountains, are fixtures of the northern latitudes of North America.

Here, the laboratory of evolution continues and offers us a window into the diversity of life on this planet and the fragile strings that bind it together. Take the cohort of hoofed mammals that mountain caribou share this region with, each of which has evolved its own strategies for living in this landscape of extremes. Where the caribou have become specialists of the forest, finding food and refuge within the vast stands of ancient trees, other species have sought out different niches.

Mountain goats (*Oreamnos americanus*) and mountain bighorn sheep (*Ovis canadensis canadensis*) follow a similar strategy to mountain caribou, setting up shop in a landscape seldom visited by predators.

A Canada lynx in an old-growth rainforest stand in the Purcell Mountains of Idaho

Instead of dense forests, mountain goats and bighorn sheep adopted a different landscape, adapting to a life among the ample cliffs of the region, living their lives in some of the most rugged parts of the mountains.

To feed themselves, mountain goats focus on a diet of lichens growing among the rocks and tundra plants found in the high-elevation habitat they prefer. Instead of performing a perennial dance with predators, they tempt death as they traverse avalanche slopes and precariously loose rocky cliffs. Females seek out inaccessible ledges on cliff faces to give birth to their kids. Mountain bighorn sheep follow a similar script in carving out a niche in these mountains, focusing on slightly lower elevations and more moderate slopes.

Moose (*Alces alces*) have an entirely different strategy. Weighing in at 600 to 1,100 pounds (272 to 500 kilograms), moose are massive creatures, the largest mammals in the ecosystem. Neither extremely fast nor nimble, moose rely on their size alone as security from predators. They use their long legs to plow through deep snow in winter and access the buds of woody plants to feed on when snow and ice makes everything else inaccessible. Their massive size makes them very efficient at surviving in cold environments, but in summer it means they can become heat stressed quickly. To temper their heat sensitivity, they often head to wetlands where their

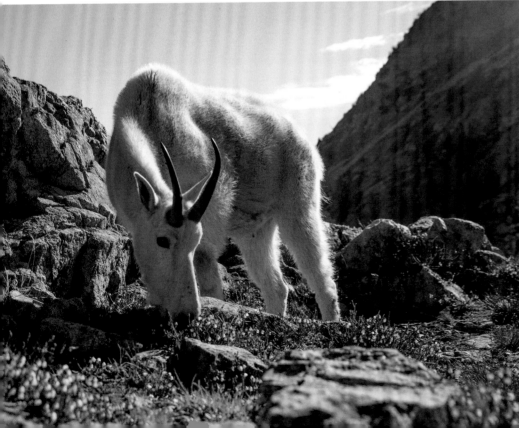

TOP AND BOTTOM *Mountain goats specialize in high-elevation cliffs and avalanche slopes throughout this ecosystem.*

long legs once again come in handy as they wade into marshes to feed on aquatic plants. Their reliance on woody browse from shrubs and saplings has historically limited moose populations in the Caribou Rainforest to riparian zones and other generally widely spaced sites of forest disturbance. However, their numbers and range have expanded dramatically in recent decades due to industrial forestry.

Populations of mule deer (*Odocoileus hemionus*) and white-tailed deer (*Odocoileus virginianus*) were historically absent from most of the rainforest. As logging operations and agricultural development have increased in the valley bottoms of the inland rainforest, white-tailed deer populations have been expanding into these areas. Even in fully protected landscapes such as national parks, climate change is affecting the ecosystem. We have seen expansion of deer into new places, a trend that will continue as winters become milder.

Elk (*Cervus elaphus*), another relatively common hoofed mammal in other parts of North America, were historically rare in the southern portions of the inland rainforest and absent in the northern parts. The continuous dense forests were not great habitat for these animals that evolved for open landscapes. But as human-caused landscape changes have created habitat they are partial to, elk, like deer and moose, are expanding in numbers and range.

TOP *A white-tailed deer fawn reaches out to nurse at a mineral lick in the Selkirk Mountains that is also frequented by mountain caribou.*

BOTTOM *A cow moose in a wetland in the Selkirk Mountains*

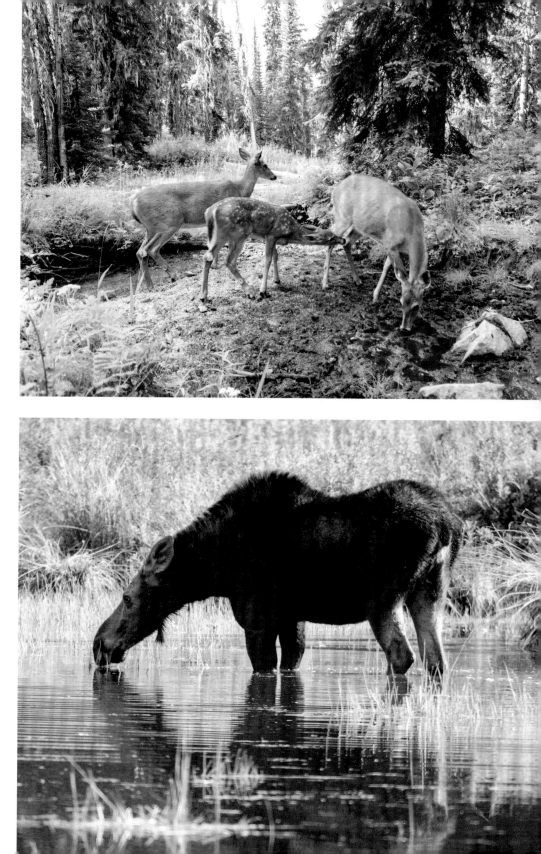

Within the order Carnivora we find another example of the wondrous diversity that this convoluted landscape supports. Five taxonomic families and nineteen species can be found in the region, each one specialized into a unique ecological niche, from a least weasel (*Mustela nivalis*) hardly bigger than a mouse to 500-pound (227-kilogram) grizzly bears. While conflicts often arise around the world between humans and carnivores, in the Caribou Rainforest low human population numbers and rugged, heavily forested mountain topography have helped ensure a refuge for these animals even through the worst periods of persecution by humans, though a number of species have been reduced in numbers and range. Today several native carnivores face renewed threats arising from habitat fragmentation and climate change.

The Caribou Rainforest is home to two carnivore specialists of deep snows and harsh winters, the Canada lynx (*Lynx Canadensis*) and the wolverine (*Gulo gulo*). Each has exceptionally large feet for their body size, giving them better flotation in loose snow. Their heavily furred footpads provide increased thermal protection in the cold snowy environment.

The Canada lynx is perhaps best known for its connection to fluctuating snowshoe hare populations across the boreal forests of the far north. Given their predator-prey relationship, population changes in one of the two species can affect the other quite significantly and quickly. Snowshoe hares turn pure white in winter to avoid detection by lynx that are primarily visual hunters. These boreal forests are

A grizzly bear scent marks a tree at the edge of a wet meadow in the southern Selkirk Mountains.

Members of the weasel family, American martens can be found in high-elevation forests throughout the Caribou Rainforest ecosystem.

characterized by relatively low biodiversity, with just a few species of trees dominating millions of square miles of forest and similarly few wildlife species. There, lynx and hares live in a relatively simple ecosystem with few competing species.

In the Caribou Rainforest, lynx occupy the mid- to high-elevation forests of the mountains where ecological conditions mimic those farther to the north of the continent. However, lynx and snowshoe hare populations do not swing as consistently and massively as those documented in the north, perhaps providing an interesting window onto what's to come in our age of diminishing biodiversity.

The closer you venture to the tropics on the planet, the greater the overall biodiversity you find. Conversely as you head toward the poles, biodiversity decreases. In the Caribou Rainforest and other places at the southern edge of Canada lynx range, both the lynx and the snowshoe hare exist at lower densities, because they must share the landscape with other competing species not found to the north. This added complexity also decreases the direct correlation between populations of lynx and snowshoe hares. If lynx populations decline, other carnivores may continue to suppress hare populations. If hare populations increase, the benefit of this is dispersed among numerous carnivores. As humans simplify ecosystems by destroying unique habitats and spurring the extinction of species, we will likely see increasing variability in population dynamics of some of the remaining species, similar to what naturally occurs in simple ecosystems in the far north.

For modern humans, the increasing fluctuations of all sorts in ecosystems will likely prove challenging, adding complications and uncertainty to our use of the landscape for foundational elements of our society, from food production to transportation systems.

The true mountaineers of the carnivore community, wolverines make their home in the subalpine and alpine regions year-round. There they hunt for marmots, ptarmigan, and other game along with scavenging on the carcasses of animals killed by other carnivores or natural calamities such as avalanches.

An exhaustive study of all the known denning locations of wolverines from around the northern hemisphere linked natal dens with landscapes that retain snowpack into the late spring, such as high-elevation mountain slopes. Snowpack likely helps insulate dens from the cold. With climate change models predicting reductions in snowpack persistence into the spring in many parts of the rainforest, the future of wolverines in the region is uncertain.

Unlike the adaptations for survival in the snow that lynx and wolverines exhibit, bears have taken an entirely different approach to winter: avoidance. They consume all the calories they need for an entire year from spring to fall and then take the winter off, sleeping it away. With an exceptionally slow reproductive rate, grizzly bear populations have been slow to recover from past attempts to annihilate them across much of western North America. Grizzly bears were declared endangered in the United States portion of the Caribou Rainforest region in 1975. Prior to this time frame, grizzly bears, like other

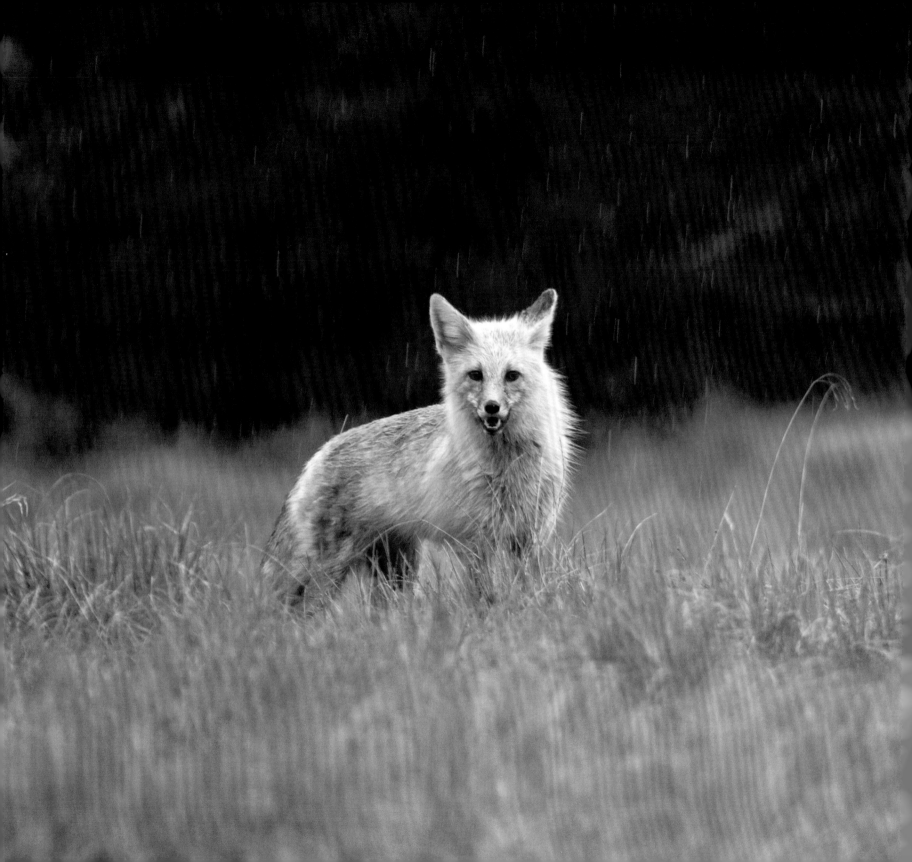

carnivores, had been the focus of systematic campaigns to eradicate them from the region. However, even with a measure of protection for grizzlies on both sides of the border, habitat fragmentation and isolation of subpopulations have continued to impede their recovery, which is further hampered by a continued hunting season for them in the northern portions of the Caribou Rainforest in Canada.

A SHIVER RAN UP MY SPINE as I watched a big male chinook salmon leap out of swirling white water of a massive rapid on the Clearwater River in the Cariboo Mountains, more than 375 river miles (603 kilometers) from the ocean. Born in a wild river fed by a sprawling mountain range, and having spent his adult years wandering the Pacific Ocean, this son of the rainforest had returned to the waters of his birth to spawn and continue a cycle of life that has graced this river since it was freed from ice thousands of years ago.

Like mountain caribou, Pacific salmon have carved out an improbable existence in these interior mountains. Perhaps the most iconic creature of the Pacific Northwest's coastal rainforests, this character, not surprisingly, appears in the interior rainforest as well. As on the coast, these fish have literally found their way into the very fabric of the forest.

Most salmon are anadromous: they are born in freshwater but travel to the ocean for their adult lives, and when they are ready to reproduce they travel back upstream to the waterway where they were born to spawn. After spawning, the adult fish die and decompose in the stream or on its shores, adding

Red foxes, such as this one out on a rainy day in the Rocky Mountains, specialize in subalpine and treeline meadows.

valuable nutrients to the stream, which in turn support a rich diversity of invertebrates that feed the young fish born into the stream.

The decaying fish also feed the forest. As has been well documented in coastal forests, salmon enrich the biological abundance of interior forests adjacent to the streams they travel up. Bears, birds, and other mammalian carnivores often carry fish away from the banks of the stream. Once they are done consuming them, the remains of the fish decompose into the soil, adding valuable nutrients to plant life and trees along the stream. Researchers looking at the ecological impact of salmon on the rainforest have documented marine-derived nutrients in the wood of rainforest trees hundreds of miles from the ocean.

Historically, salmon swam against the current all the way up the Columbia River and its tributaries, hundreds of river miles deep into the Columbia Mountains, bringing food for myriad First Nations peoples and wildlife alike. The construction of the 500-foot-tall (152-meter-tall) Grand Coulee Dam in Washington State, which opened in 1942, cut off salmon from the entire southern portion of the inland temperate rainforest, powering industry and development in parts of the Northwest while impoverishing the upstream landscape and indigenous peoples.

The Fraser River, undammed and free-flowing, still acts as a highway for millions of salmon as they migrate to spawn in the upper reaches of the river and its tributaries in the Caribou Rainforest. Steelhead, chinook, coho, and a few pink salmon make their way into the streams of the inland rainforest, but by far the largest

numbers of salmon to call the region home are sockeye salmon, with millions of fish flooding the Fraser River watershed on big return years. As is the case on the coast, the largest runs of salmon are in the fall.

The annual return of the salmon is marked with ceremonies by numerous regional indigenous groups. Salmon has traditionally been a staple food source for these peoples. Tina Donald, fisheries manager and member of the Simpcw (pronounced SIMP-qwuh) First Nation, whose traditional territory includes much of the North Thompson River watershed, a tributary of the Fraser, shared an account from her grandfather: "There were so many fish in the North Thompson that you could walk across on their backs." Donald's grandfather practiced traditional spear fishing for salmon from a canoe. "It's a vital part of our culture," she continued. However, for the past several years, there haven't been nearly enough fish returning for the band to feed themselves or provide for their elders throughout the year.

"The world is changing," said Donald. "The ocean is warming up. A couple years ago we had fish coming back really small because they didn't have enough food in the ocean. All of our rivers are warming up. . . . Fish can't handle that warm of water. Everybody wants fish but there is not enough to go around for everybody. A lot of First Nations aren't fishing because they want to make sure there are some for the future." Despite salmon returning to the rivers in quantities too few for indigenous peoples to harvest, commercial fishing activities continue in the Pacific Ocean where these fish spend their adult lives.

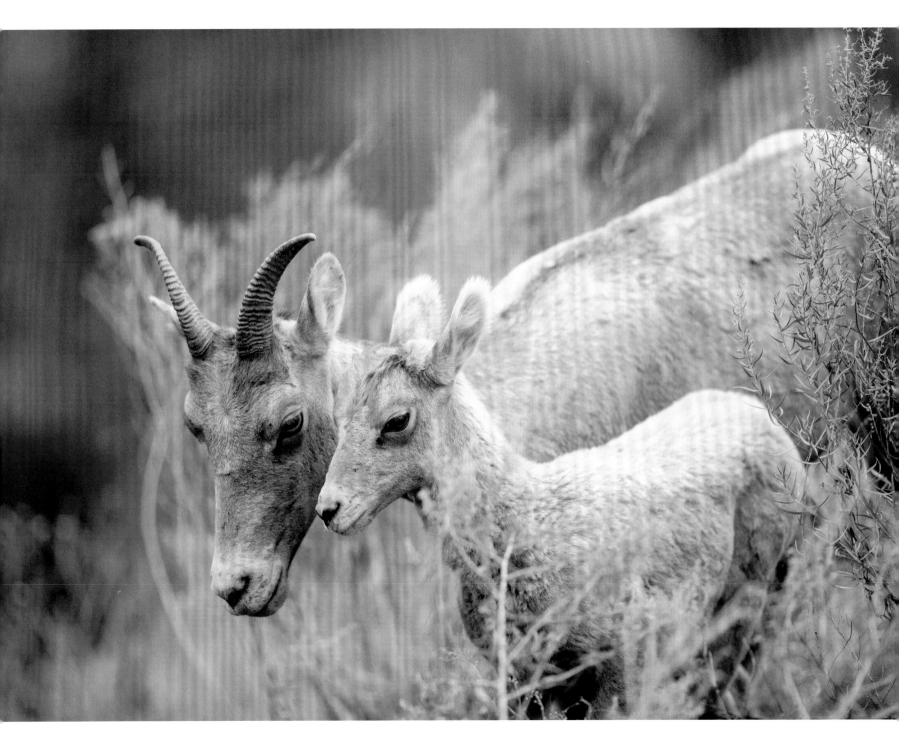

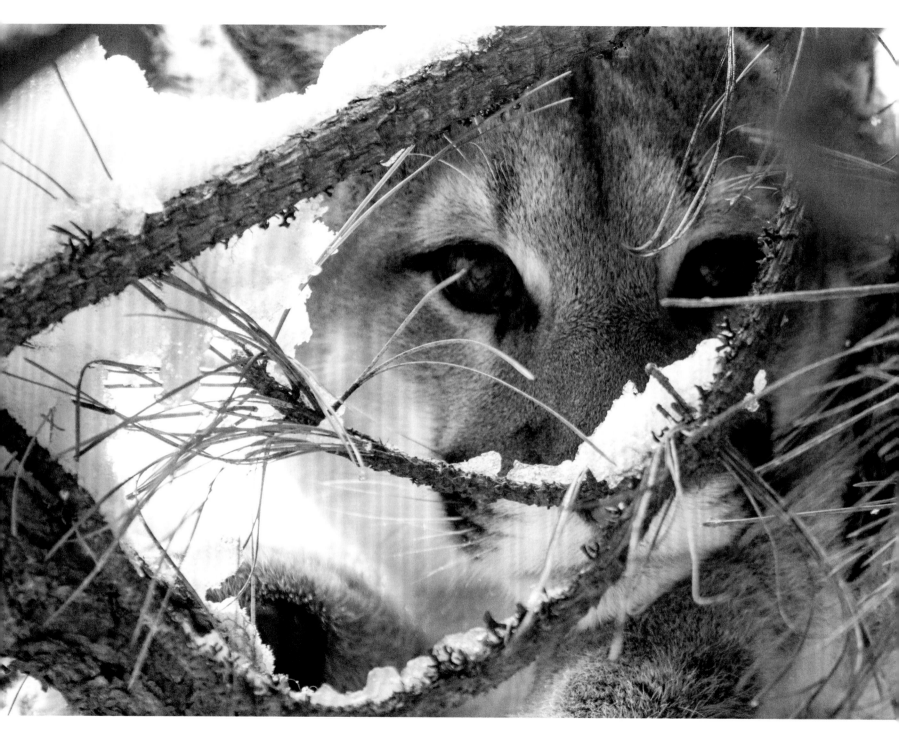

In the Columbia River headwaters, where ocean-going salmon have been excluded by the Grand Coulee Dam, you can still find a population of land-locked sockeye. These salmon adapted to life in fresh-water for their entire life cycle in the Kootenay River system after the last ice age. Commonly known as kokanee, they spawn in the rivers and streams of the region. Young fish, rather than return to the ocean, swim downstream to Kootenay Lake, where they spend their adult lives until they are ready to return to spawn in the stream of their birth.

AS WE SEARCHED FOR SIGNS of mountain caribou, a short bushwhack from the end of a long logging road in the southern Selkirk Mountains brought Kim Shelton and me into a high-elevation basin filled with dense forests and wet meadows. Tracks of wolverine and grizzly bear marked the shore of the large lake in the middle of the glacier-carved valley. Over the next three summers Kim and I, along with Marcus Reynerson and Colin Arisman, set camera traps on game trails and on the edges of meadows in the mountain cirque.

Owned and managed by The Nature Conservancy of Canada, this mountain landscape, the Darkwoods Conservation Area, was obtained specifically to help protect habitat for mountain caribou. Our camera traps did indeed capture images of caribou as well as grizzly bears, black bears, wolves, coyotes, American marten, moose, elk, and white-tailed deer.

On its face, our camera trapping effort appeared to be documenting a conservation success story of protecting habitat for a wide-ranging umbrella species, the mountain caribou, with the benefits of that trickling down to myriad other animals that also depend on that landscape. But the details are much more complicated, leaving wildlife managers and conservationists with a collection of dizzying paradoxical decisions to examine.

Parks and protected areas have increasingly become islands in a sea of development or landscape fragmentation from development and resource extraction activities. The impacts of these changes seep into protected areas themselves. At first we might imagine that the path forward would be simply to restore the landscape to what it was as best we can: remove logging roads and encourage clear-cuts to return to mature forests. Let the ecosystem return to historical conditions and the rest will sort itself out.

But some species, like mountain caribou, will likely not survive the decades it will take for the forest ecosystem to return to something close to historical conditions without human intervention in the short term. Caribou are not the only species with an uncertain future in the face of a hands-off approach from humans. The southern population of grizzly bears my camera traps captured, with such low numbers and a population possibly already isolated from other grizzlies, could disappear from a disease outbreak or from wildfires. Bears are big predators of caribou calves, and the recovery of grizzly bears could further stress caribou populations. Perhaps comparable, the recovery of endangered wolf populations in the southern portion of the rainforest coincided with a

OPPOSITE *Mountain lions rely on stealth to get close enough to their prey and catch them after a short sprint, Selkirk Mountains.*

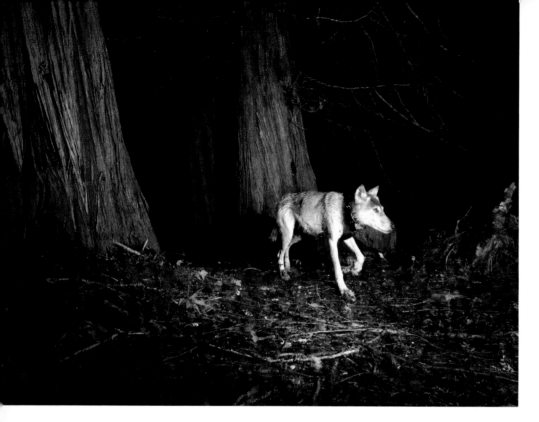

renewed decline of mountain caribou in the heavily altered landscapes of the ecosystem.

Further, decades of pumping greenhouse gases into the atmosphere around the globe have ensured that this ecosystem will never revert to the way it was, no matter how long we wait or what support we provide in that direction. Large-scale shifts are under way not just for specific species of plants and animals but for entire ecosystems around the globe. Some members of these communities can survive in new conditions. Others cannot. New species, pre-adapted for the changes, invade to fill niches vacated by less well-adapted organisms, or native species are pushed out by more aggressive newcomers.

Perhaps most important from a practical perspective, a hands-off approach to all the forests and mountains of the Caribou Rainforest does not reflect the reality of our own species' needs for survival. Humans, like all other species on the planet, have a primal drive to collect the resources we need in order to ensure the survival and prosperity of our kind, and these mountains provide the raw resources we need to survive. The political will for conservation efforts is inevitably tied to how we as a species perceive these actions affecting our own well-being.

TOP *Wolves, such as this one fitted with a GPS collar in the Selkirk Mountains in Washington State, are primarily nocturnal.*

BOTTOM *The entrance to a wolf den in the southern Selkirk Mountains. While their numbers increase in logged landscapes, wolves often seek out remaining old-growth forest patches for their dens.*

BIODIVERSITY AND CLIMATE CHANGE IN NORTHERN IDAHO

Most folks wouldn't think of a slug as a poster child for tracking the impacts of climate change on biodiversity, but that's exactly what a massive survey effort in the southern reach of the Caribou Rainforest has discovered.

In 2010, biologists from the Idaho Department of Fish and Game began an ambitious survey effort in northern Idaho to collect baseline data on a wide variety of little known species of invertebrates and amphibians as part of efforts to understand the coming impacts of climate change on the region. At the center of this effort is Michael Lucid, a tall, bearded biologist who spent years living in the Selkirk Mountains in a small cabin off the electrical grid with his wife and collaborator, biologist Lacy Robinson. They still spend summers based out of this remote location while his work takes him across multiple mountain ranges in the region throughout the year.

From the outside, Lucid's field trips to document a recovering population of Canada lynx, collect genetic samples from grizzly bears, or establish the presence of wolverines would seem like the most exciting parts of his job. But recounting the discovery of a new species of slug is what lights up his face. On a series of sunny spring days I joined Lucid in the field to track down rare frogs, salamanders, and gastropods endemic to the inland rainforest. He and his field assistant caught Columbian spotted frogs on the edge of a mountain lake fringed by dark cedar forest. They uncovered rare Coeur d'Alene salamanders. These moisture-loving creatures are easiest to find on rainy days. Otherwise they remain deep within moisture-soaked, moss-covered rocky debris at the base of wet seeps on cliffs in the rainforest.

The Skade's jumping-slug, recently discovered by scientists in the inland rainforest in Idaho

Almost magically from amidst the blanket of mosses they produced a variety of slugs and snails, each with its own fascinating story. In the collecting box where they had placed their treasures, I watched high drama play out as a larger predatory robust lancetooth snail (*Haplotrema vancouverense*) circled its prey, the smaller but more nimble Coeur d'Alene Oregonian snail (*Cryptomastix mullani*). In a stroke of slow-moving genius

and agility, the smaller snail outmaneuvered its predator and took refuge on top of its aggressor's shell.

Lucid explained to me how the magnum mantleslug (*Magnipelta mycophaga*) is an emblem of the inland rainforest. Over the course of four years, he and his team meticulously surveyed hundreds of square miles of mountain forests for these slugs while also collecting air temperature readings and other baseline climate and habitat data at the sites they surveyed. The results showed a powerful correlation between the presence of these slugs and areas with cool air temperatures in the mountains. With warming temperatures predicted in the ecosystem, Lucid hopes to use this baseline data on these slugs to track the impacts of climate change on the ecosystem.

While large, charismatic species like caribou and grizzly bears capture headlines, Lucid's attention to these smaller obscure creatures may be where the hard work of assessing and conserving biodiversity on a broad scale lies for the future. This lesson and passion will not be lost on his and Robinson's young daughter, Skade. Lucid is compiling all the information for a scientific note to document and name the new species of slug his research discovered, Skade's jumping-slug (*Hemophilia skadei*). While all children can't have a tiny endemic rainforest gastropod named after them, the fact that at least one can gives me hope for our future.

CONSERVATION PLANNING BECOMES more complex in the face of such a diverse collection of variables. Do you decommission roads that are pathways for invading species into protected landscapes, or do you leave the road in place to allow for human access to fight wildfires in the precious remaining stands of old-growth forest? Current predator-prey dynamics will be fatal for caribou in the short term. Do you intervene or stand aside and "let nature take its course"? Is doing nothing letting nature take its course or abdicating responsibility for cleaning up the ecological messes we have made already? How do you incorporate the existing, messy, and deeply flawed legislative framework and a human economic system that drives our actions on a scale far larger than this isolated rainforest?

The laboratory of evolution in the Caribou Rainforest continues. Now pushed by the heavy hand of human influence, what the world will become, which species will persist, and which will perish has become as much a study of evolutionary biology as a study of human sociology and political ecology. Humans don't have a successful track record of tinkering with ecosystems globally. But the consequences of doing nothing are potentially catastrophic in some instances, and the negative impacts of climate change are merely ramping up. Setting aside preserves of land and letting things sort themselves out may be a luxury we can no longer afford.

OPPOSITE A private moment in the lives of rarely observed mountain lions, captured with a remote camera

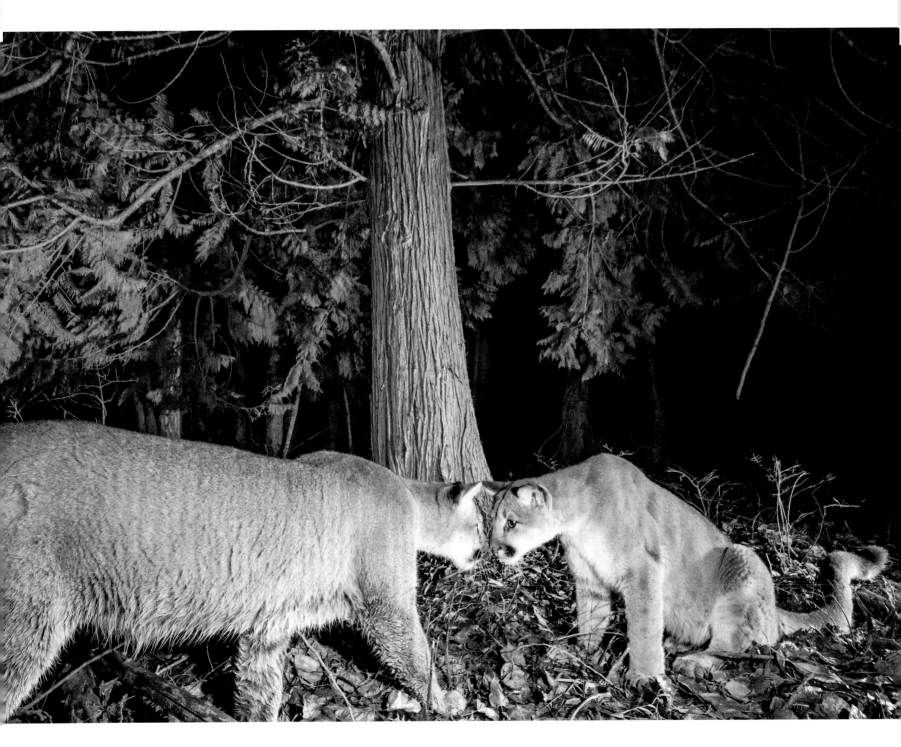

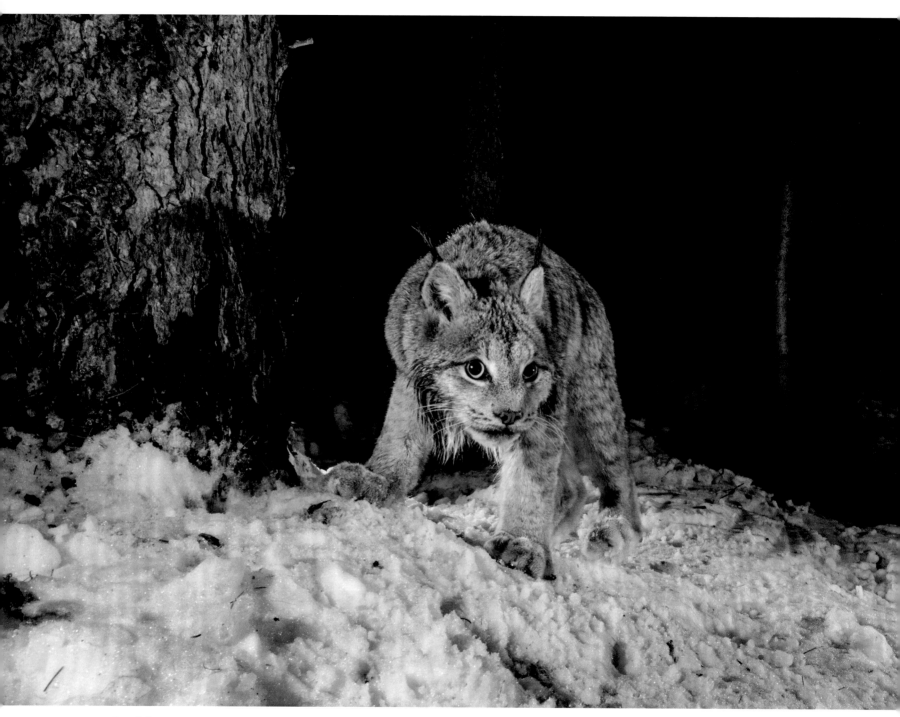

Canada lynx, Mission Range, Montana

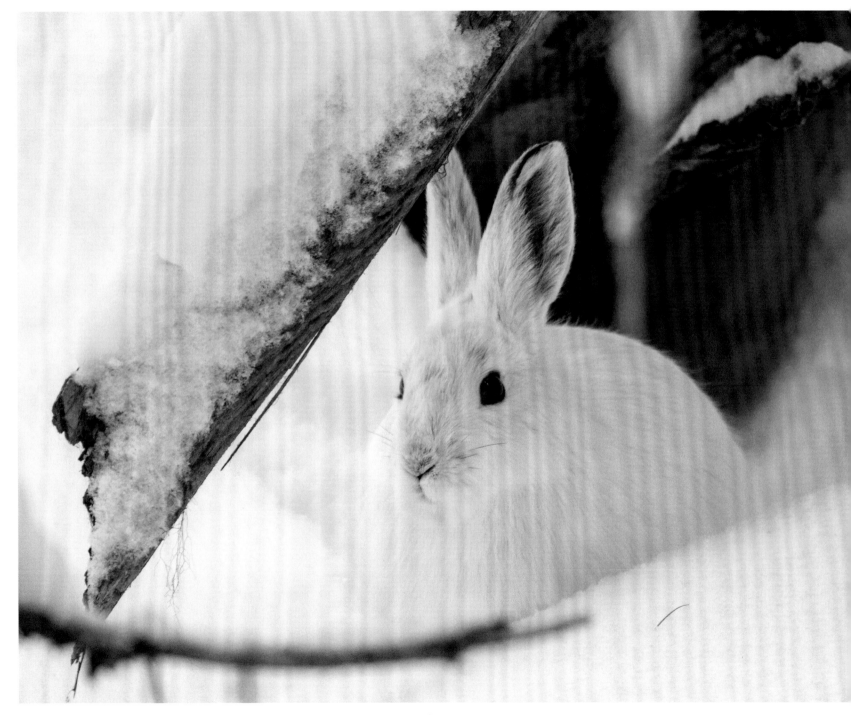

Snowshoe hares turn pure white in winter as camouflage from visual predators such as the Canada lynx.

LEFT *A white-tailed ptarmigan in its summer plumage. Residents of the alpine tundra, they turn pure white in winter. (Photo by Marcus Reynerson)*

RIGHT *A short-tailed weasel, in its winter coat, scampers down a cedar tree in the Purcell Mountains.*

Harlequin ducks migrate each spring to breed along streams and rivers in the Caribou Rainforest and winter along the Pacific Coast to the west.

Members of the weasel family, river otters hunt fish in the lakes and streams throughout the ecosystem, Cariboo Mountains.

LEFT *The largest member of the weasel family in the ecosystem, wolverines specialize in high-elevation habitat where they hunt and scavenge across home ranges of hundreds of square miles, Mission Range, Montana.*

RIGHT *The largest member of the squirrel family in the region, hoary marmots live in high-elevation meadows and are active only a few months during summer each year, Rocky Mountains.*

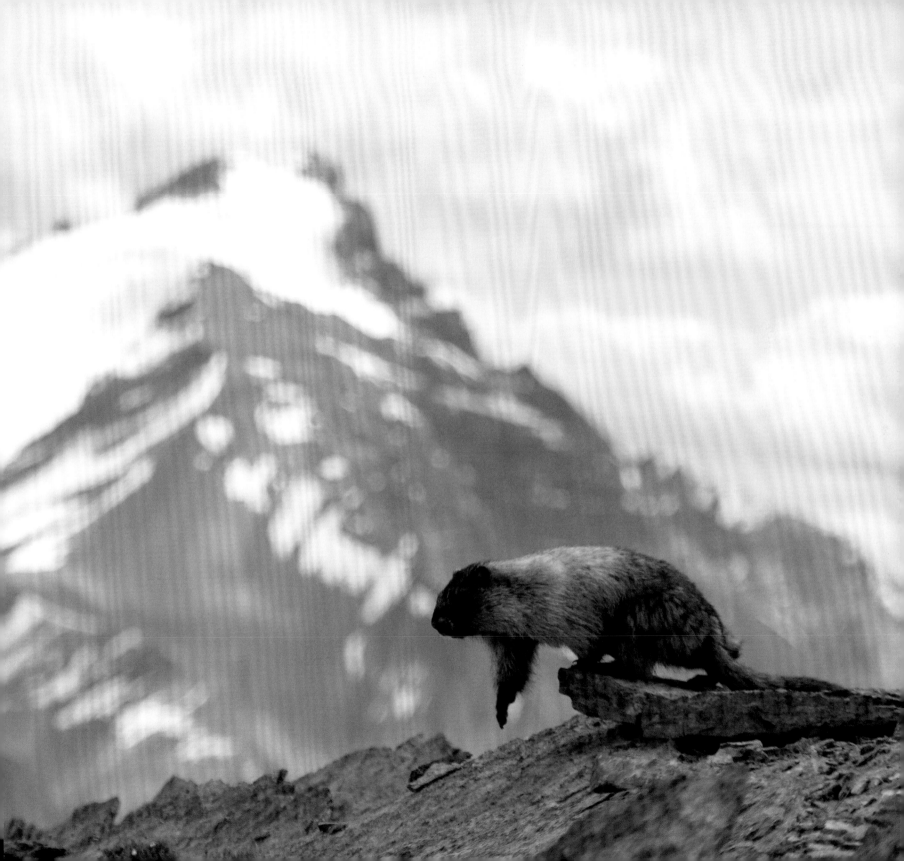

LEFT *The excited calls of American pikas from their homes in talus fields announce the presence of intruders into their world.*

RIGHT *A black bear seeks refuge in the branches of a Douglas fir. In spring, black bears predate on the calves and fawns of hoofed mammals but occasionally fall prey themselves to grizzly bears and wolves, Selkirk Mountains.*

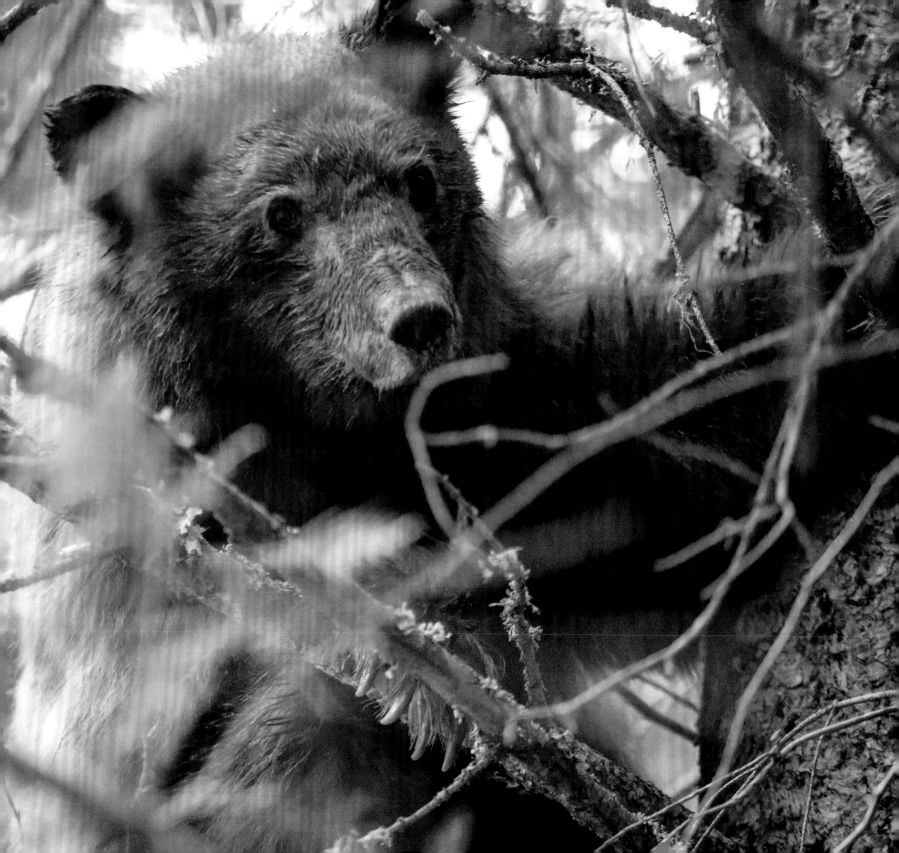

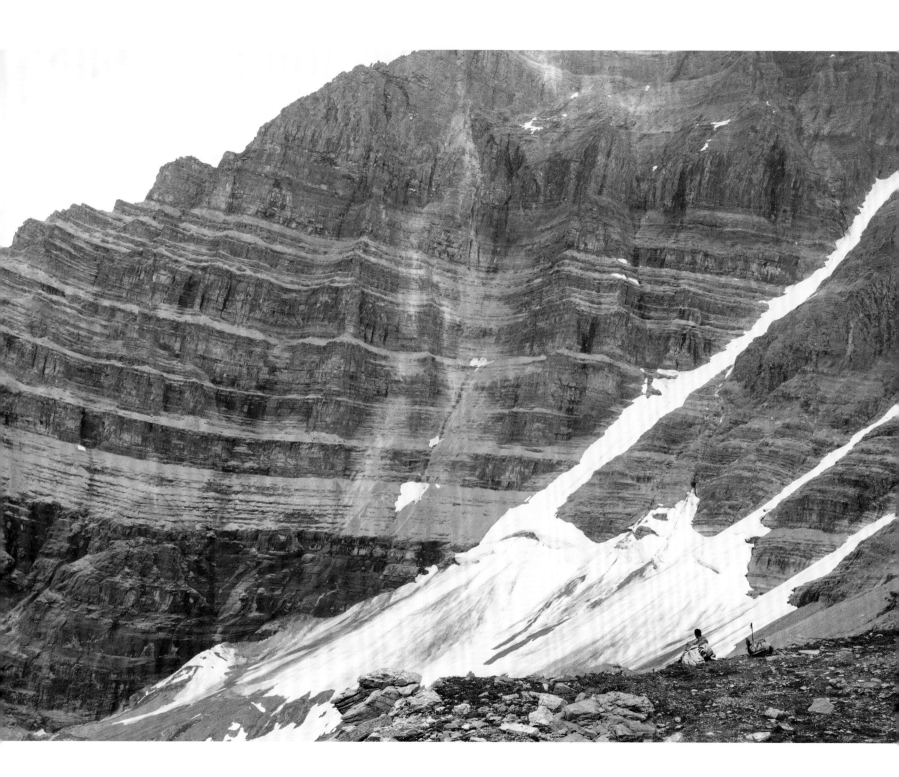

HUMAN DIMENSIONS: THE LANGUAGE OF A LANDSCAPE

With Kim Shelton and Marcus Reynerson

What's the most important to you? My people or the caribou? Or do both of them go together? What happened to them happened to me.

—Vance Robert Campbell, LImixm Ki-x'u-x'us-kit, Sinixt Nation Elder

Landscapes shape people and culture. The rugged topography of the Caribou Rainforest has certainly left its mark on the humans that have made this place home. We need look no further than the reverence for the western redcedar among the native cultures throughout the range of this iconic tree. Similarly, humans shape landscapes. Our ancestors, with far more limited tools than we possess, adapted the world to suit their needs and left their imprint on the places where they lived.

Cultural forces from within and beyond the region shape the contours of this ecosystem in both subtle and profound ways. These forces don't affect just the physical landscape. They infiltrate the human communities of the region and even the lives and hearts of individuals as people attempt to care for themselves

and their families, to respect the cultural traditions they were raised with, and to adapt to the realities of life in an ever more globalized twenty-first century.

According to the most recent theories in Western science, the human history of the Pacific Northwest goes back more than fourteen thousand years, older than the melting of the last of the continental ice sheet in the inland rainforest around twelve thousand years ago. Many indigenous peoples we talked with across the region recognize that their ancestors have lived on this land since "time immemorial," and some retain memories in their oral history of the last ice age and the floods accompanying its dispersal.

According to Roland Willson, chief of the West Moberly Dunne-za First Nations: "We have oral history stories about hunting large animals that when they walked by they had long noses and big white teeth and they shook the ground. They've found mammoth bones here, and they found mammoth bones with flint, broken shards of flint. So our people were hunting mammoth here."

Since the day of the mammoths multiple waves of migrating humans have found their way to the region, including indigenous peoples from elsewhere in North America, such as the Saulteau First Nations, Anishinaabe peoples from the Great Lakes area who arrived as refugees from the colonial invasion farther east and south on the continent. Eventually, European and Asian immigrants arrived, in the form of fur trappers at first, and eventually settlers with their eyes on a mining, agricultural, and timber economy. The most recent wave of immigration to the

On its spawning journey upstream from the ocean, a Chinook salmon leaps in a tumult of white water on the Clearwater River, Cariboo Mountains.

region has been sparked by the growth of leisure time in affluent North American culture. Urban refugees of one sort or another have found their way to the region, leading to a growing ecotourism economy and resulting real estate booms in parts of the region.

With each wave of migration, as is typical of humans on our planet, new arrivals were met with varying degrees of openness or hostility by those who came before. The historical divisions between these distinct epochs of human culture building in the region remain apparent today in the demographics, livelihoods, and contemporary cultural practices found in the region.

The biological uniqueness and diversity of the Caribou Rainforest is matched by the rich array of cultures of the first peoples of this land. Indigenous peoples suffered mightily because of the advance of Western civilization. Along with the transformation of the natural world, which gave birth to the original cultures of the region, the people themselves have been the focus of settler colonial efforts. In a manner as violent and destructive as any contemporary industrial resource extraction, indigenous people were forced from their homes or murdered for the riches of their homeland, harnessed to work for the enrichment of the colonial culture, and subjected to the theft of their intellectual and cultural property for museums and individuals around the world.

VANCE ROBERT (BOB) CAMPBELL, Llmixm Ki-x'u-x'us-kit, is a Sinixt elder who once served as headman for his people in the Arrow Lakes area of the

High camp on the edge of the Robson Glacier, Rocky Mountains

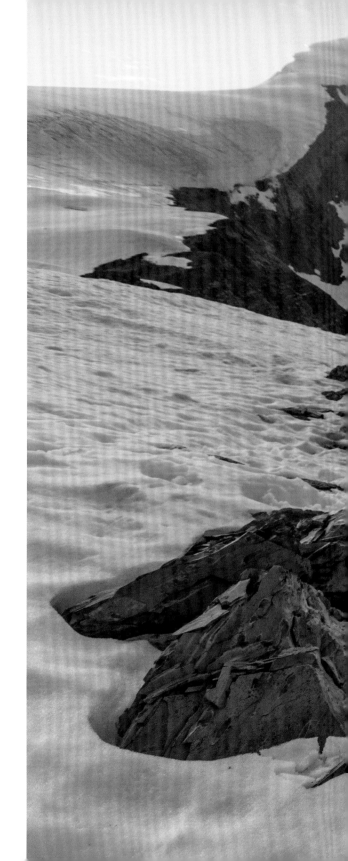

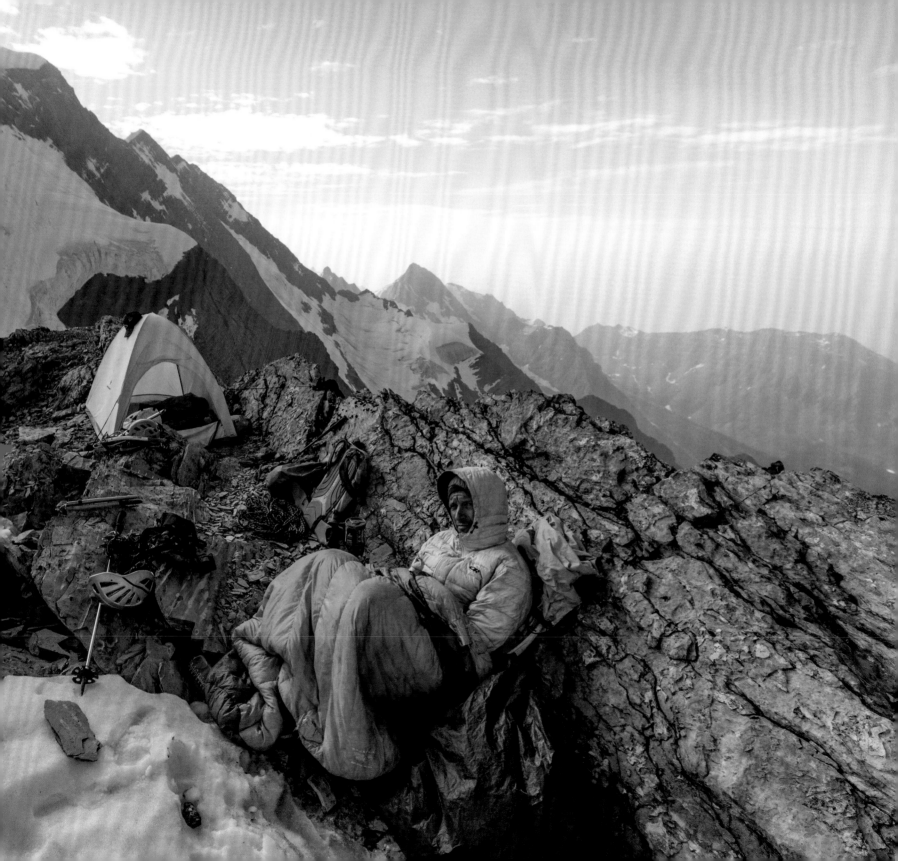

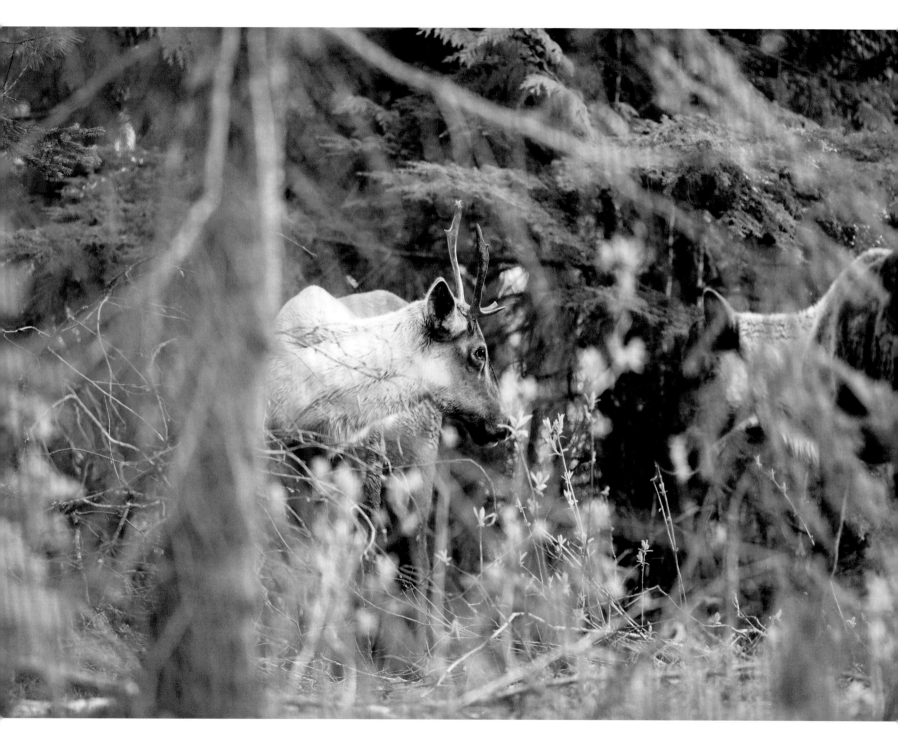

Caribou Rainforest in British Columbia. Sinixt, also known as the Lakes people, is one of the Colville Confederated Tribes that was resettled onto a reservation in north-central Washington. When we spoke with Campbell in his house in a remote part of the Colville Reservation, he often flowed into Sinixt, which he speaks fluently, when the English language fell short.

For him, every question about the mountain caribou, his people's traditional homeland, and the stories of their past leads back to an almost unbearable truth about the fate of not just the wildlife, forests, and rivers of this region but the plight of the first peoples from around the continent in the wake of European settler colonialism. After a lifetime of battling—and Campbell has been quite a warrior for his people—his passion and anger are tempered with resignation and acceptance of the reality of the changes that have forever altered the natural and cultural landscape he and his people call home. "We've been annihilated, we're through, wiped out, it's over for us." Conditions for many on the reservation perhaps support his feelings. According to the Confederated Tribes of the Colville Reservation, their communities often "lack adequate, affordable housing, home water systems, and even electricity."

For both the mountain caribou and the Sinixt, it was gold that spelled the beginning of the end for the way of life they had known for thousands of years. In 1857 the Fraser River Gold Rush began, bringing around thirty thousand American and Chinese miners inland from the coast and up from California in search of gold. Three years later, the Cariboo Gold Rush, named after the Cariboo Plateau and its then abundant mountain caribou, began in earnest. This influx of settlers and subsequent conflicts led to the first appointed politician of British Columbia and the recognition of the region as a British colony.

The mountain caribou's subdued predator response did not mix well with the hungry bellies of men lacking the cultural moorings to dictate a sustainable harvest. The caribou were hunted to comparatively miniscule numbers by the miners.

The Sinixt, who depended on these caribou for food in times of need, also suffered at the hands of the miners and settlers. Rape of native women was common. Many indigenous peoples were killed or died of disease or starvation. Others attempted to flee the apocalypse that had befallen their homeland, now a point of contention for Campbell and other surviving Sinixt people, given that Canada asserts that the Sinixt abandoned their territory of their own free will.

In 1956 the Canadian government declared the entire Sinixt nation extinct after a census found that no members resided in one of their traditional villages in the Arrow Lakes area. This census did not include all living Sinixt members in their entire traditional land, which ranges as far south as Kettle Falls, Washington. Declaring the Sinixt "extinct" was the most blatant example of the total exclusion of all First Nations and Indian Tribes from the Columbia River Treaty negotiations that resulted in the flooding of huge tracts of the Caribou Rainforest. Tribes on both sides of the border are demanding a seat at the table as the treaty is renegotiated.

OPPOSITE *Mountain caribou in low-elevation rainforest in spring, Selkirk Mountains*

Campbell responded to the idea that his people just got up and left their homeland one day with a wry smile thinly veiling the anger and pain it has caused his people:

> *For us to leave of our own free will, happily? That's bizarre. 'Cause did the* stililcha *[caribou] leave happily? The caribou, thousands of them, did they leave, just leave? No, they were murdered, every one of them, and we were murdered. And right to this day, people don't want to admit it! And yet it's written in history, about the gold miners goin' right through our territory ... all them* stililcha *got wasted just the same as the buffalo. ... Me and him [caribou], we share the same rape and destruction.*

Even as Campbell lamented the treatment of his people, members of the Sinixt Nation continued to battle for legal recognition by the Canadian government.

"I HAVE TO ENSURE THAT there are caribou here for my grandchildren to see, not just to read about in books. We have to ensure that the landscape is intact," shared Harley Davis, former chief of the Saulteau First Nations, while we sat around a fire in the Hart Ranges. Through our time spent with leaders, elders, and other members of numerous indigenous groups in the region, we got a glimpse of the unique perspectives and customs of the people. We also encountered similarities among these groups born out of a shared and profound connection to place—connections so ingrained in their culture that they cannot be separated into either religion or government. In the words of Gary Aitkin Jr., Chairman of the Kootenai tribe of Idaho:

> *This land here is very sacred; we were put here to take care of it. That's what we were told by Creator; that this land is here for you to use. As long as you take care of it, it will take care of you. So it's something we hold in high regard, it's something we are taught when we are young. And we do our best to try to keep our part of the covenant. It's our covenant with the Creator . . . everything that we do, we try to do in a good way that will benefit the 7th generation coming up.*

It was with this belief in mind that the Kootenai entered into an agreement in August 2015 with the US Fish and Wildlife Service to create a recovery plan for the Southern Selkirks herd of caribou, a source of cultural identity for these people just as it is a symbol of the ecosystem itself.

Leaders of indigenous nations throughout the Caribou Rainforest share a sense of responsibility to defend the beings within their traditional homeland. This defense is grounded in a particular kind of intelligence that acknowledges lineage and reciprocity. "Our elders have told us: the caribou were there for us, and now we need to be there for the caribou. And that's how we wound up in this situation where

we're running a recovery program for the caribou," explained Roland Willson.

The Saulteau and West Moberly Dunne-za First Nations are both signatories of Treaty 8, the largest and most comprehensive treaty Canada has with indigenous peoples, dealing with lands in northeastern British Columbia, northern Alberta, northwest Saskatchewan, and the southern portion of the Northwest Territories. Created in 1899, it made several assurances to the First Nations within its geographic bounds including that "the treaty would not lead to any forced interference with their mode of life" and that "they would be as free to hunt and fish after the treaty as they would be if they never entered into it."

In 2011, a British Columbia court ruled that resource extraction in the West Moberly First Nations' traditional territory violated Canadian treaty obligations, which allow that nation to hunt caribou on these lands. This litigation and subsequent conservation efforts have begun to force Canada to honor treaty obligations—though far from perfectly. "We have rights that we are entitled to. We have the right to hunt, trap, and fish, but we also have the right to practice our culture and the spirituality of who we are," said Naomi Owens, Treaty and Lands

TOP *Biologist Naomi Owens helps capture a mountain caribou as part of a joint effort of the West Moberly and Saulteau First Nations to pen pregnant females and protect them and their calves.*

BOTTOM *West Moberly Dunne-za First Nations chief Roland Willson is an outspoken advocate for his people and their traditional territory.*

director of the Saulteau First Nations. "We're basically 'pen warriors.' . . . We're writing a lot of letters to government and industry stating these are the cumulative effects and this is what you are impacting. So that's the best we can do at a political level as a small government."

South of the area covered by Treaty 8, the majority of the Canadian portion of the Caribou Rainforest has never been legally ceded to the Canadian government. There are no treaties between Canada and the First Nations of this region and, as such, according to international law, these lands still belong to the indigenous peoples of a place. British Columbia, the Canadian government, and the First Nations of the region have been involved in a game of chess as they work to find a way to resolve this issue.

A desire to defend their legal rights as well as protect their cultural heritage led to the development of the Klinse-za maternal pen, which protects pregnant cows and newborn calves from predators, and aims to lower the mortality rate overall for mountain caribou. Willson explained that the idea for the project initially came about because he wanted to know if he or his children could sustainably hunt and eat caribou in their lifetimes. The resounding answer was *no*—not unless a huge effort was made to bring the caribou numbers back up. "Our right to harvest caribou has been extinguished. To be a conscious aboriginal person we . . . stopped hunting the caribou." As he explained: "In order for us to take, we have to give. We have to keep the balance, and doing this work, as small as it is, is doing that."

Known locally as kokanee or redfish, landlocked sockeye are the only salmon left in the southern portion of the Caribou Rainforest since the Grand Coulee Dam blocked access to the Pacific Ocean.

The maternal pen project initially met resistance from the British Columbia government, who, according to Willson, would "be quite happy if the caribou disappear." Willson regards this resistance as an example of the provincial government's indifference, not just to the plight of caribou but to his people as well. "We're not as interested in mining the coal or exploiting the oil or gas that's in the ground. We're concerned about the caribou because that's something that we live on, we sustain ourselves on that. And if that disappears, how much longer before we disappear?" On the verge of tears, Willson went on: "I haven't shot a caribou and I won't shoot a caribou in my lifetime here. But I hope my grandchildren can. And I hope they can have the honor of experiencing what caribou are."

For Willson, Owens, and their people, to hunt and eat caribou means staying connected with lineage and culture. Sustaining a flourishing cultural connection to the land relies on having healthy ecosystems. Resource extraction on the scale the colonial governments of the states, provinces, and countries in the Caribou Rainforest currently allow is not conducive to protecting the integrity of their traditional territories in the eyes of a number of indigenous groups. Willson sees this situation as more than just a material threat to the Dunne-za. "They tried the assimilation; that didn't work. Now, I think it's cultural genocide. They're . . . forcing us off the land, they're forcing the animals off the land so that there's nothing here to be called Dunne-za anymore."

WHILE THE DESTRUCTIVE IMPACT of settler colonialism on the landscapes and the indigenous peoples of this continent is well documented, those of us with settler ancestry are not immune to its effects. This impact manifests in different ways across the economic and cultural spectrum of the Caribou Rainforest and beyond. It shows up in the rural working-class communities making a living from these resource extraction industries, as well as among the outdoor adventurers who mostly relate to these landscapes through recreation and a desire for solace from the ever-increasing pace of modern life. And it shows up in the everyday lives of people far away from the region, whose choices and actions depend on resources from these landscapes.

While heading into the mountains to photograph an active old-growth logging operation in 2016 in the northern Selkirk Mountains, we met Dwayne Paige, a wiry, energetic fifty-five-year-old logging operations supervisor who has been working in this part of British Columbia for twenty-five years. Paige was operating a large machine designed to load logs onto trucks, and he jumped out to chat with us. We asked what the work was like for him, and he cheerfully regaled us with stories about the operation he was just wrapping up after working in this particular valley for a few years. He talked about the "big wood," huge old-growth cedars, they had logged lower in the valley.

Resource extraction takes its toll not just on the land but also on the bodies and hearts of the humans who work in the industry. According to Paige, the long days and dangerous work have led to substance

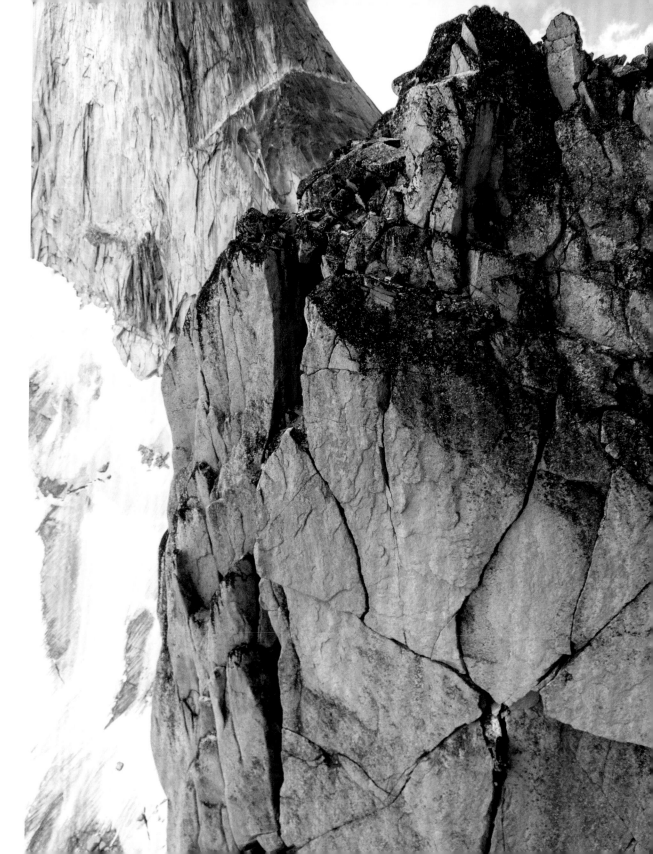

Climber near the top of Crescent Spire in the Bugaboos, a subrange of the Purcell Mountains

abuse in the industry. He shared tales about people showing up for work under the influence of alcohol, drugs, or both. "I'm working away and all of a sudden I couldn't figure out why the rigging wasn't moving," referring to a high-lead yarder used to bring logs down the mountain attached to cables, a dangerous operation in the best of conditions. "I go up, it was a ninety-footer, and there was a guy [the operator] sitting there with a needle hanging out of his arm," dead from a heroin overdose. In a field where the work is demanding and dangerous, Paige lamented needing to police his employees' behaviors, performing "smell tests" and sending people home without wages for the day if they are under the influence.

These harsh conditions aside, oftentimes, in the rural communities of the Caribou Rainforest, there are few options other than logging work. Also, according to Paige, entry-level positions don't pay well so younger people are leaving the region to find higher paying jobs elsewhere. "There's no money. There's no classes they can take, and we have to train them and they don't get

TOP *Marilyn James of the Sinixt First Nation stands in the foundation of a prehistoric pit-house constructed by her ancestors on the banks of the Slocan River or Shulk'n (pronounced SHLU-keen) in Sinixt in the Selkirk Mountains. This village site was occupied for more than three thousand years. Since Canada declared her people "extinct" in 1956, they have been denied any say in determining the use of their traditional territory.*

BOTTOM *A recent clear-cut in the Selkirk Mountains, part of the home range of the last few caribou to also use Canada's Glacier National Park*

OPPOSITE *The scar on this cedar tree is from historical bark collection by the indigenous people of this region in the Monashee Mountains. Cedar bark is used to make everything from clothing to baskets.*

that. When we were younger, we were brought up to respect that we had to work hard to get there."

It is not all drudgery out there, though. After decades Dwayne Paige clearly still loves it. "It's a nice job if you like being out in the bush. . . . I mean, look at our office," he said, with outspread arms. We met several individuals who work in the timber industry, including mill managers, foresters, and loggers, who conveyed their love of working in the woods in this traditional profession.

Just up the valley from Paige's operation, we watched David Walker felling trees for half a day. At one point, after felling a large cedar, he shut down his saw and sat down on the stump to take a break. Looking out over the cloud-draped glacier-clad mountains around us, he shared stories about the wildlife of the valley that he has seen. Later on in the day, he called us over with the excitement of a little boy to show us a huge western toad he found. After taking the toad up the hill away from the trees he was felling, he cranked up his saw and took down an old-growth western hemlock bound for the pulp mill.

Experiences like this one are not easy to put in a box. Indeed, the ways that we are choosing to live in the modern world, even those of us who advocate for the protection of these forests, have real impacts. Kate Devine, who lives in Revelstoke and spends part of the year working in the timber industry evaluating stands of trees slated for logging, said: "It's easy for someone to sit in a 5,000-square-foot timber-frame house and say you shouldn't log anymore." Devine, who spends her winter as a ski guide working with

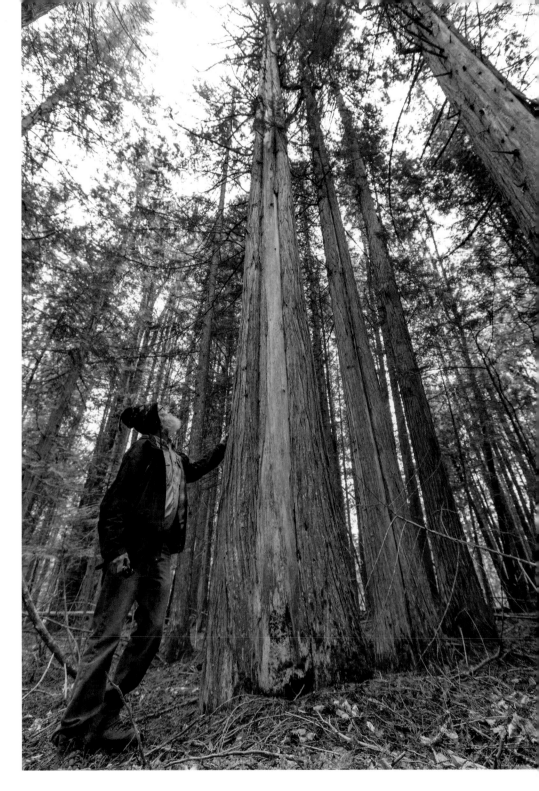

clients from all over world, continued: "People have to realize where the stuff they want comes from. Maybe you don't want it to come from your backyard, but it's got to come from somebody's backyard."

IF WORK IN THE TIMBER INDUSTRY is a mixed bag for the people working in it, its long-term value for rural communities is similarly fraught. Erik Milton, a longtime resident of the Clearwater Valley in the Cariboo Mountains, leads a local conservation effort to promote nontimber-focused land use in the region. For decades he and friends have been fighting logging of old growth in the region by the Canfor Corporation, which has exclusive rights to log on public lands in the area. Milton said: "I like to say that Canfor is in the export business and they export two things out of our community. One is [wood] fiber and the other is money. The profit they make doesn't stay here; it goes away. People all over the world are making money from this valley."

For Milton, it would be a different story if the local communities were feeling the benefits of the money being made from logging. Pay in the industry is often the highest wage folks can make in much of the region, and every logger we asked said this was the primary reason they were working in the profession. But there is no structure in place to help keep the monetary value of these trees within the region they come from. And this issue is not isolated to Milton's Clearwater Valley. "In the North Thompson Valley, they've been logging up there for quite a while and a lot of money has come out of there, but if you drive

Old-growth logging in the Selkirk Mountains

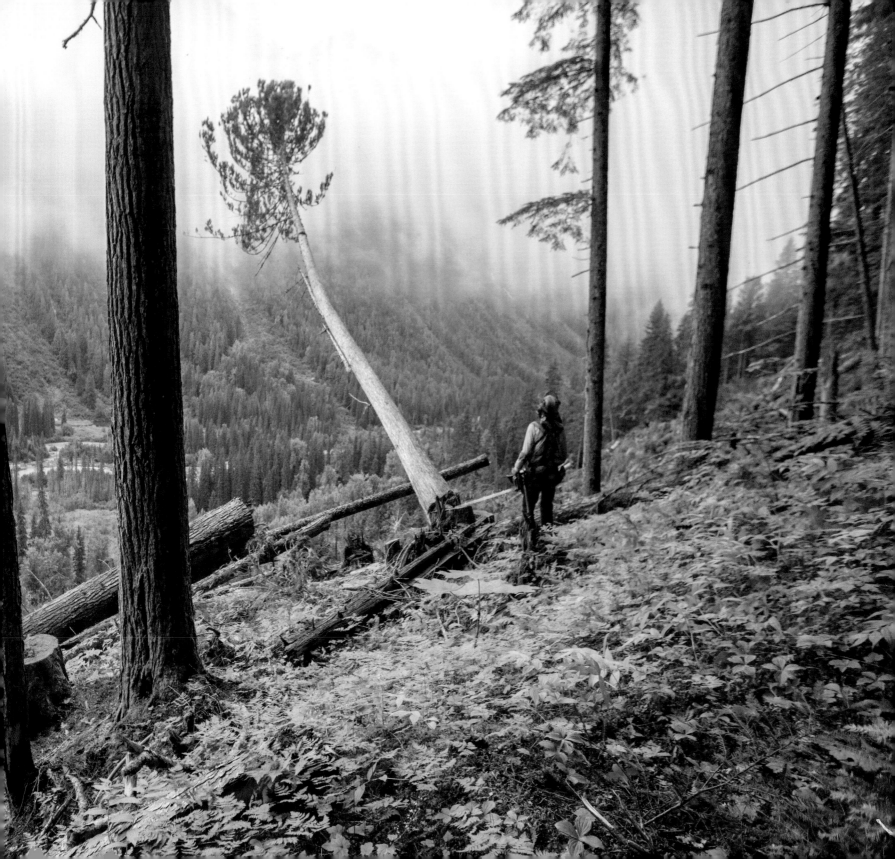

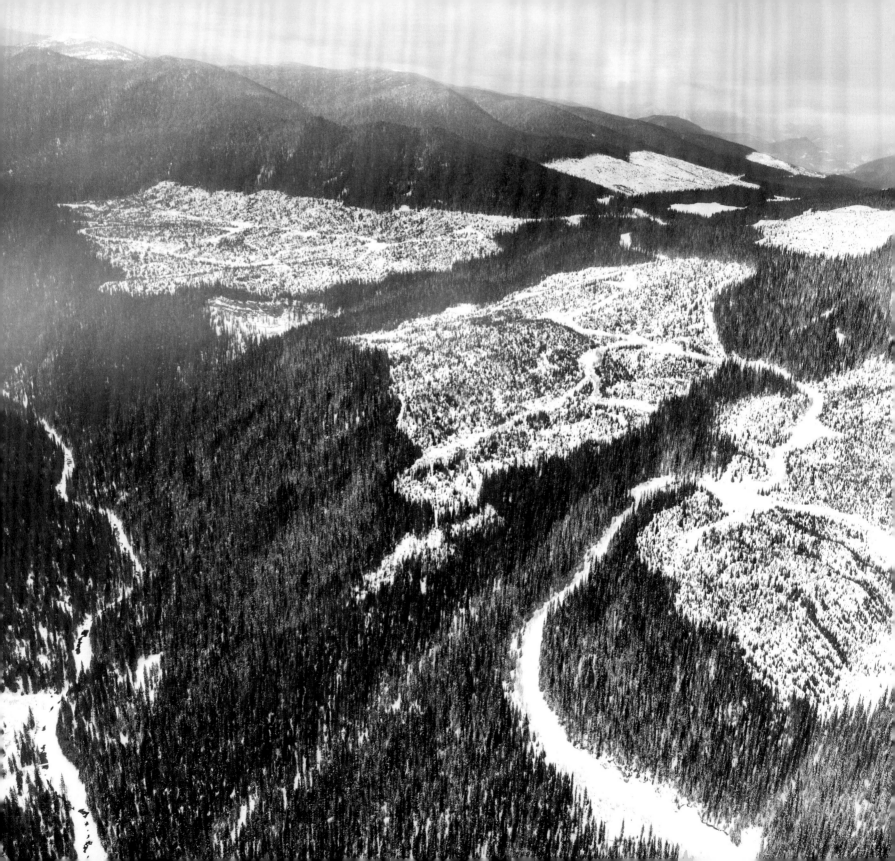

through that valley and look at the communities, you would never know."

While the timber industry blames conservation measures restricting their access to the trees for the economic hardships of rural communities, global economic trends are playing at least as big a role. As Rami Rothkop, mill manager for Harrop-Procter Forest Products, said, "British Columbia has some of the finest timber in the world, yet it has one of the lowest employment rates for the amount of wood we cut." Indeed, British Columbia cuts more than two and a half times the volume of wood as Quebec while employing fewer people, and Ontario cuts about one-fifth the volume of wood as British Columbia while employing nearly the same number of people. "We have the lowest number of jobs per volume of wood harvested of any province in Canada, perhaps of any jurisdiction in North America," according to Erik Leslie, forest manager for Harrop-Procter.

With little investment in using the current value of the forests to prepare communities for the day when all their original forests have been cut, and with a rate of cutting that will leave the landscape without enough second growth to sustain the current industry infrastructure for decades in many places, the future of current logging communities looks bleak. One has only to look to Washington State to see what happens when the old-growth timber industry goes dry.

Not four decades ago, Washington's Olympic Peninsula considered itself the logging capital of the world. But between 1988 and 1997, with the vast majority of the old growth already liquidated, logging

Patchwork, high-elevation clear-cuts like the ones shown here in the Hart Ranges fragment the refuge habitat that mountain caribou depend on.

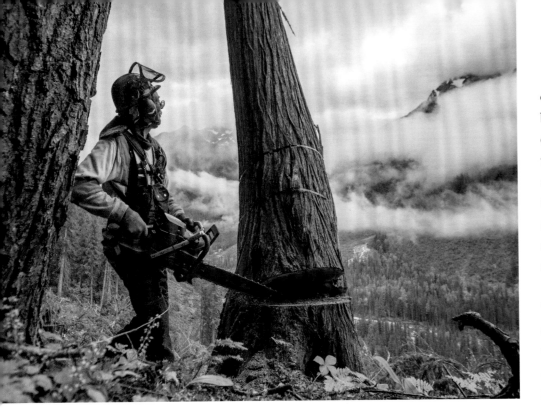

on federal land in the US Pacific Northwest dropped by 87 percent in the aftermath of the wilderness preservation battles and the endangered species listing of the spotted owl. Towns where the mills closed down and the population decreased abound not just on the Olympic Peninsula but also across the inland rainforest in Washington, Idaho, and Montana. Main streets of logging towns now commonly have more vacant storefronts than active businesses.

THE CARIBOU RAINFOREST is home to at least seven culturally unique indigenous groups, all of whom speak individual languages that are dialects of larger language groups. The Ktunaxa nation, however, comprised of seven bands, including the Kootenai tribe of northern Idaho, speaks a distinct language, unrelated to and unlike any other language in the world. With fewer than one hundred people who can speak it, the threat of extinction is real.

All indigenous nations within mountain caribou range share the threat of extinction to their language. The residential and boarding school era in the United States and Canada from the 1860s to the 1970s robbed most indigenous families of their opportunity to pass on their language, a vital part of their culture, to the children. Forcibly removed from their homes and made to speak English or be punished, indigenous children were raised with limited access to their own

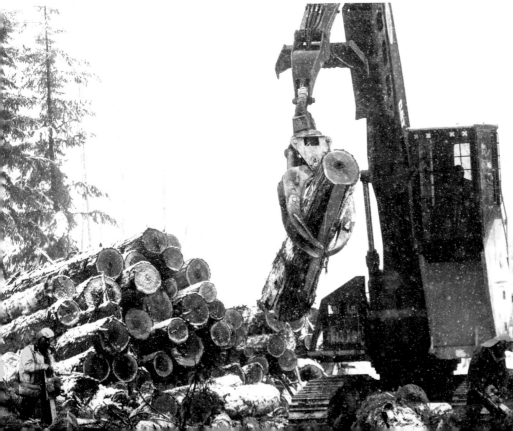

TOP *Western redcedar being felled in the Selkirk Mountains*

BOTTOM *Loggers buck and stack cedar logs during a winter old-growth logging operation in the Selkirk Mountains.*

COLUMBIA

> It's a war ... and we have a dug in enemy that won't change their ways. ... We've been here 10,000 years; we're not going anywhere. We're gonna be here long after the province is done raping and pillaging the resources out of this land, and we're the ones gonna be here cleaning up the mess that they've made.
>
> —Roland Willson, chief of the West Moberly Dunne-za

Perhaps nowhere is the power of language colonialism more powerfully represented than in one name that lies over the Caribou Rainforest like a dark shroud, heavy with five centuries of genocide, ecological devastation, and a colonial culture still largely blind to the reality of their own history: Columbia.

In the second half of the eighteenth century, North American colonists were starting to distinguish their identity from that of Britain. At that point, European countries commonly used Latin names to refer to particular countries in a formal context, and in many cases, these nations were personified as pseudoclassical goddesses. *Columbia* was an attempt by the colonists to adhere to this custom, and pay tribute to the "founder" of the continent, Christopher Columbus. Columbia eventually became the name representing the Americas, and eventually specifically the United States.

British Columbia derived its name from the *Columbia Rediviva*, an American ship that first explored the Pacific Northwest region via the "Great River of the West" in 1792, and eventually bestowed the ship's name upon the river, the Columbia, as well as the greater region it drained. Queen Victoria eventually named the Canadian region British Columbia in 1858 to distinguish it from the American jurisdiction of the Columbia River region to

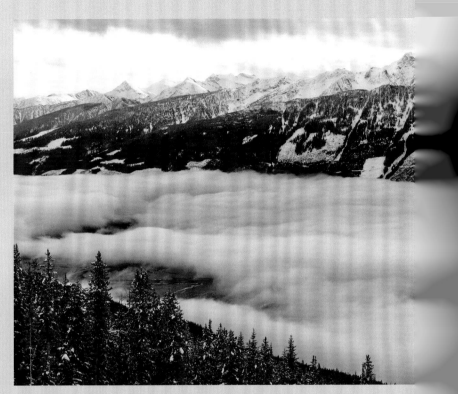

The Illecillewaet River meanders beneath low clouds close to where it joins the Columbia River in the Selkirk Mountains.

the south. From these original names flowed the naming of the Columbia Mountains, where the Columbia River originates.

The image of the personified Columbia, though expressed differently at different times, was most often a young woman wearing classically draped garments. In the nineteenth century, Columbia would be visualized as a female personification of the United States, eventually becoming an image representing the doctrine of Manifest Destiny—a widespread belief that Americans had divine sanction and moral imperative to expand across the continent to the Pacific Ocean and spread their virtuous ways. This doctrine was influential in land acquisitions leading up to the Treaty of Oregon in 1848, which brought the Columbia River region into the United States.

—Marcus Reynerson

language, customs, spirituality, and the land of their ancestors, as well as their parents and families.

"Colonization, we know, attempts to replace indigenous cultures with the culture of the settler. One of its tools is linguistic imperialism, or the overwriting of language and names," writes Robin Wall Kimmerer, distinguished teaching professor and director of the Center for Native Peoples and the Environment, at the College of Environmental Science and Forestry in Syracuse, New York. Destroying a culture's language can undermine their very ways of knowing and perceiving their world. For many indigenous cultures, Kimmerer says, "We know a thing when we know it not only with our physical senses, with our intellect, but also when we engage our intuitive ways of knowing, of emotional knowledge and spiritual knowledge."

Employing only the colonial language, English, to translate our reality, people are forced into the limitations of the worldview inherent within that language. Kimmerer suggests that one of the roots of the biological and cultural destruction that is laying waste to the Caribou Rainforest and so much of the world can be traced to one small word in the English language: "it." She writes:

> *Using 'it' absolves us of moral responsibility and opens the door to exploitation. When Sugar Maple is an 'it' we give ourselves permission to pick up the saw. 'It' means it doesn't matter. But in Anishinaabe and many other indigenous languages, it's impossible to speak of Sugar Maple as 'it.' We use the same*

words to address all living beings as we do our family. Because they are our family.

With only the word "it" to relate to the nonhuman beings around us, other creatures are denied the animacy that suggests the possibility of a reciprocal relationship. Kimmerer explains: "If you're visiting your sweet grandma and she offers you homemade cookies . . . you know what to do. You accept them with many 'thank-yous' and cherish the relationship. . . . You wouldn't dream of breaking into her pantry and just taking all the cookies without invitation. . . . That would be at a minimum a breach of good manners, a betrayal of the loving relationship." A language that identifies all other-than-human beings as "its" lends itself to the objectification of Earth. "We don't need a worldview of Earth beings as objects anymore," states Kimmerer. "That thinking has led us to the precipice of climate chaos and mass extinction."

Language is also needed to protect biodiversity on another level. Language affects our ability to see diversity. The technical terminology that accompanies any area of specialized knowledge is the product of practitioners' work to create language that reflects their intimate knowledge of the subject. Who are the specialists of the Caribou Rainforest who have developed the language for this place? Perhaps it is the people who have lived in and studied this place for thousands of years. As Mark Dowie, author of *Conservation Refugees: The Hundred-Year Conflict between Global Conservation and Native Peoples*, writes "Enlightened conservationists are beginning

OPPOSITE *A truck driver secures a load of small cedar logs from an operation in the southern Selkirk Mountains.*

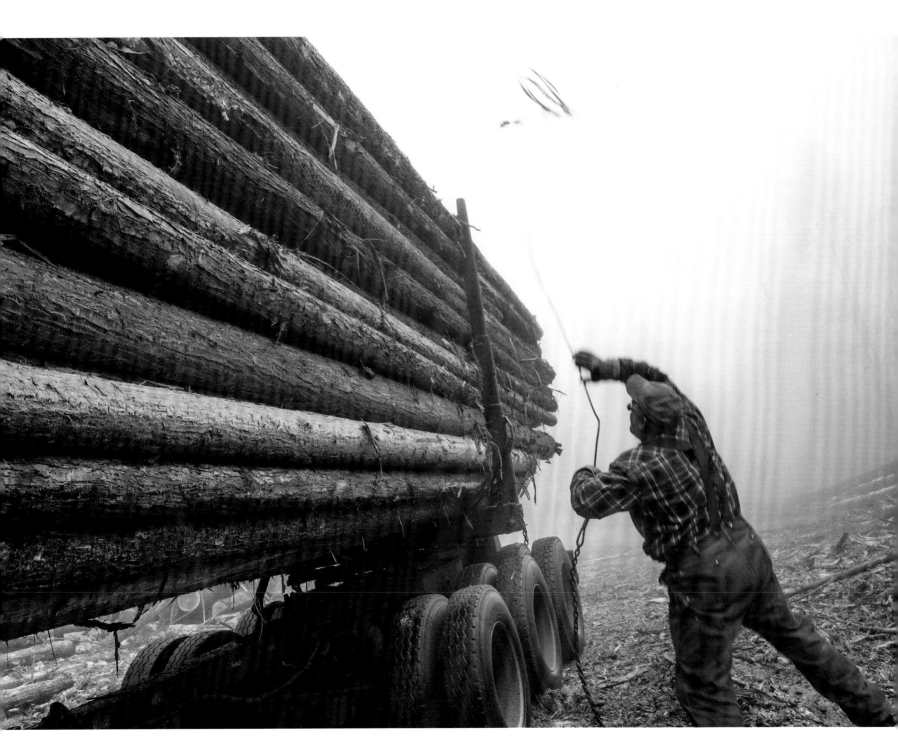

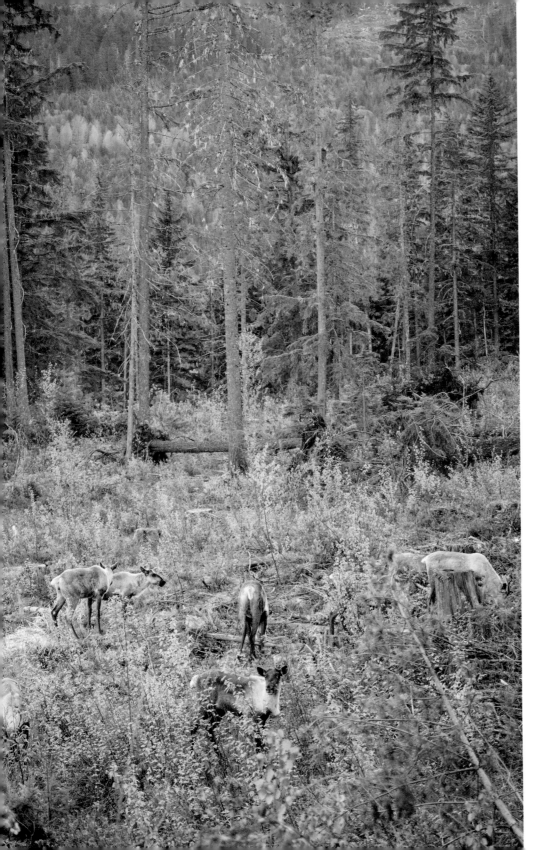

to accept the axiom that only by preserving cultural diversity can biological diversity be protected, and vice versa."

Recent language revitalization efforts by indigenous peoples in the Caribou Rainforest strive to clarify the essence of what language means to the people. The Secwepemc (pronounced she-KWE-pem) people state:

> *The language connects the land and the people. The language contains the mental, physical, and spiritual connectedness of the Secwepemc to the land. It protects and maintains all forms of Secwepemc knowledge. It keeps the people whole and connected to the Creator. It maintains the Secwepemc responsibility to the land. The language contains traditional ecological knowledge needed to protect biodiversity and it is used to transmit all forms of knowledge to future generations.*

BEFORE LENNY EDWARDS FOUND his way into a job caring for caribou mothers and their calves at the Revelstoke Maternity Pen, he had spent a large part of his adult life working as a logger. A member of the Splatsin band of the Shuswap First Nation based in Enderby, British Columbia, Lenny as a younger man traveled from home to work farther north in the province. One of his more memorable jobs was cutting

Mountain caribou feed in a clear-cut in the Selkirk Mountains.

AT WORK IN THE WOODS: HARROP-PROCTER COMMUNITY FOREST

At first, the sleepy towns of Harrop and Procter, accessible only by a tiny ferryboat on the West Arm of Kootenay Lake, seem like an unlikely location for the start of a modern-day forestry revolution. But when you learn that the managers of the local timber company and sawmill had been part of actions to blockade logging roads in the same landscape where they now plan timber harvest units, you quickly realize that something very unusual has occurred here. Tucked in the southern Selkirk Mountains, a progressive experiment in community-based forestry and watershed management has been under way for the past twenty-five years.

In the late 1970s local residents of the area became alarmed at plans by the BC Ministry of Forests for large-scale industrial logging in the watersheds that provided drinking water for their community. For nearly two decades, members of the community fought for a voice in the planning process for public lands surrounding their home. After numerous setbacks and failed attempts, in 1999, the Harrop-Procter Community Cooperative was officially incorporated, along with its subsidiary, Harrop-Procter Forest Products, to manage a 28,000-acre (11,330-hectare) Community Forest license granted to the group by the province of British Columbia.

"Five or six very large forestry companies control three-quarters of crown land in British Columbia," said Erik Leslie, the forest manager for Harrop-Procter. "There is a long history of local folks in the province not being happy with the tenure set up and wanting to have more control. If it's a multinational corporation . . . they are responsible to

Erik Leslie, left, discusses forestry operations for Harrop-Procter with two board members of the Community Forest at their office in Procter, British Columbia.

their shareholders and their shareholders live anywhere in the world. Whereas, by definition, in a community forest the shareholders live here in the community, so it's a completely different system."

According to British Columbia's Community Forest Association, "At its core, community forestry is about local control over and enjoyment of the monetary and non-monetary benefits offered by local forest resources," with a specific focus on social, ecological, and economic sustainability.

A substantial part of the area within Harrop-Procter's tenured area is set aside as caribou habitat by the province. Other parts of the area have been set aside by Harrop-Procter itself to protect the integrity of their watershed. With all of the models for the region predicting increasing wildfire hazards in these mountains, Leslie's chief concern in planning logging operations is building resilience into these forests for the large-scale climate shift in progress in the region.

"We measure success in meaningful local work," said mill manager Rami Rothkop. The incorporation of a small mill into the business structure of the Harrop-Proctor Community Forest allows the company to create value-added products from many of the trees they harvest and increase the number of local people employed. Rothkop noted that Harrop-Procter runs about the same amount of wood through their mill in an entire year as some of the largest mills in the province do in a single eight-hour shift, while both mills employ about seven people for running the mill. According to him, while this might seem "inefficient" on one level, it also means that you need to cut far fewer trees to create the same number of jobs in the local community. This approach also gives the business the opportunity to be more selective in what, where, and how they log in the watersheds that not only provide them with trees for the mill but also their drinking water, and provide habitat for mountain caribou and many other species of wildlife.

In reflecting on forestry writ large across the region, Rothkop commented, "I don't think it is an issue of the level of cut. It's what we are doing with the wood. Is that really serving communities?" While community forests like Harrop-Procter make up only a small portion of the timber harvest allotment on public lands in British Columbia (about 2 percent, according to Leslie), they represent a significant move toward connecting local communities to managing the forests that make up the watersheds and forests in which they live. They put a mandate for social and environmental values centrally into the matrix of how logging operations are designed and implemented.

right-of-ways for powerlines and pipelines through the dense forests of the region. He recalls cutting huge old-growth trees, western white pines five feet in diameter, trees that are rare now and extremely valuable. But none of the trees he cut to clear ways for lines ever made it to a mill; they were cut into sections and burned on the spot.

Now, along with looking after caribou during the early summer while they are in the maternity pen, Lenny is happy to work as an environmental monitor for his band, reviewing planned logging operations, looking for sites of cultural sensitivity to his people, and observing projects once they are under way for compliance to environmental regulations. Regarding his work with caribou, Lenny said, "It's a job for the future. [Hopefully] kids will see caribou maybe. I remember my grandfather saying they'd eat caribou. ... There's not that many so it's not a food source any more, but it's still one of our traditional animals, so it's something worth saving."

During the 1800s and 1900s, many American and Canadian parks were formed. Today, they stand as hallmarks of our society's conservation ethic. Intending to keep these pristine natural wonders in a "state of nature," the US and Canadian governments forcibly removed in numerous instances the indigenous communities that lived on these lands or access to hunt, fish, gather, or carry out other traditional activities. Both the capitalist economy that modern

OPPOSITE *Mountain caribou forage in early winter snow in the Hart Ranges.*

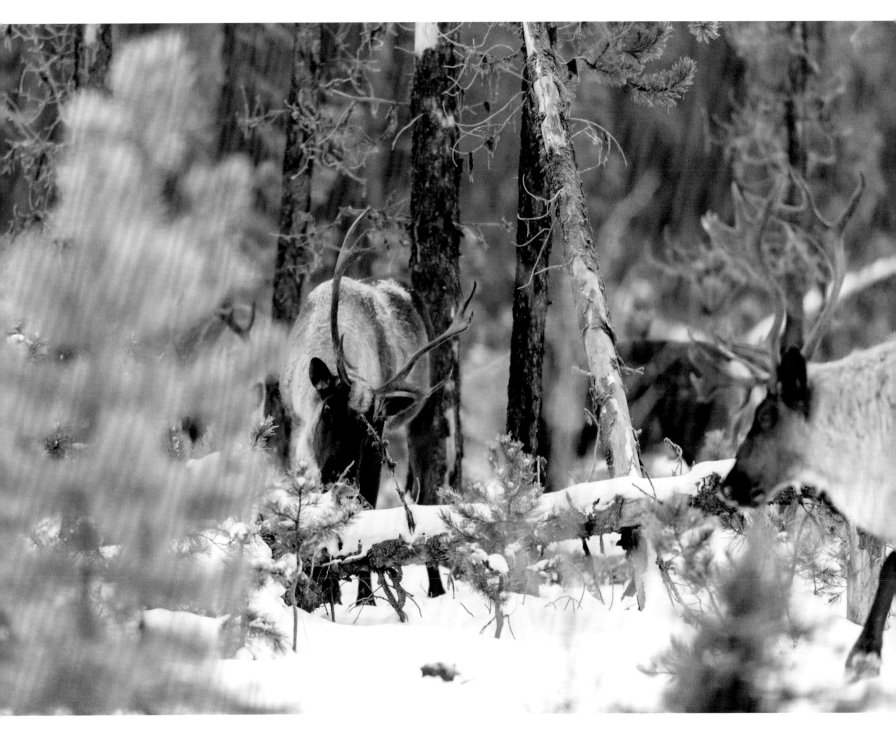

Western civilization is built on and the conservation idea that nature must be protected by removing humans from it flow from a worldview that sees people as separate from everything else in nature. In recent years governments have taken steps to reconcile native peoples' rights to carry out traditional activities within park boundaries.

Many people living and working in the Caribou Rainforest are struggling to resolve the dilemma created by these two parts of settler colonial culture's relationship to the natural world. On the one hand, there is a strong desire to protect, preserve, and enjoy the natural heritage that creates a sense of identity for the people of this region. On the other, there is a real need to earn an income and survive in the modern world through work that often contributes to the behaviors degrading the region. Harley Davis said:

I've been a logger, I've felled trees, I've worked at the pulp mill and as a chief . . . I fought for the rights of not only the members but for the wildlife, for the landscape, for the environment. But at the same time trying to generate revenue so that you can pay for the programs that the kids need, that the elders need, they all need support too. So it's a tug of war, but I guess the most important thing is . . . you've got to try to find a balance.

As this ecosystem has become more fragmented, and the natural capital degraded and exported, the resulting impacts can be felt broadly. While some of the impacts are extremely concrete—when the trees are gone, the mill closes and the corporation moves on—others are far more subtle in the short term. The "capital" that exists in these landscapes is more than just economic; it is cultural. Stuck inside the confines of the language and structure of the colonial society that created this dilemma, everyone is trapped trying to find a way out of this double bind.

Perhaps the hard-found wisdom of the cultures that have suffered the most can provide inspiration for a path forward. From a starting point of a reciprocal rather than extractive relationship with the world around us, we can build a vision of ourselves as members of a community of living beings who must work together for our collective good.

Despite all of the destruction it has wrought, modern civilization has demonstrated a huge creative capacity to learn, change, and grow. We have the power to chart a different way forward.

OPPOSITE *Arboreal lichens cling to rainforest trees as Colin Arisman skis cold powder snow in the Monashee Mountains.*

THE PATH AHEAD: REFLECTIONS ON GRIEF AND HOPE

The world is no better than its places. Its places at last
are no better than their people while their people
continue in them. When the people make
dark the light within them, the world darkens.
 —Wendell Berry, "A Poem on Hope"

It is hard for me to express in words the tremendous gratitude I feel to have had the opportunity to explore the Caribou Rainforest so intimately. The photography in this book is a visual love letter for this place. Looking at these images, remembering the experience of capturing each one in the field, I also have the feeling of being part of the rainforest, looking back at myself among the mountains, trees, and wild creatures.

This project has also been one of the most heartbreaking experiences of my entire conservation career. Barring some extraordinary changes in global economics and regional politics, the fate of mountain caribou across much of their range looks grim. Even if efforts to end old-growth logging in British Columbia pick up steam, in many ways we are now fighting over tattered remnants of a vast ecosystem that once

OPPOSITE *Starlight, the aurora borealis, and the beam from my headlamp blend to light up a fall night in the Selkirk Mountains.*

appeared endless. Behind the proud voices of indigenous peoples, standing up to assert their rights in the face of continued subtle and overt racist colonialism, are communities still staggering under the weight of past campaigns of extermination and assimilation. In the northern portion of the rainforest, the orgy of resource extraction continues. Ghost towns on the US side of the border, where the lumber mills shut down decades ago, foretell the fate of the bustling industrial towns to the north, once the timber is gone and the corporations that promised wealth have cut and run, as they almost always do.

On my bad days, when I imagine the future of this place, it is filled with smoke and wildfire—a product of runaway climate change, impoverished rural communities, governments tied to the wishes of corporate shareholders in faraway places, and affluent tourists from elsewhere working hard to use society's remaining "disposable income" to escape the disaster through outdoor recreation.

On those days I remember moments like a day spent searching for mountain caribou in the southern Selkirks with conservation ecologist Greg Utzig, tromping through a sphagnum bog in the middle of a subalpine cirque thick with spruce and fir forest. We paused, swatting mosquitos, and he explained that the most aggressive climate change models show the climate in this part of the rainforest will be better suited to supporting ponderosa pine forests—a stalwart of the semiarid dry forests of western North America. The town of Nelson in the Kootenay Valley in British Columbia, which now supports western

Snow dusts the branches of a stand of old-growth rainforest protected as a "Late Successional Reserve" on public lands managed by the BC provincial government in the Selkirk Mountains.

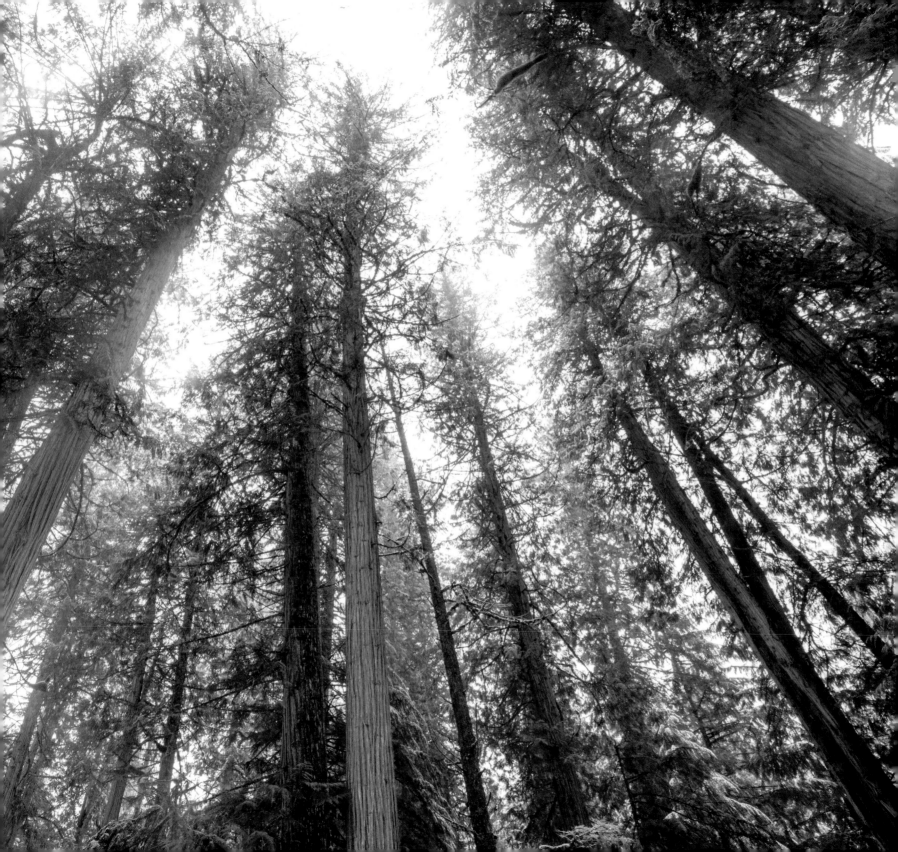

redcedar trees, might end up with a climate similar to Boise, Idaho, 400 miles to the south, amidst a sea of sagebrush.

"Why bother trying to hold onto mountain caribou here?" I asked him, knowing they can't adapt to landscape shifts of that scale. After reflecting on the uncertainty of models and some of the less aggressive iterations suggesting some subalpine habitat might persist, he said: "I don't see us going in the right direction.... I'm not optimistic, but I still have hope. These ecosystems matter too much to me. I just can't stop."

The first time I presented my photography on this project, a few folks from the crowd came up afterward and noted that by the end of my slideshow they felt demoralized, like the situation was hopeless. These interactions were a major turning point for me in this project. I started exploring how people deal with the grief of the destruction we are bringing down on the world around us, the challenges we are leaving for future generations of our own kind. How do we acknowledge the realities of the challenges we face and maintain the will to move forward with whatever tools we have available to effect positive change?

Books like this one are supposed to end on a hopeful note. As often as not, fear, guilt, and shame lead to disassociation from environmental problems rather than engagement. Instead, to tell conservation stories, it has become fashionable to look to inspiration and encouragement to drive public engagement in the issues of the day. But, honestly, as a documentarian attempting to record the realities of this ecosystem both from a natural history and human cultural

perspective, I would be misleading us all if I omitted the very real sense of unfolding tragedy that encompasses this ecosystem on so many levels. Personally, before I could feel truly inspired and driven to help bring about positive change, I needed to address my grief over this state of affairs—a challenge I realized I do not face alone as I listened to the reflections of people like Utzig, who have dedicated their life's work to understanding and caring for the region.

"[P]ain is the price of consciousness in a threatened and suffering world," write ecological philosopher Joanna Macy and Molly Young Brown in their book *Coming Back to Life.* "What we are dealing with here is akin to the original meaning of compassion: 'suffering with.' It is the distress we feel on behalf of the larger whole of which we are a part. It is the pain of the world itself, experienced in each of us."

For Macy and Brown, the doorway to action lies in recognizing that our ability to feel the suffering and grief of the world around us allows us to act from a place of solidarity with the world. "It is not only natural," write Macy and Brown, "it is an absolutely necessary component of our collective healing. As in all organisms, pain has a purpose: it is a warning signal, designed to trigger remedial action." In the same way our own body works to find and stop the sources of pain within us, we become the hand of Earth working to address ills that afflict us.

It is not by turning away from this pain but by *turning into it* that we can find a way through to inspiration and action. When we don't shut ourselves off from the pain, out of our suffering will flow

the clarity and will to act, not in an attempt to hide from the pain but to heal it. This process of "seeing with new eyes," as Macy and Brown call it, allows us to embrace the opportunities for creative change and action that exist in service to the larger whole that we are a part of.

EVERY PERSON ON THIS PLANET has a stake in how we behave in this ecosystem and each one of us is making choices that influence our impact. Herein lies our hope, our opportunity. If the pulp from rainforest trees is making its way around the world through the global economy, then there is power to influence this situation as well. If the future of this rainforest will be decided in part by how people handle climate change, then our lifestyles and our choices at the ballot box in countries around the world are all referenda on this magnificent ecosystem. We all have power here to effect positive change.

"The human dimension creates a challenge that often results in choices far apart from what any of our sciences and even common sense might suggest are logical or 'right,'" said Helen Schwantje, wildlife veterinarian for the BC Ministry of Forests, Lands, Natural Resource Operations, and Rural Development, whom I met at the Klinse-za maternal pen for mountain caribou. "Science and logic can direct us in some choices or recommendations," she continued, "but the sociopolitical influences or human dimensions of an issue may be the deciding factor." If we recognize that it is actually the human animal we are trying to manage here, not caribou, cedar

trees, obscure lichens, or newly discovered rainforest slugs, it is precisely this human dimension that is the key to a path forward. "Walking the lines of communicating among urban and rural folks or Western and indigenous beliefs can be quite challenging. It is often hard for any of us to appreciate or even see each other's points of view," said Schwantje. With this as our starting point, we can recognize the challenges before us.

Add to this a growing sense of urgency from various elements of society, and the tensions build. Struggling with the bureaucratic and political maze of trying to initiate emergency measures to stave off the disappearance of the last herd of mountain caribou in the traditional territory of the Kalispell tribe in Washington State, tribal wildlife biologist Ray Entz made an impassioned statement at the end of a working group meeting for stakeholders involved with this process: "We can accept failure if we try and fail but we can't accept it from apathy." With the laborious task of building consensus among members of the group dragging on over years, there is a very real possibility that these animals, key elements of this tribe's culture, could be gone before their "recovery plan" is complete.

This globally unique jumble of mountains, forests, wild creatures, and people is bleeding and we must stop cutting. With thousands of square miles of ancient forests, roadless mountains, and pristine rivers, there is much worth fighting for. "We need to get away from this industrial-scale approach. It's too late for that. Those days are gone, and the sooner

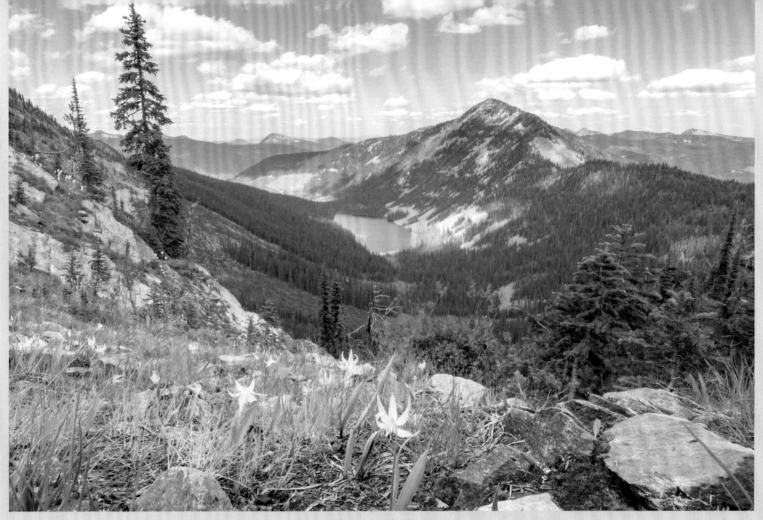

Looking down on Devils Hole Lake in The Nature Conservancy of Canada's Darkwoods Conservation Area

THE PEACE OF WILD THINGS: DARKWOODS CONSERVATION AREA

It's August in the mountains. I'm treading water in a large subalpine lake and looking across its surface into the upper end of the mountain basin that cradles it. A dark forest of spruce and fir lines the lake. Forest creeps up the mountainsides in patches, punctuated by avalanche paths and cliffbands. Snow lingers in deep chutes on the steep north face of the craggy peak at the head of the valley. The itch of mosquito bites, the grime and sweat of a day bushwhacking, and thoughts of what's next seem to float away.

Somewhere, out there, are a few mountain caribou, I muse, as I float and gaze across the lake. A year later, after a few more bug bites and

mountain lake dips, camera traps set in that very basin confirmed this fact, capturing images of not just caribou but members of the threatened grizzly bear population in these mountains, as well as a host of other wildlife species who call these mountains home.

This refuge in the southern Selkirks is part of the home range of the last group of mountain caribou that still travel back and forth across the international border between British Columbia and Washington and Idaho. The Nature Conservancy of Canada's (NCC) 136,000-acre (55,000-hectare) Darkwoods Conservation Area is the largest privately held conservation-oriented property in all of Canada.

Darkwoods was originally acquired in 2008 with the intention of preserving and restoring vital mountain caribou habitat. Beyond caribou, the conservation value of this land is diverse and growing. Situated close to the international border and adjacent to a pair of provincial parks, Darkwoods is a vital component of conservation planning for maintaining habitat connectivity in the Selkirks to support ecosystem resilience in the face of climate change and to further ongoing transborder recovery efforts of caribou, grizzly bears, lynx, and wolverines.

Despite a history of large wildfires in this part of the Selkirks and decades of logging activity, Darkwoods still contains stands of mid- and high-elevation old-growth forests. Such forests play a critical role in our attempts to mitigate the effects of climate change. As the forests grow and age, they capture carbon dioxide out of the atmosphere and bind it up in the structure of the forest. The NCC pioneered a novel plan to both finance their ongoing management of the reserve and support the economic development of carbon sequestration activities as a financially valuable asset through a program selling carbon offsets to businesses, government agencies, and individuals.

According to Adrian Leslie, who manages Darkwoods for NCC, when the property switched to a conservation holding, there was considerable concern from the local community that it would negatively impact the local economy by removing land from the timber harvest land base that fuels local employment. Outside of the parks, these mountains are far from pristine—crisscrossed with forestry roads and clear-cuts of all sizes and ages. In many drainages only the upper ends of the basin have been spared cutting at one time or another. Since the purchase, along with stopping all timber harvest in caribou habitat within the preserve and protecting the existing uncut forest stands, NCC has been deactivating roads in caribou habitat. It has also continued to help supply wood to the local market using carefully planned timber harvests designed to reduce fuel loads in second-growth forests, support a return to old-growth characteristics, and build resilience in the face of projected climate change shifts that include increasing wildlife risks and forest disease infestations.

Darkwoods is a working landscape—working in ways that reflect a changing paradigm of natural resource values. Along with traditional resources such as wood fiber, this property is working as a refuge for biodiversity. It is a bedroom for sensitive resident wildlife, and a corridor for climate refugee species up and down mountain slopes and south to north along their crest. It is working as a vault for the excess carbon our species has pumped into the atmosphere.

And, as I have learned from my floating reflections in several of its more than fifty mountain lakes, it is working as a refugium for what poet Wendell Berry calls "the peace of wild things," something with uncountable value for the human soul.

we realize that, the more options we have left," said Candace Batycki, who has been working on conservation issues in the region for decades.

"There is always going to be a place for logging and there should be because people need to be connected to the landscape," she said. For Batycki, this switch doesn't mean an end to using these forests, but a switch in how we use them. Indeed, besides sustaining the economic lives of people in the region, having people working in the forests is integral to maintaining a deep relationship with the ecosystem.

Healthy ecosystems are resilient. They can maintain the foundational processes that define them in the face of stresses and unusual pressures. They can fill in the gaps made by one species disappearing with another able to occupy the vacant niche. But as parts of an ecosystem are damaged or removed, resiliency becomes stressed and recovery from trauma becomes more difficult or impossible.

The same is true of healthy human communities. Looking into the inner workings of the lives of mountain caribou and the functions of this ecosystem, I have been continually struck by how the experience of these animals reflects those of my own species. The same is true on an ecosystem and human community level. Our fate as individuals is tied to our ability to manage our communal experience. Solutions that work for some people at the expense of others are not solutions at all.

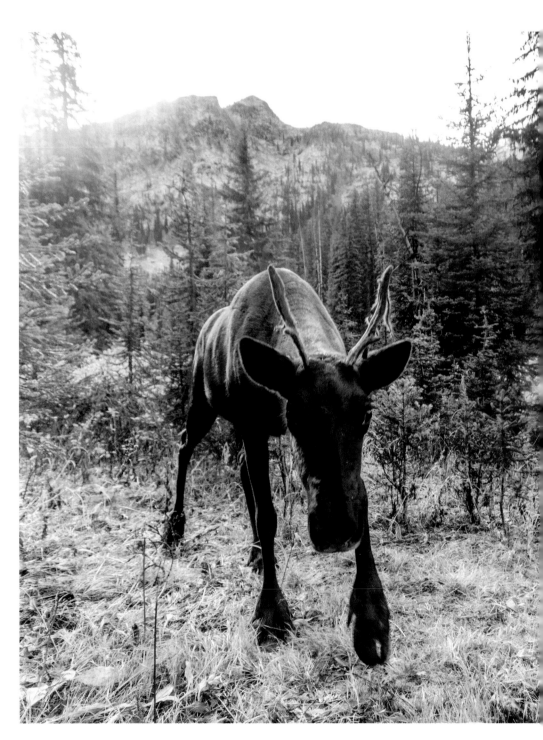

A curious mountain caribou from the Southern Selkirks herd inspects a camera trap in Darkwoods Conservation Area.

The juggernaut of Western civilization's cancerous relationship with its habitat has been a long time in the making. By the time it arrived in these mountains, it had a great deal of momentum driving it. Like a big ship at sea, it will not just stop and it cannot turn on a dime. But real change is possible and within our grasp.

On more than one occasion while embarking on a field trip for this project, I thought about the long odds of success for what I was searching for on that particular trip. What were the chances that I could track down a herd of mountain caribou in winter on skis without any specific information on where to find them? Very low. But what were the chances of failure if I didn't go? One hundred percent. The choice was always a clear one: Go. Try. Step forward with hope and optimism. But let your experience be shaped by realism as well. If I failed, I looked for insights as I planned my next attempt. Slowly, the story and the images came together.

This is the situation we find ourselves in. Can we find a way to radically remake our relationship with these forests, maintain living wages for local peoples with a model of forestry that rests on keeping capital in the community? Yes, undoubtedly we can. Will it be easy? Definitely not. What other option do we have? Along with the entire Caribou Rainforest Ecosystem and all of its living members, humans too are now on a journey that we can't simply step away from.

On my last trip to the Caribou Rainforest before completing this manuscript, I returned to the first place I found the tracks of mountain caribou many years before I started this project. I traced the game trail through the forest down which I had followed a pair of caribou long ago—a trail carved into the mountains by the passage of caribou for thousands of years. With less than twelve animals left in this herd and cut off from their closest relatives by what seem like insurmountable obstacles, their future appears bleak.

But the one constant in the history of life on this earth is change. Regardless of whether mountain caribou make it through the eye of the needle, this ecosystem is in the process of remaking itself again. Picking my way along the trail of these caribou through a world they have called home for untold generations, I wonder about the options for my own way forward, and the choices my kind, the humans, face today. I have walked this path with these animals and in this forest with reverence and gratitude for the opportunity to witness this wondrous place. If there is one message I can bring back from this magical place, it is very clearly written in the tracks of the caribou and the seedlings of cedars, firs, and spruce. Keep going.

OPPOSITE *A lone bull caribou inspects the tracks of other mountain caribou, Hart Ranges.*

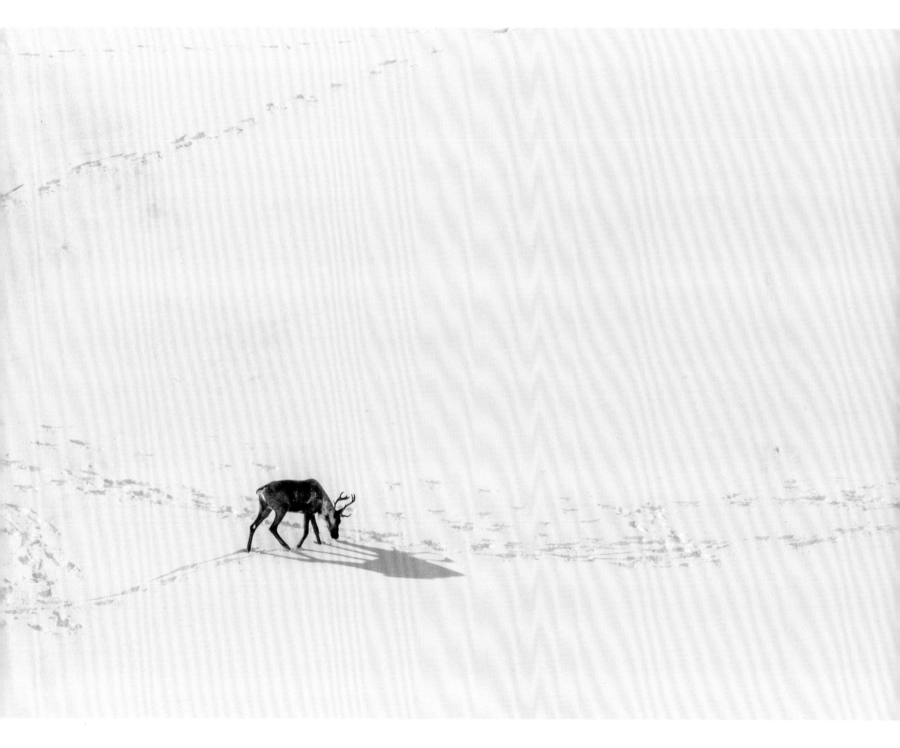

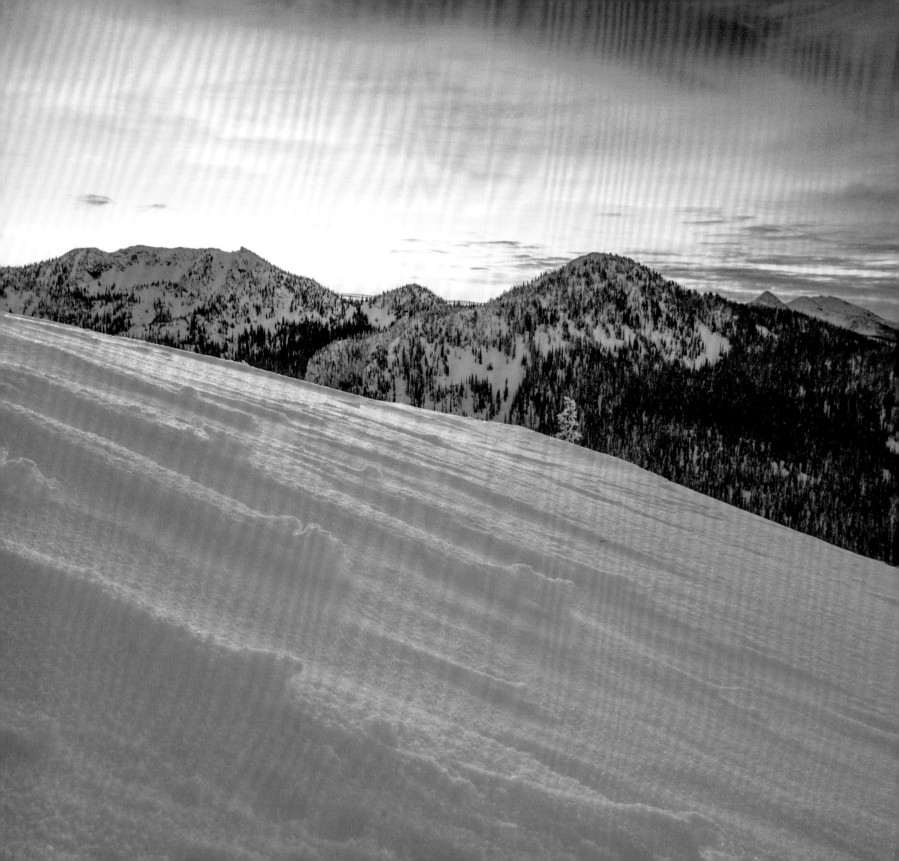

ACKNOWLEDGMENTS

Completing this book required the help and support of a huge number of people. Foremost, Marcus Reynerson, Kim Shelton, and Colin Arisman worked tirelessly alongside me for several years both in the field and out, volunteering their time while helping research photography opportunities, arranging meetings with folks in the region, fundraising for our work, and helping get the content that we were producing out into the world far and wide. Their friendship and camaraderie has been one of the most amazing collaborative working relationships of my career. I learned a great deal from each of them over the course of this project and shared many frustrating and inspiring moments.

When I first got curious about starting this project, the first person I called was Joe Scott, a veteran conservationist who has been leading campaigns spanning the US–Canada border for decades. His thoughts, ideas, and connections helped make this project possible from the outset. From him I developed an ever-widening network of contacts, which helped me understand this story and figure out how to portray it as accurately as I have been able to here. Specific individual professionals who helped me understand the complicated ecological, social, and political landscape of this story include: Kevin Bollefer, Norm Merz, Adrian Leslie, John Bergenske, Candace Batycki, Greg Utzig, Leo DeGroot, Rob Serrouya, Kelsey Furk, Dale Seip, Roy Howard, David King, Doug Heard, Ian Tomm, Daniel Kellie, Gilbert Desrosiers, Brian Pate, Scott McNay, Line Giguere, Brian Glaicar, Erik Leslie, Craig Pettitt, Ray Entz, Bart George, Ken Wu, Trevor Goward, and Cheryl Moody.

A number of organizations and individuals helped fund the fieldwork for this project including Sculpt the Future Foundation, Patagonia, Andy Held, Ellen Haas, Johanna Goldfarb and Kerry Levin, Ralph Moskowitz, Michelle Keller, Marianne Moskowitz and Greg Kindel, Josh Leavitt, Kokopelli Packrafts, Rob Speiden, Natural Awareness Tracking School, Selkirk Conservation Alliance, Joan Golston, Mark Darrach, Thag Simmons, Pieter Van Winkle, Dan Davis, Nancy Tomkins, and Alexandria Loeb. The financial sponsorship of Blue Earth Alliance, and attention from board members Natalie Fobes and Karen Ducey, was vital for helping with my fundraising and networking for the project.

OPPOSITE *Winter sunrise in the Selkirk Mountains*

I am tremendously grateful to the numerous individuals from a number of different First Nations and Indian tribes from the region who took time to talk and share their personal experiences and cultural perspectives with me and my project collaborators. These include Chairman Gary Aitken Jr., Lenny Edwards, Naomi Owens, Chief Roland Willson, Harley Davis, Boris Bekoff, Bob Campbell, and Marilyn James. Thank you for trusting me with your stories and thoughts.

Many people went out of their way to assist me with the fieldwork for this project: Forest McBrian, Steph Williams, Lindsay Walker, Brian Glaicar, Mike Bromberg, Kate Devine, Virginia Thompson, Adam Lieberg, Luke Lamar, Cody Dems, Lacy Robinson, Michael Lucid, Casey McCormack, Bart George, Gabe Spence, Monica Nissen, Judith Robertson, Myriam Rioux, Erin Smart, and Gilbert Wall.

Many conservation groups and nonprofits supported my research and fieldwork. These include: Conservation Northwest, The Nature Conservancy of Canada, Yellowstone to Yukon Conservation Initiative, Wildsight, Swan Valley Connections, Selkirk Conservation Alliance, The Nature Conservancy, Harrop-Procter Community Forest, Revelstoke Caribou Rearing in the Wild, and Wildlife Infometrics.

The photography and visual storytelling for this book and associated content for this project has pushed me into new realms as both a photojournalist and an artist. I am grateful for the mentors in my life who provided me with the foundational skills to tackle this project: Aaron Goldfarb, Charles Worsham, and Steve Smith. I am grateful to Neal Wight, Bryce Comer, and Steven Gnam for your support with my camera trapping efforts on this project; Colin Arisman for helping me develop in my videography skill; Benj Drummond for editorial help getting this project off the ground; David De Rothschild for inspiring me to look for creative ways to capture content and communicate about this story; and Sarah Rice for helping me select and arrange photos for the book.

I am grateful for the expert review of sections of the manuscript by Rob Serrouya, Greg Utzig, Ken Wu, Trevor Goward, Thomas Murphy, Steve Smith, Nate Bacon, and Randy Morris. Despite the best efforts of so many individuals to help catch my mistakes, I'm sure a few got through. They are mine alone.

This project would have not been possible without the love of my family and friends who have supported me in pursuing this story and endured the challenges of my many days away from home and my intense preoccupation with the details of this project.

From my initial conversations with Braided River, I knew this would be a great fit. The vision of Braided River is inspiring and I am so happy to be contributing to it with this book. I am grateful to publisher Helen Cherullo, as well as to Lace Thornberg, Deb Easter, Janet Kimball, Laura Shauger, and Ellen Wheat for helping guide this book from the idea phase to reality.

SOURCE NOTES

THE CARIBOU RAINFOREST: A FOREST LIKE NONE OTHER

61 "Forested ecosystems cover roughly 31 percent," UN FAO report, *Global Forest Resources Assessment*, 2010.

61 "Rainforests currently make up only about 14 percent," DellaSala, 2010.

61 "the world's forest cover, reduced by half," DellaSala, 2011.

61 "Currently temperate rainforests make up only 2 percent of forests globally," DellaSala, 2010.

61 "tropical rainforests can have fifty to two hundred tree species," DellaSala, 2010.

63 "greater than in any other landscape on the planet," Keith et al., 2009.

63 "whereas temperate rainforests can have close to 1,900 metric tons," DellaSala, 2010.

63 "provides the precipitation to create these rainforests," Stevenson et al., 2011.

63 "But nowhere else on the planet . . . of the Pacific Northwest." Arsenault and Goward, 2000.

63 "The most dramatic expression of this rainforest," Goward and Spribille, 2005.

64 Map: Caribou Rainforest Ecosystem boundary was defined by an aggregate of the ecosections that contain interior temperate rainforest, according to D. Demarchi and E. Lea in *Regional and Zonal Ecosystems in the Shining Mountains*. Mapping and report prepared for BC Ministry of Environment, Lands, and Parks, in cooperation with Montana Department of Fish, Wildlife, and Parks. Victoria, BC, 1992.

65 "Old-growth forests are defined by very old trees," Franklin and Spies, 1991.

65 "In this ecosystem, typically forests must," Stevenson et al., 2011.

65 "These forests are a result, in large part," Cannings and Cannings, 2015.

65 "However, the current tree association typical of," Gavin et al., 2009.

67 "Farther south, one western redcedar tree," DellaSala, 2010.

67 "Many of the forests of the inland rainforest," Trevor Goward, Arsenault and Goward, 2000.

68 "found most abundantly in antique stands." Trevor Goward, Arsenault and Goward, 2000.

68 "the vast industrial-scale operations going on today," Rajala, 1998.

69 "Industrial Forestry in the Caribou Rainforest" (sidebar), by David Moskowitz, previously published in *High Country News*, October 31, 2016.

69 "It's going to a pulp mill." Conversation with David Walker, Selkirk Mountains, BC, July 20, 2016.

69 "a resource extraction town with an outdoor recreation veneer." Conversation with Michael Copperthwaite, October 14, 2016.

69 "confirms that caribou protections have not reduced their logging on public lands." Kerry Rouck phone interview, August 2, 2016.

71 "The Grand Coulee Dam on the Columbia River ended salmon runs," Clark et al., 2015.

71 "The resulting reservoirs create significant habitat fragmentation," Stevenson et al., 2011.

73 "minerals into usable products," Cristescu et al., 2016.

73 "Summer drought will likely be exacerbated," Utzig interview, February 25, 2016.

MOUNTAIN CARIBOU: GHOSTS OF THE RAINFOREST

92 "Greg Utzig likens mountain caribou to the canary in the coal mine," Utzig interview, 2016.

95 "Forest fire frequency in this ecosystem is increasing," Utzig et al., 2011.

96 "Chris Ritchie is responsible for overseeing mountain caribou recovery efforts," Ritchie interview, August 16, 2016.

96 "the population has declined more than 25 percent," BC Ministry report, 2017.

WILDLIFE OF THESE MOUNTAINS: A LABORATORY OF EVOLUTION

120 "I feel bad for people who don't understand it," Brian Glaicar interview, May 1, 2016.

120 "What is the value of a caribou?" Kerry Rourk phone interview, August 2, 2016.

131 "the direct correlation between populations of lynx and snowshoe hares," Koehler, 1990.

131 "study of all of the known denning locations of wolverines," Aubry et al., 2007.

134 "Researchers looking at the ecological impact of salmon," Stevenson et al., 2011.

134 "There were so many fish in the North Thompson," Tina Donald phone interview, September 4, 2017.

139 "Most folks wouldn't think of a slug as a poster child," biologists Michael Lucid and Lacy Robinson interview, May 19, 2017.

HUMAN DIMENSIONS: THE LANGUAGE OF A LANDSCAPE

153 "What's the most important to you? My people or the caribou?" Chapter epigraph, Vance Robert Campbell interview, Nespelim, Colville Confederated Tribes reservation, Washington, November 16, 2016.

155 "According to the most recent theories in Western science," Heintzman, 2016, and Katz, 2017.

155 "According to Roland Willson," Willson interview, West Moberly Lake, BC, July 14, 2016.

159 "When we spoke with Campbell in his house," Vance Robert Campbell interview, November 16, 2016.

159 "In 1956, the Canadian government declared the entire Sinixt nation extinct," McNeel, 2011, and James, 2016.

160 "I have to ensure that there are caribou here for my grandchildren," Harley Davis interview, Chetwynd, BC, March 16, 2016.

160 "This land here is very sacred," interview with Gary Aitkin Jr., Chairman of the Kootenai tribe of Idaho, Bonners Ferry, Idaho, July 6, 2016.

161 "The Saulteau and West Moberly Dunne-za First Nations are both signatories of Treaty 8," refers to Treaty No. 8, printed 1969 by the Queen's printer in Ottawa, treaty dated June 21, 1899, signed by the Crown and First Nations of the Lesser Slave Lake Area.

161 "We have rights that we are entitled to." Naomi Owens interview, West Moberly Lake, July 14, 2016.

163 "Our right to harvest caribou has been extinguished." Willson interview, West Moberly Lake, July 14, 2016.

164 "big wood," Dwayne Paige interview, Selkirk Mountains, BC, July 19, 2016.

167 "It's easy for someone to sit in a 5,000-square-foot timber-frame house," Kate Devine interview, Revelstoke, BC, July 20, 2016.

168 "I like to say that Canfor is in the export business," Erik Milton interview, Clearwater Valley, Cariboo Mountains, September 20, 2016.

171 "British Columbia has some of the finest timber in the world," Rami Rothkop interview, Harrop-Procter Forest Products, Nelson, BC, February 11, 2016.

171 "Indeed, British Columbia cuts more than two and a half times the volume," Natural Resources Canada, 2016.

171 "We have the lowest number of jobs per volume of wood harvested," interview with Erik Leslie, forest manager, Harrop-Procter, May 16, 2017.

171 "But between 1988 and 1997," Niemi et al., 2000.

173 "It's a war . . . and we have a dug in enemy," interview with Roland Willson, chief of the West Moberly Dunne-za, July 14, 2016.

174 "Colonization, we know, attempts to replace indigenous cultures with," Robin Wall Kimmerer, Spring 2015.

174 "We know a thing," Kimmerer, 2016.

174 "Using 'it' absolves us of moral responsibility," Kimmerer, 2015.

174 "If you're visiting your sweet grandma," Kimmerer, 2013.

174 "Enlightened conservationists are beginning to accept the axiom," Dowie, 2011.

176 "The Secwepemc people state," J. Billy, 2017.

178 "It's a job for the future." Lenny Edwards interview, Monashee Mountains, BC, May 1, 2016.

181 "I've been a logger, I've felled trees," Harley Davis interview, Chetwynd, BC, March 16, 2016.

177 "Five or six very large forestry companies," Erik Leslie interview, Harrop-Procter, May 16, 2017.

177 "At its core, community forestry is about," British Columbia Community Forest Association.

178 "We measure success in meaningful local work," Rami Rothkop interview, Harrop, BC, February 11, 2016.

THE PATH AHEAD: REFLECTIONS ON GRIEF AND HOPE

183 Chapter epigraph from "A Poem on Hope," by Wendell Berry, 2010.

186 "I don't see us going in the right direction," Greg Utzig interview, February 25, 2016.

188 "The human dimension creates a challenge," email correspondence with Helen Schwantje, October 4, 2017.

188 "We can accept failure if we try and fail," Ray Entz interview, Bonners Ferry, Idaho, November 1, 2017.

188 "We need to get away from this industrial-scale approach," Candace Batycki interview, Nelson, BC, February 21, 2017.

SELECTED BIBLIOGRAPHY

Arsenault, A., and T. Goward. "Ecological Characteristics of Inland Rainforests." *Proceedings of a Conference on the Biology and Management of Species and Habitats at Risk, Kamloops, BC, February 15–19, 1999,* vol. 1. Victoria: BC Ministry of Environment, Lands and Parks, 2000.

Aubry, K. B., K. S. McKelvey, and J. P. Copeland. "Distribution and Broadscale Habitat Relations of the Wolverine in the Contiguous United States." *Journal of Wildlife Management* 71: 2147–58, 2007.

BC Ministry of Forests, Lands, and Natural Resource Operations. Mountain Caribou 2017 Population Trends. Unpublished data.

Billy, J. "Secwepemctsin: Language of the Secwepemc." Secwepemctsin, Language of the Secwepemc, Raven in the Moon. Secwepemc Nation. Accessed August 28, 2017. landofthe shuswap.com/lang.html.

Bridge, G. "Contested Terrain: Mining and the Environment." *Annual Review of Environment and Resources* 29(1): 205–59, 2004. doi:10.1146/annurev.energy.28.011503.163434.

British Columbia Community Forest Association. "What Is Community Forestry?" Accessed September 9, 2017. http://bccfa.ca /what-is-community-forestry/.

British Columbia, Forest and Range Practices Act: Government Action Regulations. BC Reg. 582/2004. O.C. 1246/2004. Deposited December 13, 2004. Accessed October 3, 2017. www.bclaws.ca/civix/document/id/complete /stratreg/582_2004#section2.

Cannings, R., and S. Cannings. *British Columbia* (3rd edition). Vancouver, BC: Greystone Books, 2015.

Caughley, G. "Directions in Conservation Biology." *Journal of Animal Ecology* 63(2): 215–44, 1994.

Clark, K. A., T. R. Shaul, and B. H. Lower, eds. *Environmental ScienceBites.* Columbus: Ohio State University, 2015.

Cristescu, B., G. B. Stenhouse, and M. S. Boyce. "Large Omnivore Movements in Response to Surface Mining and Mine Reclamation." *Scientific Reports* 6(1), 2016. doi:10.1038 /srep19177.

Davis, Harley. Interview. Chetwynd, British Columbia. March 16, 2016.

DellaSala, D. A. *Temperate and Boreal Rainforests of the World.* Washington, DC: Island Press, 2010.

Dietrich, W. *The Final Forest: Big Trees, Forks, and the Pacific Northwest.* Seattle: University of Washington Press, (1992) 2010.

Dowie, M. *Conservation Refugees: The Hundred-Year Conflict between Global Conservation and Native Peoples.* Cambridge: The MIT Press, 2011.

Espirito-Santo, F. D. B., M. Gloor, M. Keller, Y. Malhi, S. Saatchi, B. Nelson, and R. C. Oliveira Jr., et al. "Size and Frequency of Natural Forest Disturbances and the Amazon Forest Carbon Balance." *Nature Communications.* March 18, 2014. doi:10.1038/ncomms4434.

Franklin, J. F, and T. A. Spies. *Ecological Definitions of Old-Growth Douglas-Fir Forests.* Washington, DC: United States Forest Service, 1991.

Gavin, D. G., F. S. Hu, I. R. Walker, and K. Westover. "The Northern Inland Temperate Rainforest of British Columbia: Old Forests with a Young History?" *Northwest Science* 83(1): 70–78, 2009. doi:10.3955/046.083.0107.

Global Forest Resources Assessment 2010 (n.d.). Food and Agriculture Organization of the United Nations. Accessed September 1, 2017. www.fao.org/forestry/fra/fra2010/en/.

Goward, T., and T. Spribille. "Lichenological Evidence for the Recognition of Inland Rain Forests in Western North America." *Journal of Biogeography* 32(7): 1209–19, 2005. doi:10.1111/j.1365-2699.2005.01282.x.

Green, A., B. Ricker, S. McPhee, A. Ettya, C. Temenos. *British Columbia in a Global Context,* Vancouver: Geography Open Textbook Collective, 2014. http://opentextbc.ca /geography.

Heintzman P. D., D. Froese, J. W. Ives, et al. "Bison Phylogeography Constrains Dispersal and Viability of the Ice Free Corridor in Western Canada." *Proceedings of the National Academy of Sciences* 113(29): 8057–63, 2016.

James, Marilyn. Sinixt Nation. "Sinixt Nation: Keeping the Lakes Way," 2016. Accessed November 23, 2017. sinixtnation.org/.

Katz, B. "Found: One of the Oldest North American Settlements." Smithsonian Institution, April 5, 2017. Accessed September 29, 2017: www.smithsonianmag.com/smart-news/one-oldest-north-american-settlements-found-180962750/.

Keith, H., B. G. Mackey, and D. B. Lindenmayer. "Re-Evaluation of Forest Biomass Carbon Stocks and Lessons from the World's Most Carbon-Dense Forests." *Proceedings of the National Academy of Sciences* 106(28): 11635–40, 2009. doi:10.1073/pnas.0901970106.

Kimmerer, R. W. *Braiding Sweetgrass: Indigenous Wisdom, Scientific Knowledge, and the Teachings of Plants.* Minneapolis, MN: Milkweed Editions, 2013.

——. "Nature Needs a New Pronoun: To Stop the Age of Extinction, Let's Start by Ditching 'It.'" *Yes! Magazine* 73, Spring 2015. www.yesmagazine.org/issues/together-with-earth/alternative-grammar-a-new-language-of-kinship.

——. "Robin Wall Kimmerer: The Intelligence in All Kinds of Life." *On Being with Krista Tippett.* February 24, 2016. https://onbeing.org/programs/robin-wall-kimmerer-the-intelligence-in-all-kinds-of-life.

Koehler, G. M. "Population and Habitat Characteristics of Lynx and Snowshoe Hares in North Central Washington." *Canadian Journal of Zoology* 68(5): 845–51, 1990.

Leslie, Erik. Interview. Nelson, British Columbia. May 16, 2017.

Macy, J., and M. Y. Brown. *Coming Back to Life: Practices to Reconnect Our Lives, Our World.* Gabriola Island, BC: New Society Publishers, 1998.

McNeel, Jack. "The Sad, Strange Saga of the Sinixt People." *Indian Country Today.* November 9, 2011. Accessed November 11, 2017. https://indiancountrymedianetwork.com/news/the-sad-strange-saga-of-the-sinixt-people/.

National Research Council. *Environmental Issues in Pacific Northwest Forest Management.* Washington, DC: The National Academies Press, 2000.

Natural Resources Canada. Forest Resources Statistical Data. Accessed August 15, 2016. https://cfs.nrcan.gc.ca/statsprofile/overview/qc.

Niemi, E., E. Whitelaw, and E. Grossman. "Bird of Doom . . . or Was It?" *The Amicus Journal* 22: 19–25, Fall 2000. www.history.vt.edu/Barrow/Hist4244/SB724_01.pdf.

Oswalt, S. N., and W. B. Smith, eds. *US Forest Resource Facts and Historical Trends.* Washington, DC: United States Forest Service, 2014.

Rajala, R. A. *Clearcutting the Pacific Rain Forest: Production, Science, and Regulation.* Vancouver, BC: University of British Columbia Press, 1998.

Stevenson, S. K., H. M. Armleder, A. Arsenault, D. Coxson, S. C. DeLong, and M. J. Jull. *British Columbia's Inland Rainforest: Ecology, Conservation, and Management.* Vancouver, BC: University of British Columbia Press, 2011.

Treaty No. 8, Ottawa Queen's Printer Reprint 1969. Made June 21, 1899, signed by the Crown and First Nations of the Lesser Slave Lake Area.

Turney-High, Harry Holbert. "Ethnography of the Kutenai. Memoirs of the American Anthropological Association." As quoted in: Flinn, Paul. *Caribou of Idaho.* Idaho Fish and Game Department, 1955. Available through the Boundary County Museum, Bonners Ferry, Idaho.

Utzig, G., J. Boulanger, and R. F Holt. *Climate Change and Area Burned: Projections for the West Kootenays.* Report #4 from the West Kootenay Climate Vulnerability and Resilience Project, 2011. Retrieved March 11, 2018. www.westkootenayresilience.org/report4_fire-draft.pdf.

PHOTOGRAPHER'S NOTES

In the summer of 2015, I ended up with a month free after a planned expedition fell apart. On a whim, I decided to go track down some mountain caribou, an animal I had written about in my first two book projects but never actually seen in person. I thought it would be a fun adventure and perhaps I could cobble together a collection of images for an article and slideshow on this rare creature. What I discovered shocked me. Watching ancient cedar trees go down the road on log trucks and learning that we were turning old-growth hemlock trees into toilet paper was not what I expected to find when visiting habitat for a "protected" endangered species. After that month I knew this was a place and a story that I needed to pursue.

I relished the opportunity to work in a remote mountain rainforest with a focal species that spends winters at treeline. The fact that the best way to find mountain caribou in summer is to look at a map and pick the place you think will have the worst mosquitos was slightly less exciting. On a personal, emotional level, the photography and research for this project was also incredibly draining and humbling. Over the course of the project, several of the herds of caribou I was following continued to decline precipitously. I photographed old-growth forests that

are now no longer standing and forests as they were being cut down.

The human culture of the Caribou Rainforest is a complicated one. I faced resistance from the timber industry to document their work because of their concerns that if people see what is going on there they might attempt to intervene. First Nations and tribes are understandably extremely wary about how their culture will be used or represented. Within the conservation world, there are strongly held and opposing perspectives about how to proceed with caribou and forest conservation, and I had to navigate these issues with care. I had to email and call individuals in the BC provincial government repeatedly for more than a year to get answers to my questions and set up interviews. Ultimately, however, the support I received from such diverse individuals and organizations was vital for the project and extremely rewarding and educational for me.

MY GOAL, BOTH IN THE FIELD taking photos and afterward developing them, is to express my experience of the natural world *as I actually encounter it*. I shoot with a variety of digital single-lens reflex (DSLR) camera bodies and lenses. My development of digital negatives includes global adjustments of

exposure, white balance, and contrast. For some high-contrast landscape images I apply a digital split-neutral-density filter or merge two or more differently exposed frames to capture the full range of light found in the field but that is impossible to capture in one exposure.

A number of the creatures I aimed to photograph for this project are rare, occupying large home ranges in remote settings. Others are primarily nocturnal. It became clear that to bring these animals out of the shadows, I needed to do more than put a long lens on a tripod and start snapping. Even working from a blind would not be possible given the unpredictable nature and low density of many of these animals. Out of necessity, camera trapping became an integral part of not just my attempts to document wildlife, but my own journey to understand and develop a relationship with the creatures of the Caribou Rainforest.

Capturing a wild animal in a trap of any sort requires a deep knowledge of the animal and how it uses the landscape. Over the years I have met people who trap wildlife for all sorts of reasons: to feed themselves, for their fur pelts, to remove "problem" animals, and to attach a GPS tracking device and release them back into the wild for research. In my case, the "trap" is a motion-sensing device that triggers a camera to take a picture.

I designed camera traps in several ways. Some traps were set on travel routes used by the animal I was targeting. I also set up traps at natural attractants such as a mineral lick for caribou or a tree where mountain lions regularly scent mark. For other installations I teamed up with wildlife researchers and set up camera traps at locations where they were setting out attractants, such as scent lures or bait, to attract certain species in order to document their presence on the landscape.

For traps set for diurnal species and when flash photography would be overly invasive, I relied on natural light. For nocturnal species, I needed to use artificial lighting. Each camera trap had between two and four individual strobes set to help create engaging lighting highlighting the animal and its environment. Because of my inability to tailor the settings for these photos for the exact field conditions when the subject triggered the camera, development of these images was in many cases more involved than for my standard wildlife photography. Night images, especially, required greater attention to editing exposure, highlights and shadows, flash lighting artifacts, and other issues from shooting in low light.

In the modern world, we are often far disconnected from the point of contact that produces the things we need and want from the earth and, in turn, from the impacts of those actions. With all the images from this project, I hope to help bridge that divide for the viewer. For myself, the process of capturing these images has made that connection very clear.

This amazing planet never ceases to inspire and call forth right action from those who pay attention.

OPPOSITE *Vacinium bushes turn bright red in fall at treeline in the Selkirk Mountains.*

GET INVOLVED

VISIT THE CARIBOU RAINFOREST

The majority of the Caribou Rainforest Ecosystem is found on public lands. Large portions are remote and inaccessible, while other portions are managed for industrial uses such as logging. Parts are protected within parks and designated protected areas in both the United States and Canada and include hiking trails and recreational access.

Idaho and Washington

Roosevelt Grove of Ancient Cedars Scenic Area, Idaho Panhandle National Forest, www.fs.usda.gov/ipnf
Salmo-Priest Wilderness, Colville National Forest, www.fs.usda.gov/recarea/colville/recarea/?recid=79330

Montana

Glacier National Park, www.nps.gov/glac

British Columbia

For provincial parks, visit www.env.gov.bc.ca/bcparks/explore for an alphabetical list. For national parks, choose the park name from the list at www.pc.gc.ca/en/index.
Ancient Forest/Chun T'oh Whudujut Provincial Park and Protected Area
Glacier National Park
Mount Revelstoke National Park
Mount Robson Provincial Park and Protected Area
Purcell Wilderness Conservancy Provincial Park and Protected Area
Stagleap Provincial Park
Wells Gray Provincial Park

HELP PROTECT THE CARIBOU RAINFOREST

The future of the Caribou Rainforest depends on citizens taking action on local, national, and international levels. Join us in working toward a bright and just future for all people and creatures of this magnificent ecosystem.

Conserve Mountain Caribou

Advocate for a holistic management plan for mountain caribou: Wildsight, https://wildsight.ca, and Conservation Northwest, www.conservationnw.org.

Protect the Inland Rainforest

Support efforts to end old-growth logging: Ancient Forest Alliance, www.ancientforestalliance.org.

Maintain and Restore Landscape Connectivity

Connect and protect habitat by supporting a joint Canada–United States effort: Yellowstone to Yukon Conservation Initiative, https://y2y.net.

Support Indigenous Peoples' Rights

Build sovereignty for First Nations and honor indigenous peoples' rights in Canada: Idle No More, www.idlenomore.ca.

Tackle Climate Change

Join the global movement to protect our planet's climate: https://350.org.

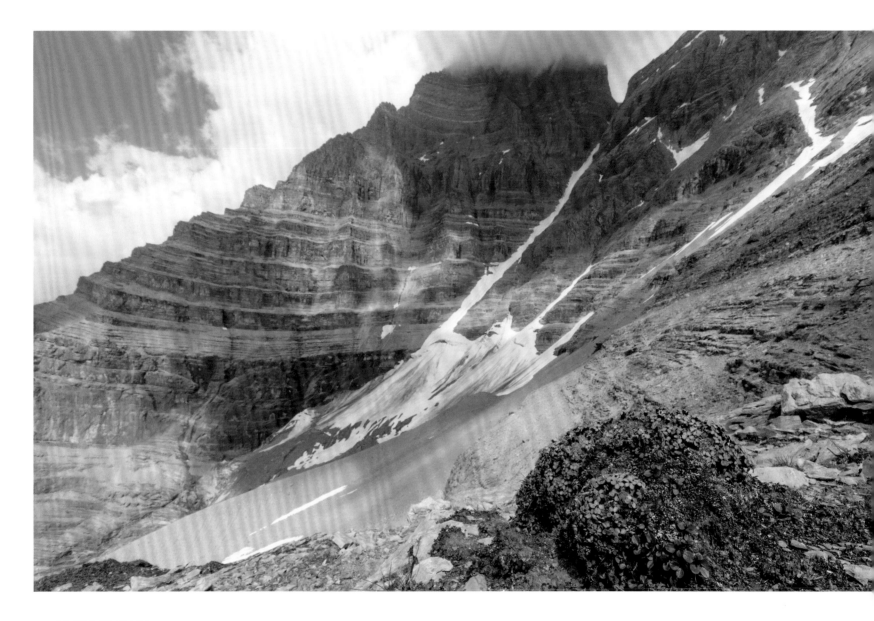

IN APPRECIATION

This book was made possible in part by generous support from Furthermore, a program of the J. M. Kaplan Fund, and from Braided River Headwaters members, including Tom and Sonya Campion, Jacob and Margo Engelstein, Ellen Ferguson, Craig McKibben and Sarah Merner, Allen and Lisa Preger, and Ann and Ron Holz.

ABOUT THE AUTHOR AND PHOTOGRAPHER

A professional wildlife tracker, photographer, and educator based in northcentral Washington State, **DAVID MOSKOWITZ** is the photographer and author of two other books, *Wildlife of the Pacific Northwest* and *Wolves in the Land of Salmon*. His photography and writing have appeared in numerous other books and publications. David holds a bachelor's degree in environmental studies and outdoor education from Prescott College. Certified as a track and sign specialist, trailing specialist, and senior tracker through CyberTracker Conservation, he is an evaluator for this rigorous international professional certification program.

David has contributed his technical expertise to a wide variety of wildlife studies regionally, focusing on using tracking and other noninvasive methods to study wildlife ecology and promote conservation. He helped establish the Citizen Wildlife Monitoring Project, a citizen science effort to search for and monitor rare and sensitive wildlife in the Pacific Northwest. Find out more about David's work at http://DavidMoskowitz.net.

In 2015 David founded the Mountain Caribou Initiative, a visual storytelling project that highlights conservation challenges and opportunities in the Caribou Rainforest. He also produced the documentary film *Last Stand: The Vanishing Caribou Rainforest*. Images, video, and reporting from this project have appeared in print, digital, and broadcast media in North America and Europe. Learn more at http://CaribouRainforest.org.

ABOUT THE CONTRIBUTORS

Hailing from Minnesota, **KIM SHELTON** grew up in North Yorkshire, United Kingdom, and moved back to the States after eighteen years overseas. She spent seven years learning and instructing survival and primitive living skills at the Wilderness Awareness School, in Duvall, Washington, putting them to the test in 2014 on Discovery Channel's very first episode of *Naked and Afraid*. Kim has always been fascinated by the stories of people, places, and nonhuman beings. She hosts a podcast about these things from her home on the Leech Lake Band of Ojibwe Reservation in northern Minnesota.

Naturalist, educator, and photographer **MARCUS REYNERSON** has had an affinity for the living world since childhood. He has worked in wilderness education, outdoor leadership, and conservation for numerous organizations and communities across North America. Engaged in telling stories that bring to life the complexity of humans living in the twenty-first century, Marcus is the lead instructor for an internationally renowned environmental leadership immersion program for adults at the Wilderness Awareness School in Duvall, Washington. He lives east of Seattle, in the Snoqualmie Valley.

BRAIDED RIVER

BRAIDED RIVER, the conservation imprint of Mountaineers Books, combines photography and writing to bring a fresh perspective to key environmental issues facing western North America's wildest places. Our books reach beyond the printed page as we take these distinctive voices and vision to a wider audience through lectures, exhibits, and multimedia events. Our goal is to build public support for wilderness preservation campaigns, and inspire public action. This work is made possible through the book sales and contributions made to Braided River, a 501(c)(3) nonprofit organization. Please visit BraidedRiver.org for more information on events, exhibits, speakers, and how to contribute to this work.

Braided River books may be purchased for corporate, educational, or other promotional sales. For special discounts and information, contact our sales department at 800.553.4453 or mbooks@mountaineersbooks.org.

THE MOUNTAINEERS, founded in 1906, is a nonprofit outdoor activity and conservation organization, whose mission is "to explore, study, preserve, and enjoy the natural beauty of the outdoors . . ." Mountaineers Books supports this mission by publishing travel and natural history guides, instructional texts, and works on conservation and history.

Send or call for our catalog of more than 800 outdoor titles:

Mountaineers Books
1001 SW Klickitat Way, Suite 201 • Seattle, WA 98134
800.553.4453 • www.mountaineersbooks.org

ISBN 978-1-68051-128-4

Manufactured in China on FSC®-certified paper, using soy-based ink.

For more information, visit www.caribourainforest.org

Publisher: Helen Cherullo
Project Manager: Laura Shauger
Developmental and Copy Editor: Ellen H. Wheat
Cover and Book Designer: Jen Grable
Cartographer: Martha Bostwick
Scientific Advisor: Greg Utzig
All photographs by the author unless noted otherwise.

"A Poem on Hope" is copyright © 2010 by Wendell Berry. Reprinted by permission of Counterpoint Press.

Portions of the rainforest chapter appeared in an article published by *High Country News* in 2016.

Page 1: *A yearling mountain caribou peers under its mother in the Caribou Rainforest.* Title page: *Fall snow dusts the higher elevations of peaks in the Cariboo Mountains.* Page 4: *Mountain caribou cow in low-elevation rainforest close to the Columbia River, northern Selkirk Mountains.* Page 6: *The broad leaves of devil's club almost glow on a rare sunny day in the Caribou Rainforest, northern Cariboo Mountains.*

This book was made possible with generous support from Furthermore, a program of the J. M. Kaplan Fund, and from the Kalispel Tribe and Northern Quest Resort & Casino.

Library of Congress Cataloging-in-Publication Data is on file for this title.

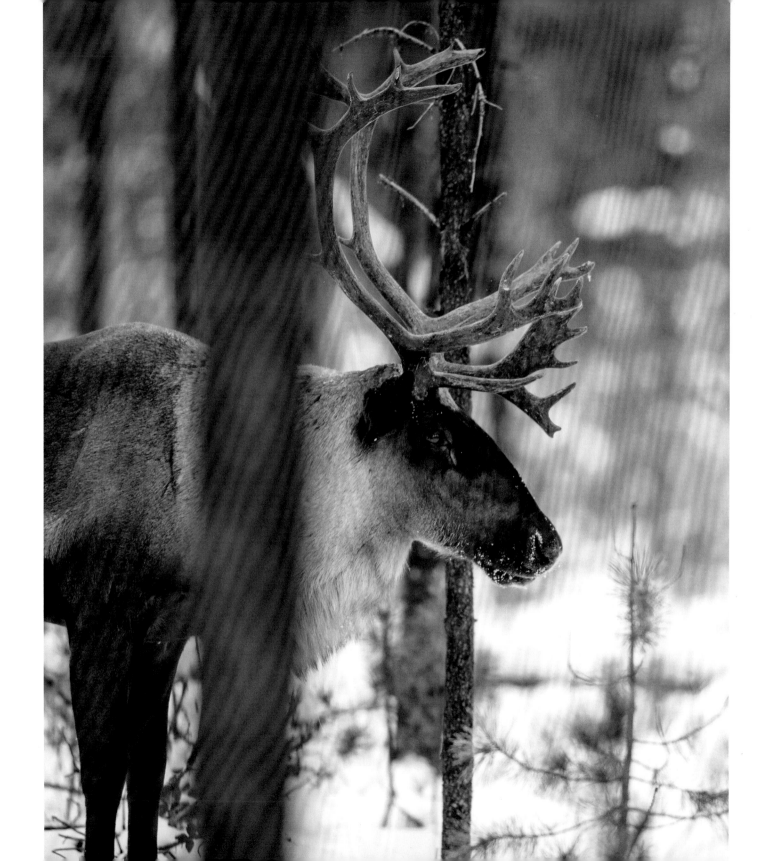